CREATIVE
WATERCOLOR
PAINTING
TECHNIQUES

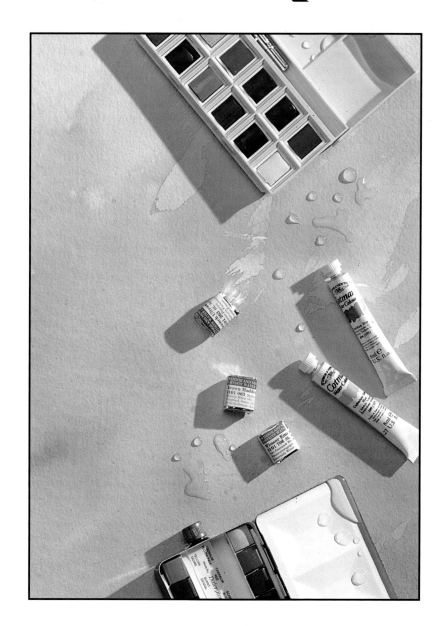

CREATIVE
WATERCOLOR PAINTING TECHNIQUES

NORTH LIGHT BOOKS

Front cover painting by Ian Sidaway.
Painting on page 3 by John Harvey.

Based on *The Art of Drawing and Painting*, published
in the UK by
© Eaglemoss Publications Ltd 1995
All rights reserved

First published in the USA in 1995
by North Light Books,
an imprint of F&W Publications Inc.,
1507 Dana Avenue,
Cincinnati, Ohio 45207.

ISBN 1-89134-711-9

Manufactured in Hong Kong

10 9 8 7 6 5 4 3 2 1

Contents

PART 1

Basics of Watercolor Painting

The magic of watercolour

Watercolour is justly regarded as one of the most beautiful of all the painting media. For centuries painters have loved its freshness and translucency and today it is as popular as ever.

At its best, watercolour looks effortless. That's why so many people are tempted to try their hand at it, and why almost as many are disappointed with the results.

There are some basic principles and techniques to watercolour painting. Once you've mastered these, you'll find you can create successful watercolour pictures.

Laying flat washes, controlling colours flooding into each other and creating textures with an almost dry brush are all part of the process of discovering just how versatile watercolour is. You'll find that deliberately blurring several colours together can create some beautiful effects, while painting on damp paper produces a soft-edged look that is most appealing.

This doesn't stop you taking full advantage of the unpredictable. Chance marks and happy accidents bring sparkle and spontaneity to your painting. When such things occur, leave well alone – let the picture itself 'talk back'.

The characteristic translucency of watercolour comes from the whiteness of the paper showing through the transparent colour. This is the only white available in watercolour, which is why artists choose to work mostly on white paper.

▼ **All the magic of watercolour is here – transparent washes, soft gentle colours blending subtly together and sparkling white highlights.**
'Château in Brittany' by Albany Wiseman , 140lb paper, 18 x 24in

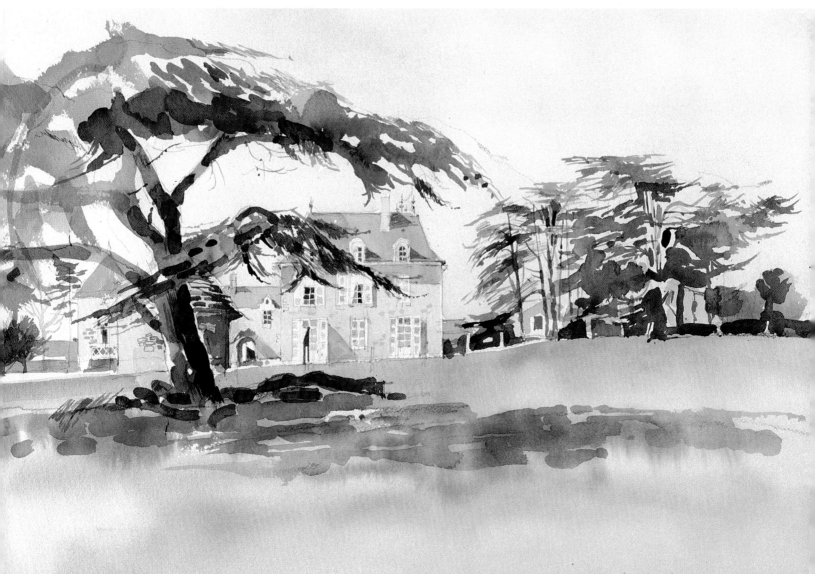

Keeping a record

As soon as you've taken the wrappers off your new pans of watercolour, paint a blob of each one on a sheet of paper and label it. Then when you pick up an unidentifiable pan, all you need to do is moisten the tip of your finger, dab it in the paint and test the colour on a piece of paper. Then take a quick look at your home-made chart to tell you what colour it is.

Brush starter kit

Keep things simple. You don't need many brushes to start with — one No. 12 round brush is all that's required for the landscape painting overleaf. It can cope well with washes and most other basic techniques. For finer work you'll find a No.6 round and a No. 2 round useful. Buy all three in a sable/synthetic fibre mix — pure sables are very expensive.

Pans or tubes?

Watercolour is available in two main forms – semi-moist cakes of paint in pans, and soft paint in tubes. There are pros and cons to each.

Pans (and half pans) are most often available in assorted boxes of 12, 18 and 24, but they can also be bought singly, so you can have just as many or as few as you like. Useful if you need a whole range of colours at hand, they're ideal when you're keen to carry the bare minimum of equipment around with you.

Tubes are sold individually or in boxes. They have the edge over pans when it comes to covering large areas because you can buy big tubes and squeeze out as much paint as you need, but working on a small scale can be a tedious business as you constantly stop to squeeze different colours from the array of paint tubes.

Artists or students?

Whether you plump for pans or tubes, you'll need to choose between artists' quality watercolour and students'. Be prepared, though – it may be your pocket that does the deciding!

Students' colours are aimed at the beginner and in consequence are the cheaper of the two. All the colours are the same price.

Artists' colours, made from vastly superior pigments, cost four to six times more than students', depending on the colour you choose.

When it comes to the crunch, go for artists' colours if you can – with watercolour, more than any other medium, buy the best you can afford. Cheaper colours can't always produce the same effects as the more expensive ones.

One final word before you commit yourself to a choice of paints – buying a selected range of colours in a box does have distinct advantages. For a start, it is easier to transport than a whole bundle of loose tubes or pans, brushes and palettes. But more than this, a box stops the paints drying out. And many have convenient built-in mixing palettes in the lid.

Getting started

Bear in mind when starting out with watercolour that you require a *thin* wash, not a thick, opaque layer. If you use the paint straight from the tube or pan, you're liable to get through it far too fast – working with watercolour paint correctly is very much cheaper.

By dissolving the paint in water you create washes of different intensities – more water gives a paler wash, less water gives a deeper colour. You can also use layer upon layer of these transparent washes to build up the colours and shapes you want on the paper.

▶ Preparing a pan colour wash

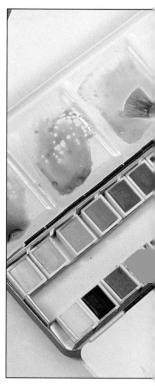

Using your brush, transfer a little water from the jar to one of the wells of the palette or to a saucer.

Wet the paint with the brush and mix the colour well. Now load the brush with paint and transfer to the water in the palette.

Mix well, then add more paint or water as needed until you have a wash of the right colour – but remember that watercolour dries paler. Test the colour on a scrap of paper.

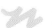

◄ Start off by mixing some paints – remember you need two jars of water, one for cleaning brushes, the other for mixing paints. Change the water regularly so your colours don't turn muddy.

► Preparing a tube colour wash

Squeeze a little watercolour paint into one of the wells of the palette or into a saucer. Dip your brush in the jar and load with water. Transfer to the palette and mix well with the paint.

Add more water with your brush until you have a wash of the colour you want – remember, though, that watercolour dries paler. Test the colour on a scrap of paper.

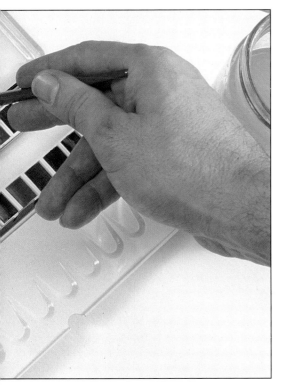

Mixing colours: summer trees

To paint a simple landscape, find a pleasing view or do what our artist did and paint from the photograph he had taken.

If you've never worked with watercolour before, start by mixing up a few washes and allowing yourself time to get the feel of the brush and the paint.

Before you begin, make sure you have all the equipment at hand. Set up plenty of palettes for mixing washes, and don't forget you need two jars of water – one for mixing and another for cleaning your brush.

Our artist chose a heavy piece of water-colour paper for this painting and taped it to a board. As an alternative to a single sheet, you could use a glued pad to hold the paper taut.

He also picked a sheet of paper larger than he needed to give space for testing colours. If you prefer, use a smaller piece and paint right up to the edges. You can test your colours on scraps of paper.

Keep things as simple as you can. Break down the landscape into broad areas of colour, then work with just a limited range of paints. The large brush won't lend itself to putting in fine detail anyway.

At all costs avoid overworking – the paint and paper surface are actually quite delicate. If the paper starts to get really wet, don't panic – you can always blot it off with kitchen paper.

Finally, do have faith. It's sometimes hard to believe that everything will be all right when the paint dries, but you'll be pleasantly surprised at the final result.

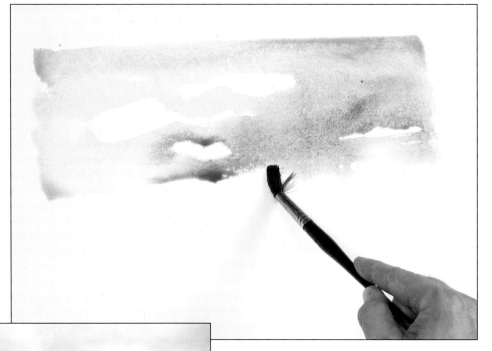

1 Mix two washes for the sky – a lighter one of cobalt blue and a darker one of dilute Payne's gray. Test the colours.

2 Load the brush with cobalt blue. Quickly lay a band of colour at the top of the paper. Don't worry about covering all the paper – any white showing through will stand for clouds.

Now load the brush with Payne's gray and, starting below the cobalt band, lay the colour across the paper. Angle it in all directions to get a modulated colour – full of lights and darks. Allow colours to flood into one another so you lose brush marks. Paint grey to the horizon.

To create an impression of distance here, lose some colour by laying a clean wash of water over the bottom of the sky. Add warmth to the sky with a yellow ochre/Payne's gray mix. Leave to dry.

▲ **The set-up** Our artist used this photo as his starting point, but didn't copy it slavishly (he left the car out, for example).

3 Mix up three washes for the foreground. One of sap green with a little cadmium yellow; another of sap green; and a third of sap green with some brown madder alizarin.

Working quickly, lay a band of the first mix. Then lay a band of the second mix below. As with the sky, allow the colours to flood into one another. Finally, lay a band of colour with the third mix.

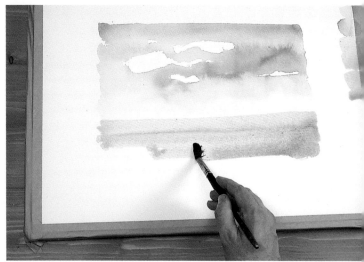

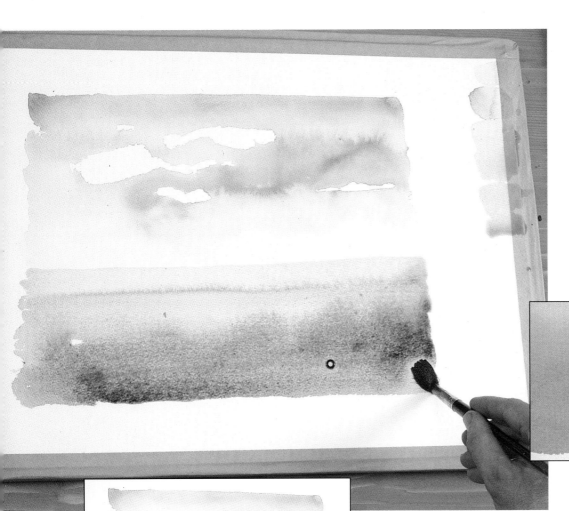

4 For the near foreground, add a little Payne's gray to the wash of sap green and use it to lay a fourth band of colour.

 Then paint more bands underneath, adding more and more Payne's gray as you approach the bottom of the paper – this darker colour will create the impression of closeness. Don't worry too much about the effect – this is all underpainting which you'll paint over later. Leave to dry.

5 As you paint, remember that your colours will dry much paler – as in the foreground here.

6 For the centreground trees, make a wash of sap green with a touch of brown madder alizarin. Paint them in, remembering that you're simplifying the shapes.

7 For the base of the trees, make an intense mix of sap green and Payne's gray. While the first tree colour is still wet, flood in plenty of the new wash. At the bottoms of the trees, pull the paint down with the brush to describe the tree trunks. Leave to dry. (As it dries, notice how crisp edges form where the paint gathered on the paper in small puddles.)

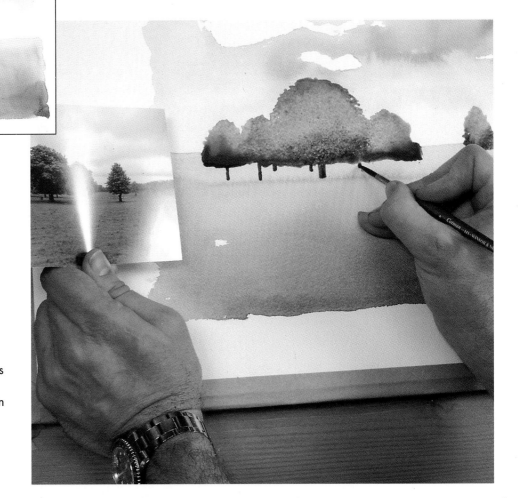

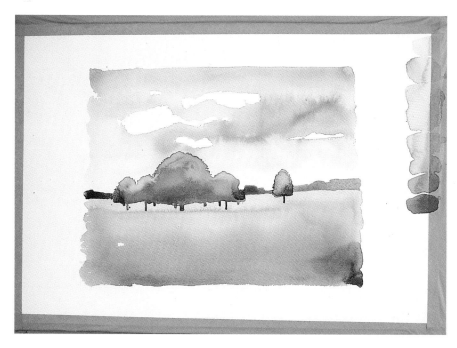

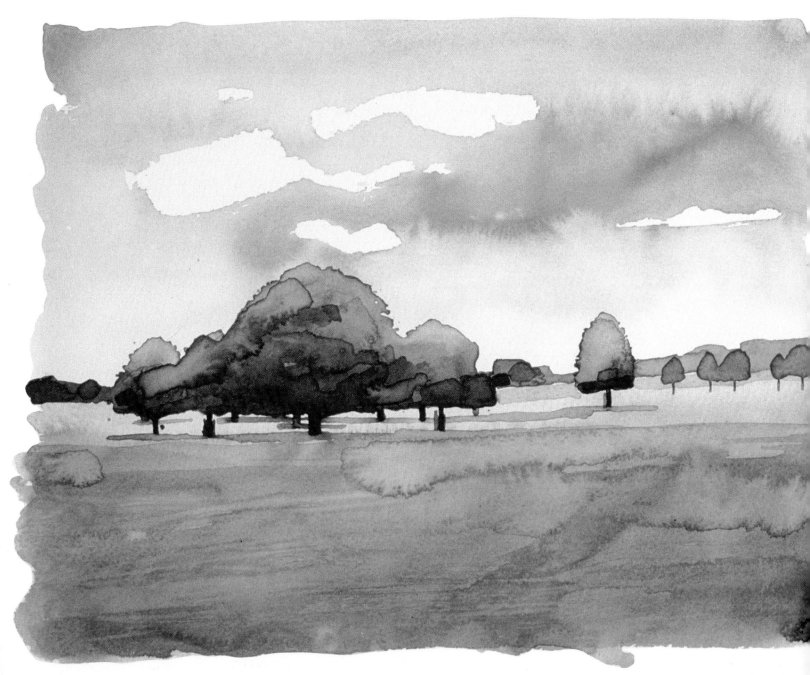

◀**8** Still using the intense mix of sap green and Payne's gray, lay in the trees on the horizon on the left. Leave to dry (20 minutes to half an hour).

▼**9** Paint in shadows under the trees with the sap green and Payne's gray mix.

Then, using one of your darker green washes, lay some patches of colour on the trees. Avoid moving the paint around – you want puddles which will dry with hard edges to describe clumps of foliage. Paint the smaller trees in the background using the same technique.

Now step well back and assess what your picture needs. Here the underpainted foreground looks rather thin and flat, so the artist added texture to it by laying more sap green and Payne's gray mix over it. Again, he didn't work it too much because he wanted some crisp edges to form. Leave the finished painting to dry.

Palettes for watercolours

Watercolour palettes come in a vast range of shapes and sizes – so you can be guided almost entirely by your own personal likes and dislikes when you come to choose one.

Some artists aren't happy unless they're surrounded by lots of different palettes, while others find just one ample for all requirements. Some will mix paints on the first surface that comes to hand, while others will only mix their paints on porcelain. The choice is entirely yours.

Whether they're made of ceramic, enamelled metal, plastic or high impact polystyrene, the one property all watercolour palettes share is their white appearance. This allows you to see the true colour of a wash with minimum distortion. Of course, you can use any white, watertight surface. Ordinary plates and saucers, hors d'oeuvres dishes, cups, bowls – even yogurt pots – are all excellent makeshift palettes.

The design you go for depends on how you intend to use your paints. For expansive washes, you need a palette with deep recesses to mix the paint with generous amounts of water. For tighter, more detailed work, you may want smaller recesses, but more of them, so you can make use of many colours. Watercolour palettes are designed with quite specific uses in mind. The more popular designs (listed below) give you a good cross-section to choose from.

Slant tiles/palettes are good general palettes. They're rectangular in shape and come in two styles – divided slant and slant well. The divided version (see **2** below) has compartments which slope down to a deep recess at one end in which you can mix a fairly large wash. The top end of the slope is good for small, dry mixes, or for drawing up a little paint from the deep end to assess its tone.

Slant well tiles/palettes are the same shape, with the addition of a small, round well at the top of the deep end of each recess. You squeeze your paint into these, then move a little into the slant to dilute it or mix it with another colour.

Tinting saucers (see **3** below) are small, circular saucers divided into four shallow compartments, each with a useful brush-rest on the edge. Because of their size they're great for small washes, but you'll probably need two or three. It might be useful to have one solely for masking fluid, additives and mediums, so you can keep these separate from your colour mixes.

A variation on the tinting saucer is the cabinet saucer, which is the same basic design minus the divisions. Each holds a large wash, so you'll need

▼ Buying watercolour palettes can get quite confusing when you take in the many different designs available. Keep your own painting requirements firmly in mind, and you're on the way to acquiring a useful selection of palettes.

The palettes below are:
1 Kidney-shaped plastic palette
2 Divided slant tiles/palettes
3 Tinting saucers
4 Slant well tiles/palettes
5 Compact plastic palettes with a variety of recesses
6 Cabinet saucers
7 Deep-welled palette tray
8 Medium-welled ceramic palette

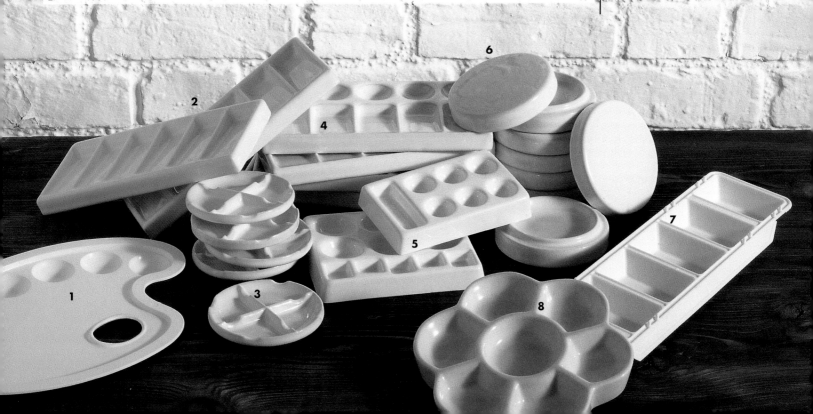

a separate saucer for each wash, and enough space on your table for them all. You buy cabinet saucers in stacks of about five with a lid.

Slant tiles, tinting saucers and cabinet saucers are usually made of shiny white ceramic. The smooth, slippery quality is considered by many artists to be the most sympathetic surface for mixing their watercolours.

Plastic palettes (see previous page) enable you to work with really large washes – it's always best to mix more than you think you'll need to ensure you don't run out. These palettes have deep wells with plenty of room in each compartment to contain a substantial amount of fluid paint. You should bear in mind, though, that a colour, when seen in a deep pool in your palette, appears much darker than it does when spread on the paper in a thin layer.

Plastic palettes are not only cheap but lightweight – perfect for painting outdoors. However, they do tend to stain more than ceramic palettes, making it difficult to see the exact colour of your wash.

Field kits and thumb-hole palettes
If outdoor painting is your interest, you can choose from a number of field kits or painting boxes, designed to hold pans or tubes of paint with integral palettes in the lid. Some also have a hinged flap for mixing and tinting, and a thumb ring in the base to give you a secure grip with one hand. These compact kits are light and easy to carry around with you.

Another alternative is the watercolour version of the traditional kidney-shaped oil palette with a thumb hole. You dilute the paint in the individual wells around the edge, using the large flat surface in the centre for drier mixes. This style of palette is also convenient for outdoor work, since you can hold it quite comfortably with one hand. Be careful not to tip it at an angle, though, or your washes could run together or – even worse – spill on to your painting!

▶ An ordinary white household plate makes an excellent palette. Choose a wide-rimmed one so you have plenty of room to squeeze out blobs of paint.

▼ Their versatility makes divided slant tiles/palettes popular. Mix your wash in the deep end, then test the colour at the shallow end.

Keep it clean
The discipline of rinsing your palettes in clean water when you have finished a painting session is all important. You may find it handy to keep a small sponge especially for cleaning palettes, and a rag or paper tissues for drying them. Not only is it much quicker to deal with a dirty palette before the paint dries, it's also very irritating to start off a painting session by cleaning a whole load of last week's dirty equipment.

▲ When you have large areas to cover – background washes, say – there's nothing more irritating than running out of paint halfway through. Use these large plastic palette trays to ensure you make up enough of the mix in one go.

◀ Tinting saucers, with their compact recesses, are perfect for small-scale mixing.

Mother & kittens

▶ **The set-up** Our artist had a sketchbook with her when she met this tortoiseshell mother cat feeding her hungry kittens. She made a few sketches of the family group nestled in a cushion, then used them to work up a finished painting. A quick snapshot provided her with all the colour reference she needed.

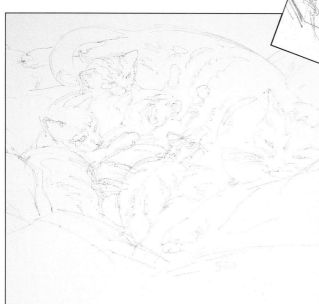

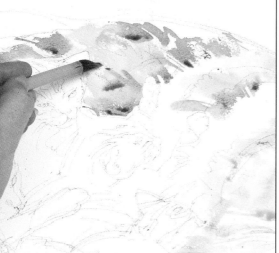

◀ **1** Using your HB pencil, sketch the outlines and main features of the cat and her kittens. You'll find it a useful guide if you add a rough indication of their markings and the folds of the cushion.

◀ **2** Mix washes of Indian yellow, burnt sienna and light ochre in separate wells of the slant tile palette. Work quickly and loosely to paint the cat's face and body with these washes, using your medium Chinese brush. Let the colours diffuse together to indicate the texture and markings of the fur.

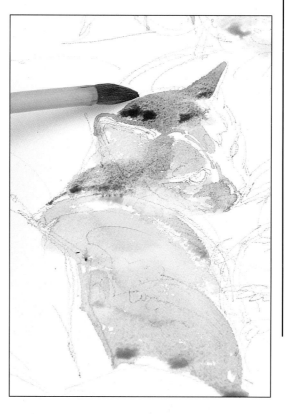

▶ **3** Use the same brush to paint the tabby kittens with your orange-brown mixtures. For the dark markings, mix sepia with a little Prussian blue in another compartment of your slant tile palette. Then apply it wet-on-wet so the colours spread and dry without a hard edge. Leave areas of white paper to stand for the lightest tones.

If you wish, combine your washes to make a variety of colours and tones to build up the fur markings on the kittens.

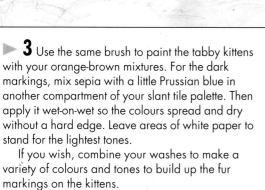

Tip

Bamboo pens
Bamboo pens are inexpensive and available from many art shops. The

small split in the nib holds drawing ink or paint. Dip a soft brush into your wash and transfer a little paint to the upturned end of the nib. Avoid dipping the pen into your paint, or you'll end with a splodge instead of a line.

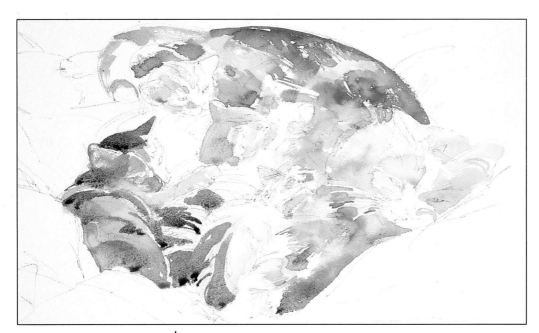

◀ **4** Continue working around the group, using your washes to build up the tones and details gradually.

Avoid concentrating on any one area for too long since this creates a disjointed effect. By bringing the whole group along at the same pace, you create a more natural image with a sense of balance. Work 'fast and loose' at this stage, letting your brush marks break the boundaries of your pencil outlines. Neatly filled in outlines can be death to any watercolour painting.

▶ **5** Use your reed pen to draw the tiny striped markings on the kittens' foreheads (see Tip). This pen makes soft lines and allows you more control than a brush when working on delicate linear details.

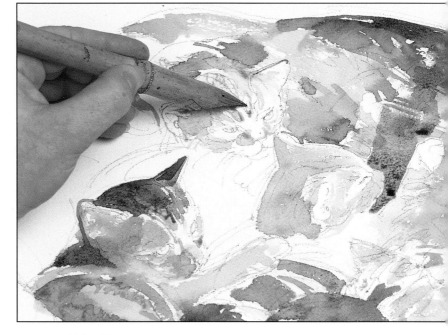

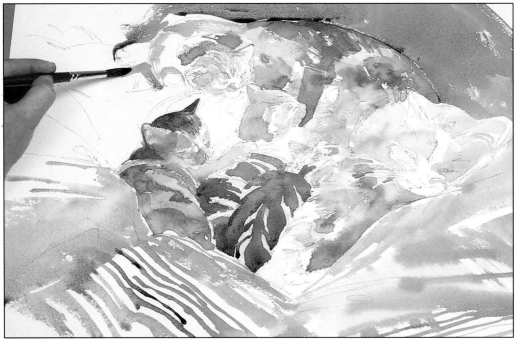

◀ **6** Leave the painting to dry. Meanwhile, mix a mid-toned blue-green from viridian and a little ultramarine in your palette tray. Make up plenty of paint – more than you think you'll need. There's nothing more frustrating than running out of paint half-way through applying a wash. Wash in the lightest tone of the cushion, using your No.10 brush.

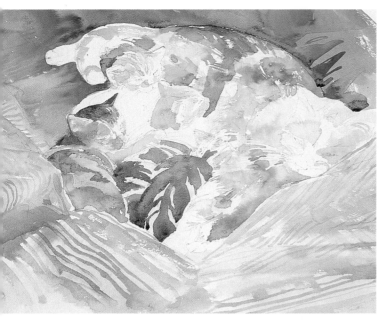

◀ **7** Vary the strength of your blue wash to indicate the shadows and highlights on the cushion. This helps to suggest that the cat and kittens are nestled in a hollow, and makes the cushion look solid and rounded. Dilute the wash with more water for the lighter areas, and add a little indigo for the darkest tones, behind the mother cat's back, for example.

Notice how the stripes on the fabric follow the form of the folds and indents in the cushion, adding textural interest in the foreground. Again, leave the painting to dry thoroughly before you go on.

▶ **8** Now that you've established the main elements, begin tightening up the details and fur markings. Use feathery brushstrokes to achieve a sense of the fur's texture. Mix some sepia and ultramarine in your palette tray for the darkest markings on the kittens. Apply this near-black wash with your medium-large Chinese brush. Start with the kitten right at the back, working your way down to the foreground. Dilute Prussian blue with plenty of water for the kittens' eyes – you may want to do this in your tinting saucer.

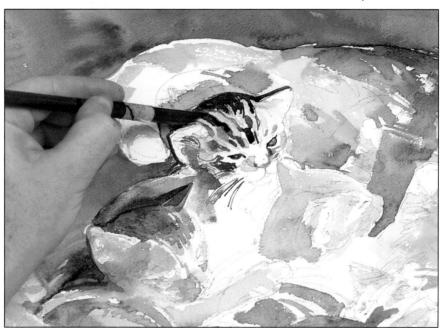

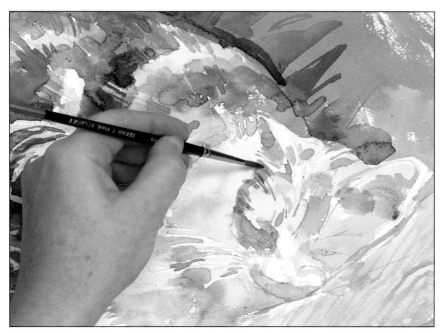

◀ **9** Keep working around the painting, building up the fur markings. Define the features on the mother cat, using various tones mixed from burnt sienna, Indian yellow and sepia. Your No.3 brush is useful for finer details. Mix up washes for small areas of colour in your tinting saucer, using either your palette tray or slant tile for larger washes.

► **10** Paint the dark markings on the mother cat's lower leg and one side of the face, overlaying washes of indigo and sepia and adding a touch of ultramarine for the darkest tones. Deepen the tones of the cushion in the background to strengthen the feeling of depth and perspective. For this, add indigo to the cushion wash.

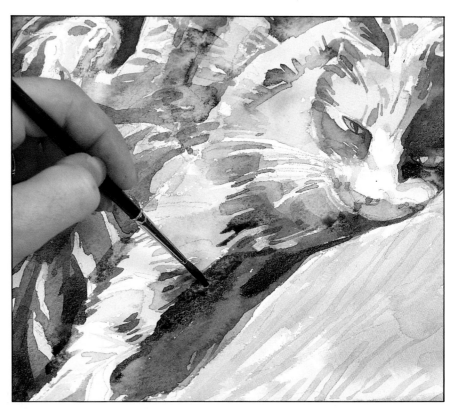

▼ **11** In the final painting, you can almost feel the warmth of this family group all huddled together. The texture of the fur and patterns of the markings have been wonderfully handled.

The artist used the same washes in her palettes over and over again, adjusting them to make the tones and colours she wanted. Not only is this an economical way to paint – making each wash from scratch would be expensive – but it also holds the entire painting together, lending it a feeling of harmony and unity.

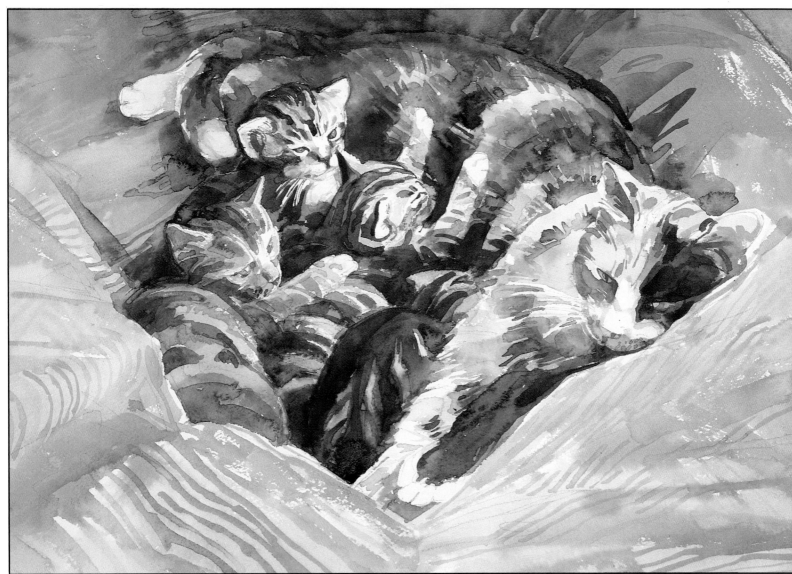

Watercolour paper

There's an enormous range of watercolour paper on the market. Choose the right one and your painting is off to the best possible start.

A painting surface is usually referred to as a support. With watercolour, the quality and choice of that support are all important, and should never be skimped on. Don't try to economize by painting on cheap drawing paper. This is a great mistake – when you apply wet colour, it buckles ('cockles') and may even tear.

Choosing paper

You can buy paper in single sheets, usually measuring 30 x 20in. Some papers also come in block form – either ring bound or as pads of sheets gummed along the edges. You paint on gummed sheets in the pad, then remove them.

Blocks are available in a range of sizes. All are mounted on rigid card/cardboard, so they can be used without a drawing board – useful for working out of doors or away from home.

Most watercolour paper is machine made, but some superior kinds are manufactured by hand, often from pure linen rag instead of the usual wood pulp. Handmade papers are more expensive and are generally recognizable by their irregular surface and ragged ('deckle') edges.

Most modern machine-made papers are treated on both sides with size – a weak glue solution that makes the paper absorb less paint. Some machine-made papers and all those made by hand are sealed with size on only one side. You can generally tell which this is because it has a sheen. With good quality papers, it's easier – the watermark reads the right way round. If you are ever left in any doubt, do check with the assistant in the art shop.

The paper surface

There are three types of surface on watercolour paper: **hot pressed (HP)**, which is very smooth; **cold pressed (CP)**, which has a semi-rough surface (and is often referred to as NOT paper, meaning that it is not hot pressed); and **rough**.

A good choice for beginners is NOT/cold pressed paper. Smooth enough to take a flat wash, it has enough texture to give a lively finish.

Hot-pressed paper produces even colour and is good for detailed work. A rough support is coarse and produces a flecked or textured finish, depending on how you apply the paint. Both these papers require practice to get the best results.

▼ **Whether it's a small sheet of handmade paper or a large machine-made block, there's a watercolour paper for every possible occasion.**

Stretching paper

Lightweight watercolour papers have to be stretched before you use them. If you don't, they buckle and wrinkle when wet paint is applied (see right). As a general rule, you need to stretch any paper that weighs less than 140lb. Paper thickness is measured by its weight per 500 sheets/ream. This figure is almost always mentioned with the manufacturer's name. So, when you buy a sheet of 90lb Saunders paper, for instance, this means that 500 sheets of it weigh 90lb.

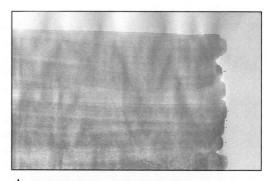

▲ **Lightweight paper that hasn't been stretched 'cockles' when liquid applied to it dries out.**

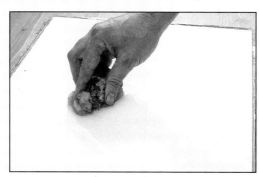

▲**1** Place the paper on your drawing board and wet thoroughly and evenly. The easiest way to do this is with a small sponge and bowl of cold water. Now move quickly on to step 2 while the paper is still wet.

▲**2** Stick the paper to the drawing board using brown gummed paper tape all round the edges. It should overlap the paper by about 2cm (¾in). Leave the paper to dry naturally before using. It may look wrinkled but it will flatten as it dries.

Bouquet of tulips

Still life allows the artist considerable control over the arrangement of the subject. Here our artist has made an unusual image by laying the flowers on the table rather than putting them in a vase – creating a horizontal composition, not an upright one, which would be more usual for a flower study. He did this because he liked the bright blue paper the flowers were wrapped in. It provided a cool foil to counter the warm red of the tulips and he decided it would be interesting to exploit that in the composition. He introduced further drama by homing in on the subject so that parts of the paper wrapper are cut off by the edges of the picture area. Some interesting background shapes are trapped between the outline of the paper wrapper and the side of the support.

Make sure to stretch the support before you start so you end up with a smooth picture. Then keep things as simple as you can, breaking the tulips down into broad areas of colour.

1 With the HB graphite stick, loosely draw in the outline of the picture.

◀**2** Make up a watery mix of sap green and cadmium yellow. With the No. 6 brush, quickly block in all the areas of leaf and stem. Move the paint round evenly – you want a flat colour, not a textured one where paint has been allowed to sit patchily on the paper.

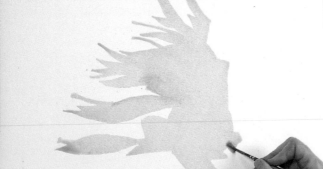

▲ **The set-up**

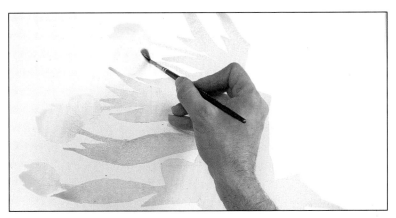

► **3** Make a mix of Naples yellow and cadmium yellow. Load the brush and paint in the whole flowerheads. Don't move the paint round too much – allow it to puddle in places. To soften the colour slightly, blot some of the paint off with kitchen paper. Leave to dry.

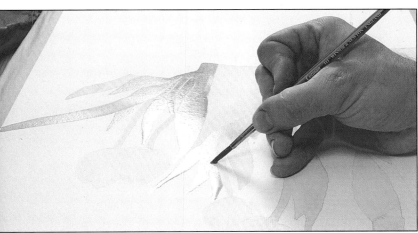

◄ **4** Darken the sap green and cadmium yellow mix slightly with cobalt blue. Look carefully at the leaves to identify the mid-green tones, then paint them in, simplifying the shapes as you go. Notice how this green defines the paler stems in places. Leave to dry.

◄ **5** Darken the green mix again with a little more cobalt blue. Look at the leaves and pick out the darkest green tones – where the leaves are turning over, say. Then paint them in, still using the No. 6 brush.

With a light mixture of cadmium yellow, paint the edges of the flowerheads where the yellow is going to show through. Leave to dry.

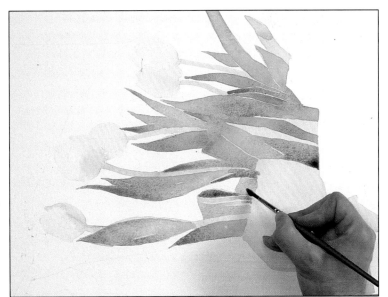

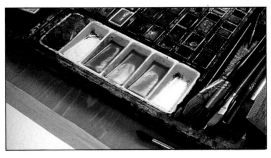

▲ **Make up three different red washes (see step 6 below)**

► **6** Make up three washes for the flowers – alizarin crimson, alizarin crimson with brown madder alizarin, and alizarin crimson with brown madder alizarin and cadmium yellow. Use the first to paint the pale parts and the second for the darker parts. Load the brush with the third mix, position it where you want red with a hint of yellow, then just let the paint flow from the brush.

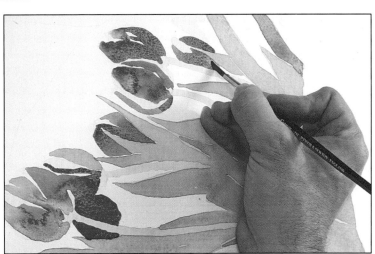

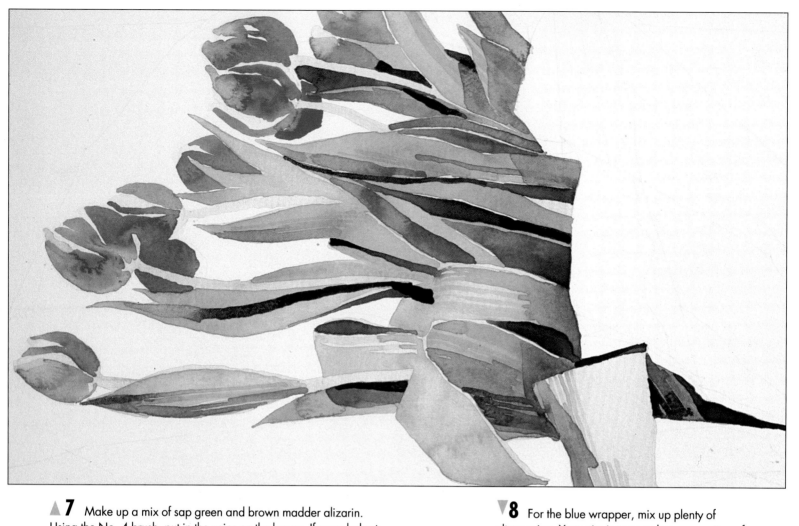

7 Make up a mix of sap green and brown madder alizarin. Using the No. 4 brush, put in the veins on the leaves. If your darkest leaves and shadows are too pale, darken the mixture with more brown madder alizarin and re-touch them. Leave to dry.

8 For the blue wrapper, mix up plenty of ultramarine. Your aim is to complete one section of the wrapper before you move on to the next. Use the No. 6 brush for the larger areas and switch to the No. 4 for the edges, painting over the leaves or flowers with the ultramarine as necessary to correct their shape. Leaving small white lines here and there around the edges gives the impression of light hitting the subject, bringing it forward.

9 In among the foliage use the No. 1 brush for the background. A good way to do this is to apply a little colour and paint an outline. Then you can flood colour inside the outline with the No. 4 brush – the outline holds the paint in place. Finish the wrapper, then leave to dry.

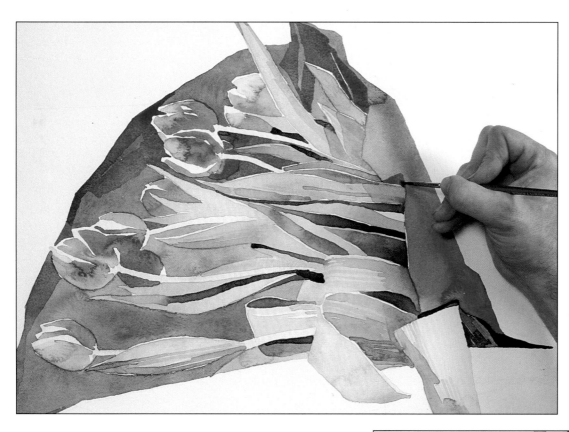

◄ **10** Still using the same ultramarine mix, paint in the folds and lighter shadows of the wrapper. Make these shapes angular to convey the tissue's crinkliness.

Darken the mix with more ultramarine and brown madder alizarin and paint in the darker shadows and creases with the No. 1 brush.

Now that you've painted in the blue wrapper, the picture should begin to look rather different. For instance, the flowerheads that looked fine against the white might need more emphasis against the blue. If so, add alizarin crimson to the mix and paint in shadows on the flowerheads.

► **11** For the outer wrapper, make up a light mix of burnt sienna with a little brown madder alizarin and paint in with a No. 6 brush. Leave to dry before using the same mix with a little ultramarine added to put in some of the wrapper's darker patches.

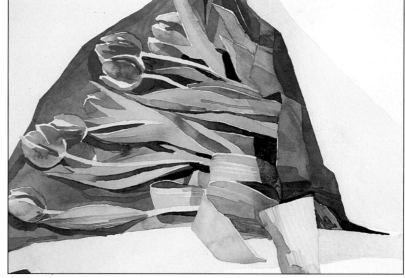

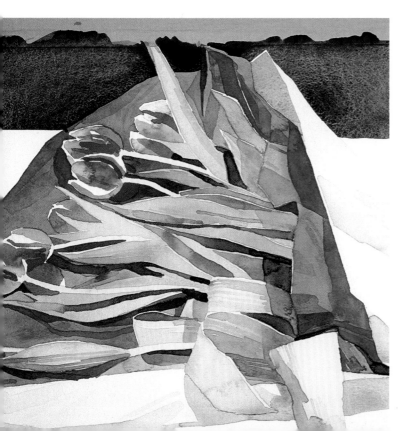

◄ **12** Make a wash of sepia and Payne's gray. Paint in the large areas of the background with a No. 12 brush and the finer details with a No. 4. Spread the paint evenly – you want a flat colour here rather than a textured one, which would distract attention away from the flowers. Finish off the flowerheads with touches of cadmium yellow.

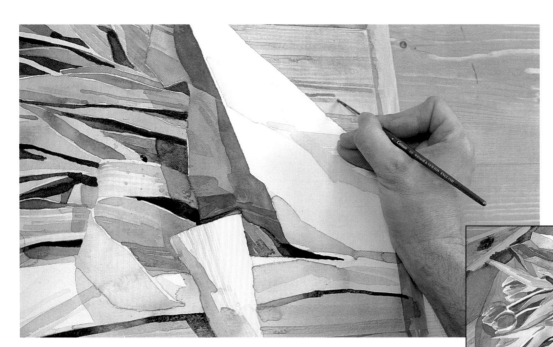

◀ **13** For the table top, mix up yellow ochre with a touch of brown madder alizarin. Paint in the larger areas with a No. 12 brush, and use a No. 4 for the edges. Again, you want an area of flat colour. For the shadow underneath the wrapper, mix sepia with Payne's gray and paint it in with the No. 4 brush. Paint in the wood grain, using yellow ochre with a little bit of sepia. Leave to dry.

▶ **14** Cut the painting free from the board with a craft knife (right). If your paper-stretching was successful the finished painting (below) should be completely flat.

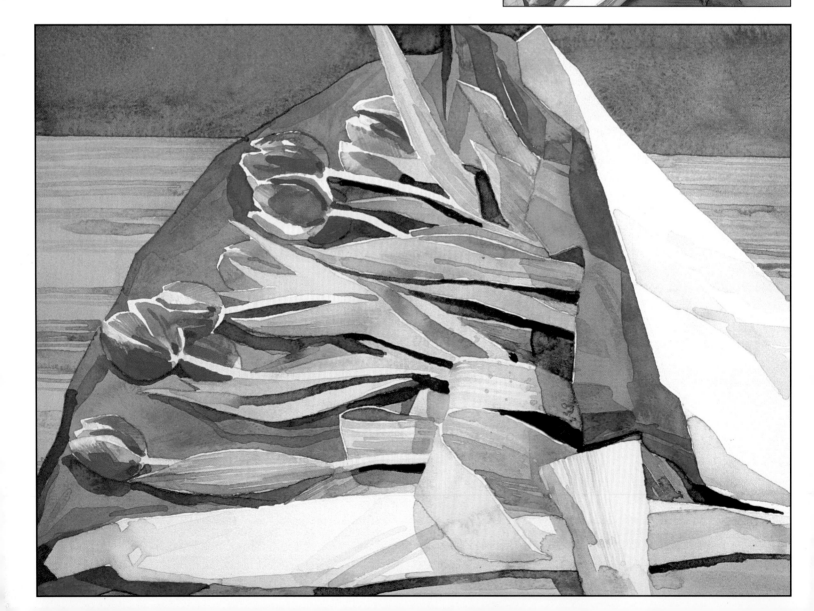

Brushes for watercolours

Walk into an art shop without knowing which and how many watercolour brushes you need, and you'll probably be daunted by the vast range available.

Beginners often buy too many brushes when starting watercolour painting. Instead of a boon this can be a handicap – not only are you left wondering just which brush to use, but changing from one to another takes your mind off composition and colour. Using a few essential brushes solves this problem.

Buy the best brushes you can afford. The better the brush, the better it performs and the longer it lasts. Don't buy a cheap brush – the ferrule may rust and the hair may fall out because it isn't attached firmly enough.

Choose your material
The material of the brush determines its price and performance. Sable brushes are the best – they are springy, hold a lot of water and last a long time. But they can be at least four times the price of synthetic brushes.

Synthetic brushes are cheap, but they quickly lose their point and don't hold as much water as the sables. Other materials include squirrel, camel and ox hair. But they too don't last long or hold water well. It's best to buy brushes in a sable/synthetic mix – they are reasonably priced and perform well.

► Watercolour brushes for most purposes – and pockets. Flats are also called chisels or one-strokes.
Fan shaped spread: 14A wash brush (1), No.12 round sable/synthetic (2, 15), size 2 sable/synthetic lettering brush (3), No.12 round sable (4), ⅜in flat sable/synthetic (5), No. 4 fan sable/synthetic (6), No.14 round sable/synthetic (7), 2in flat wash sable/synthetic (8), wallet set of sable/synthetic brushes, Nos. 1, 4 and 6 round, ⅜in flat and size 1 lettering (9), wallet set of synthetic brushes, Nos. 1, 4 and 6 round, ½in flat and size 1 designers' (10).
In the brush pot: ⅜in flat sable (11), ½in flat synthetic (12), No.8 round sable (13), No.10 round sable/synthetic (14), No.10 round synthetic (16), ¼in flat synthetic (17).

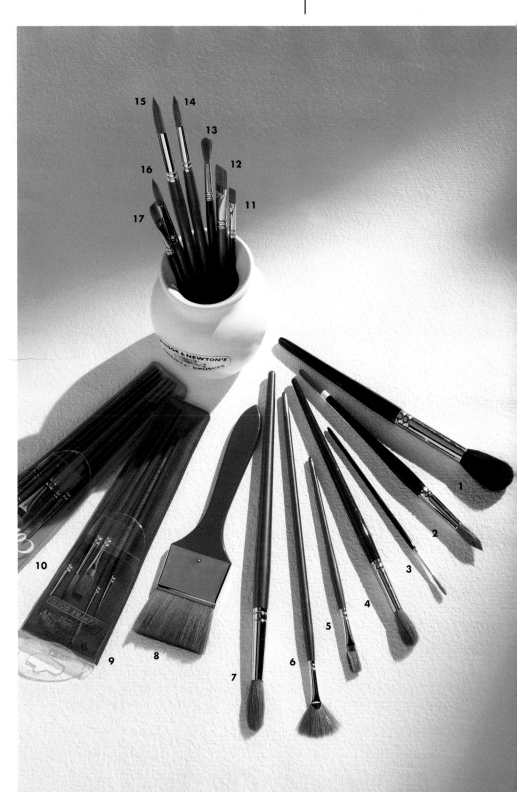

Brush sizes

Most brushes have a number stamped on the handle which refers to their size. The smallest available is the 0000, and the largest is the No.24 wash brush. As you would expect, the cost rises as the size of the brush increases.

One common mistake beginners make is buying a brush which is too small. Because it can only make fine marks, its uses are limited. But a fairly large, good-quality brush (such as a No.12) comes to a fine point when dipped into water, enabling you to paint precise details, and is excellent for large washes too.

Shapes and styles

Rounds and flats (the flats are also called chisels or one-stroke brushes) are the main types used for watercolour – although wash and fan brushes are sometimes needed as well. Flats have a flat ferrule – rounds have a round ferrule.

Rounds These are the most useful, general-purpose ones to choose. Capable of making broad sweeps and washes as well as fine, controlled work,

they are indispensable. A No.12 and either a No.6 or No.8 will meet most of your needs.

Flats are very adaptable – with a No.10 flat brush, for example, you can make large washes or form crisp lines and shapes. When you're working wet-in-wet, a large flat brush makes a generous mark.

Wash brushes are designed to paint large areas quickly. Some are wide and flat, while others (mops) have large round heads. A large flat is a good substitute. Alternatively, you can use sponges and clean cotton rags for large washes.

Fans Their name describes the shape of these brushes. They are useful for feathering and blending techniques and for dry-brush work.

Riggers and lettering brushes are round with very long hair. They are designed to hold a lot of paint and produce a thin, fine line.

Starter set The following three brushes make an excellent starting choice: a No.12 and a No.6 round and a No.10 flat. All should be a sable/synthetic mixture. Extra but non-essential ones to buy later include a No.14 wash brush and a No.2 round lettering brush (for precise detail).

A variety of brushstrokes

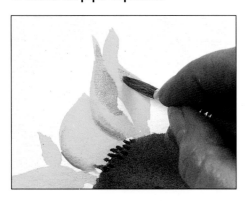

The No.12 round brush is a useful wash brush – press down on it to splay the bristles and cover as much of the paper as possible.

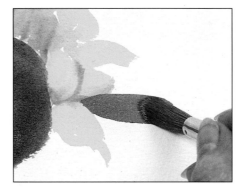

The No.12 round tapers from a wide base to a fine point – perfect for forming graceful shapes such as the petals of flowers.

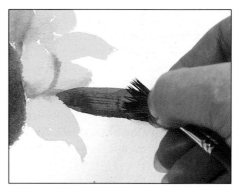

The fine point of the No.6 round brush is useful for adding details, such as the edge of these flowerheads.

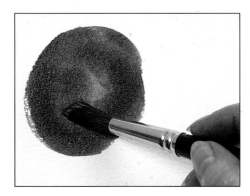

Using the shape of the No.6 brush , you can also create small strokes for the internal tones on these petals, giving them form.

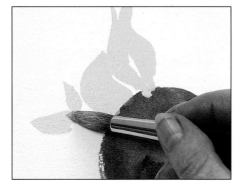

A well loaded No.12 brush forms a single, bold stroke, perfect for the stalk of this flower. Press down to spread the bristles.

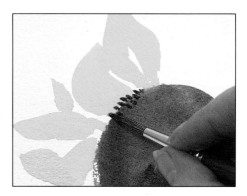

You can create a fan-shaped brush by pinching the bristles. Here the artist drags a dryish No.6 brush over the stalk to create depth.

Birthday tea-table

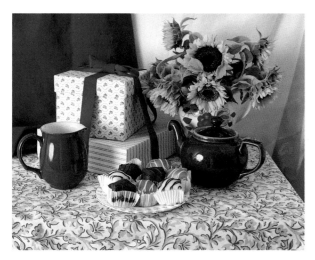

The set-up Warm yellow sunflowers offset the cool blue china and pottery and colourful cakes.

Our artist (who is left-handed) used four brushes – from a No.2 round for the delicate icing on the cakes to the big No.14A wash brush for the blue curtain, but you don't have to use exactly the same ones. Your basic No.12 and No.6 rounds give good enough points for the detailed fine lines, and are excellent for large expanses of wash. The choice of brushes is always personal – so experiment to find which suits your style of painting best.

1 With a composition such as this you need to make an accurate drawing before beginning. Choose your viewpoint carefully, then sketch in the main items of the still life with the 2B pencil.

2 Wet the white curtain area with the No.14A wash brush and clean water. Change to the No.12 and drop in light touches of raw sienna and raw sienna mixed with a tiny amount of cobalt blue.

Mix some very dilute cobalt blue with a touch of raw sienna for the table top. Paint in the dark edge in the foreground and the lighter table top with the No.14A wash brush. Add more paint to darken the mix and, with the No.12 brush, create the shadows under teapot, jug, boxes and plate.

Wet the blue curtain area with the No.14A wash brush and lay on a dilute wet-in-wet wash of cobalt blue. While this is damp, apply a darker tone of cobalt blue over the whole surface, using vertical brushstrokes. Mix up a darker tone still, and go over the curtain again, starting at the right and working towards the left of the curtain.

Paint in two dark central folds wet-in-wet in the curtain – one with cobalt blue hardly diluted at all, the other with cobalt mixed with Vandyke brown.

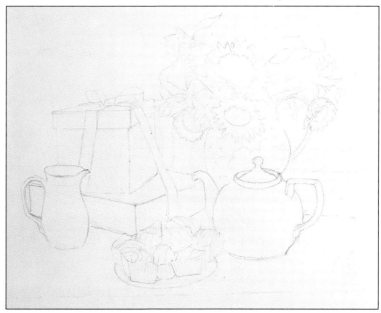

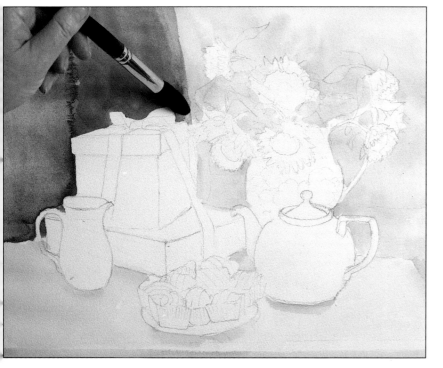

3 Mix some crimson, cobalt blue and raw sienna and paint in the shadows on the top of the upper box and the side.

While the paint on the side of the box is still wet, drop in touches of raw sienna with the very tip of the No.12 brush.

4 For the horizontal stripes on the side of the box facing the jug, use three tones of grey (made from varying strength mixes of alizarin crimson, cobalt blue and raw sienna).

Apply the first – very dilute – tone with a wet brush. Make the other two tones darker by using less water, and dry-brush them on. Don't forget to paint the stripes seen through the handle of the jug.

Use a mix of grey and alizarin crimson to paint the vertical stripes on the side facing the teapot and also the ones on top of the box.

◄ **5** When the curtain area had dried, our artist felt it was too light, so she added another darker tone of cobalt blue to the area above the boxes, using the No.14A brush.

► **6** Put a cadmium yellow wash on to the sunflower petals with your No.12 brush.

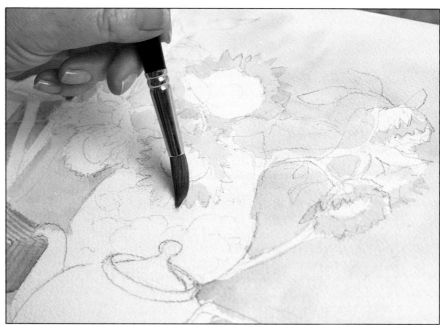

▼ **7** Using the same brush, paint the pinkish cakes with a weak wash of alizarin crimson, leaving some streaks of the white paper to show through for the icing. While the paint is still wet, drop in darker tones here and there. Also paint the parts of the cakes showing through the paper holders.

Paint the two yellow cakes using a dilute cadmium yellow. Change to a mix of cobalt blue and Vandyke brown for the chocolate ones – again dropping in darker tones while the first wash is still wet. Remember to paint the cake showing through the paper holders.

Adding the shadows of the cakes on the plate (with the same grey mixture you used for the box stripes) helps to bring the cakes forward in the picture.

▼ **8** Mix several tones of green from varying amounts of cadmium yellow, cobalt blue and Vandyke brown and paint in the leaves and stalks, adding more brown to darken the mixes as you go. Apply a dilute, mustardy green first layer with the No.12 brush. When that is dry, add two more darker tones for the leaves at the back. Leave white spaces at the edges of the leaves.

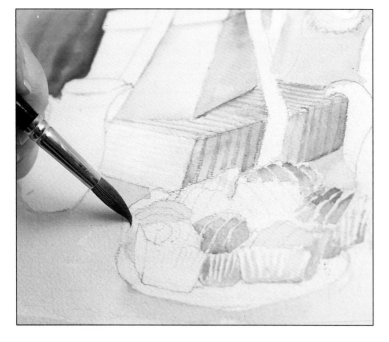

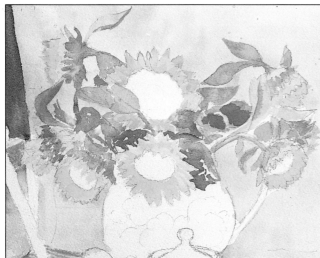

◀ **9** Our artist then returned to the sunflower petals to add another tone. Using cadmium yellow mixed with a tiny amount of cobalt blue (which darkens the yellow slightly), dry-brush the colour on to the petals.

The broad range of greens and browns on the leaves and stalks now provide a three-dimensional perspective.

Tip

Lighten it up
Use a cloth, kitchen paper or cotton wool to lift off areas of colour – this is yet another way to create lighter areas of tone in a painting.

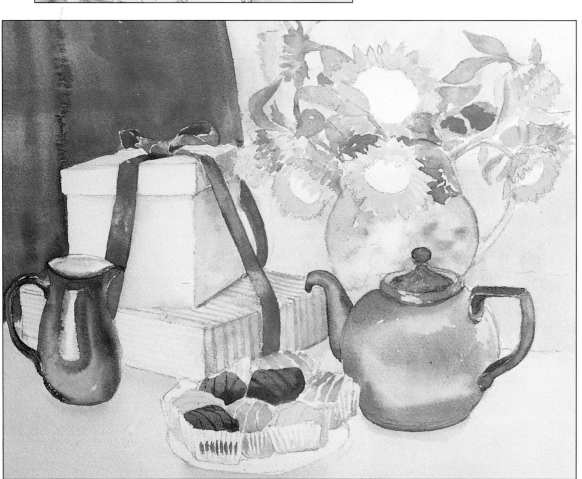

◀ **10** For the blue ribbon apply a darkish wash of cobalt blue, remembering to leave white spaces against the curtain (for the knot) to bring the whole thing forward. Use cotton wool to dab off small areas of paint.

11 Apply a pale cobalt blue wash to the vase with the No.12 brush, adding dilute grey (made from cobalt blue, raw sienna and alizarin crimson) to the sides. While the paint is still wet, drop in dots of cobalt blue and a green mixed from cobalt blue and yellow.

Use a light cobalt blue wash for the jug, making sure to leave the highlights as white paper. The second tone is a darker cobalt blue, and the third is cobalt blue mixed with a touch of Vandyke brown. Use Vandyke brown for the dark areas on the handle, along the lip and down the sides. Add light grey inside the jug.

The first wash for the teapot is cobalt blue mixed with alizarin crimson (with the crimson showing through to add depth). Leave white areas for highlights. Use a bluer mixture of cobalt blue and alizarin crimson for the handle and spout.

▶ **12** Using the No.2 brush, paint the icing on the yellow cakes with cobalt blue mixed with Vandyke brown, and add more detail to the chocolate icing. (The No.2 brush allows you to paint fine details, but remember to hold the brush close to the ferrule for maximum control.)

13 With the No.5 brush, paint the inside of the flowerheads with cadmium yellow mixed with a touch of Vandyke brown – this produces a mustard-coloured base. While it is still wet, add a strongish brown wet-in-wet to the centre of the heads.

Change to the No.12 to dry-brush a rich, strong cadmium yellow on to the petals for some dark tones.

14 Use the side of the No.5 brush to create a textured effect on some of the leaves. Apply individual colours – cadmium yellow, raw sienna and Vandyke brown – with a dryish brush.

15 Step back to assess the work before adding the finishing touches. Here, the artist paints more blue dots on the vase with dilute cobalt blue and stronger grey shadows on the left and right sides. The handle of the vase – mainly cobalt blue with light grey for the shadow – needs work. Apply touches of raw sienna to the left of the highlight on the jug. The upper highlight, rim, spout and handle of the teapot also need touches of raw sienna to warm them slightly.

Use a light grey (cobalt blue, alizarin crimson and raw sienna) for the pattern on the top box and, with more blue, touch in the table-top pattern. Darken the shadows under the jug, teapot and lower box.

Our artist then turned her attention to the shadows on the white background. With the No.12 brush she added warm greenish folds (cadmium yellow and cobalt blue) to the curtain. Finally, she applied green and brownish veins to the sunflower leaves.

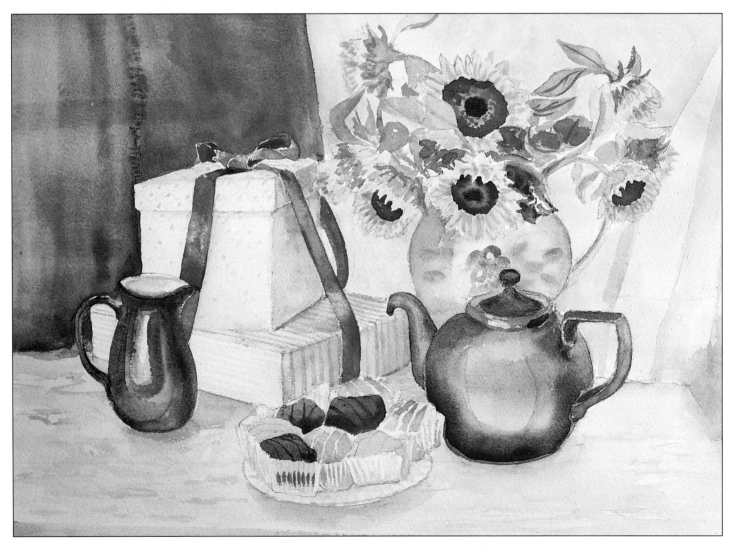

Painting with Chinese brushes

The distinct and beautiful style of Chinese and Japanese art owes much to a certain type of brush, but Chinese brushes are also excellent for use in Western-style painting.

The Chinese brushes you buy today from your local art shop are essentially the same as those used for many centuries in the Far East. They are excellent not only for skilled calligraphy, but also for the delicate paintings so admired in the West where the form of a subject – a leaf, fish or frog, for example – is often described accurately by a single brushstroke.

The qualities that make Chinese brushes perfect for this simple, delicate, yet highly skilled style of painting also make them good general brushes for Western-style watercolour techniques. Their long bristles and many fibres carry large quantities of dilute paint for laying expansive washes, and the tip comes to a very fine point for intricate dots, thin lines and small details.

These brushes are wonderfully responsive in your hand. The slightest change in pressure alters the mark. With practice, you'll find you can control the width of your line merely by changing the pressure you put on the brush. You'll discover

lively, undulating lines that go from thin to thick without impeding your brushstrokes.

Chinese brushes come in small, medium and large sizes. For your purposes, look for a medium size – roughly the same as a No.14 round. This can hold a reasonable amount of fluid paint, but the tip retains a very fine point. As with any unfamiliar equipment, if you've never tried painting with a Chinese brush, experiment on some scrap paper before you begin a painting. Try loading the brush with paint and laying a wash. See what kind of lines you can make by changing the pressure on the brush, and what marks you can get by using only the tip.

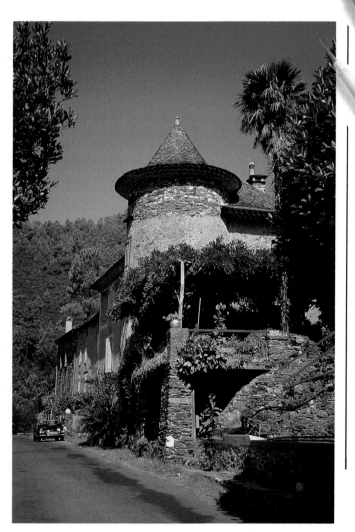

▶ **The set-up** Intense sunlight creates a striking contrast between the strong light tones and deep, dark shadows on this pretty French villa. With abundant greenery in the background, weathered old stonework, and just a spattering of bright, colourful flowers, this snapshot makes a charming inspiration for a watercolour painting.

For this demonstration our artist chose to use a tile palette, which allowed her washes to blend into each other. This made it impossible to chart the exact colours she used at any time, so take this opportunity to experiment with your own colour mixes. You might find it handy to have a piece of scrap paper to test your colours before you use them. (This is, in any case, standard practice for many artists.)

▲ Chinese brushes are readily available in art shops, and even Chinese supermarkets. You can usually select from goat, sheep and wolf hairs, and you may find some made from deer, rabbit or red panda hair! The bristles are bound together and glued into a hollow handle. The range of sizes is wide, from small and fine, to very large brushes for huge washes.

YOU WILL NEED

- [] *15 x 22in sheet of NOT/cold pressed watercolour paper*
- [] *Medium-sized Chinese brush; No.3 round soft fibre brush: one HB pencil*
- [] *Palette; 2 water jars*
- [] *Fifteen watercolours: Naples yellow, sap green, brilliant green, viridian, Prussian blue, indigo, raw sienna, Indian red, Indian yellow, light ochre, geranium lake, burnt umber, raw umber, Vandyke brown, permanent green*
- [] *Seven Ecoline liquid watercolours (or their traditional watercolour equivalents): orange, sepia, carmine, forest green, celestial blue, ultramarine violet, ultramarine deep (some colours in the Ecoline range are not lightfast; check with your local supplier or the manufacturers before using them if you want to frame your picture and display it)*

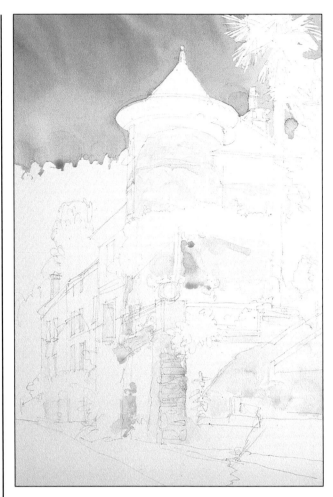

◀ **1** Loosely sketch the composition with the HB pencil to give yourself a rough guide. Load your Chinese brush with a wash of celestial blue mixed with ultramarine deep and lay a flat wash over the sky. Use the tip of your brush between the leaves of the palm tree and around the foliage and rooftops.

Use a dilute mix of orange and Naples yellow to put in areas of light tone where the sunlight hits the villa (on the turret, windows and the left side of the stone pillar). Add some of this wash to the sky mixture to make a cooler tone for the balcony recess and stone wall beneath. (Don't use up all your orange/yellow wash – you'll need it again in step 5.)

Keep the painting quite loose at this stage – you'll add detail later. Wait for the painting to dry completely before continuing.

▶ **2** Begin painting the foliage all round the picture with varying mixtures of sap green, brilliant green and viridian. Work wet-on-dry, allowing one wash to dry before you put a different green next to it, overlapping them a little. This suggests one mass of foliage behind another. Don't try to be precise, but instead use the brush to make loose, generalized shapes.

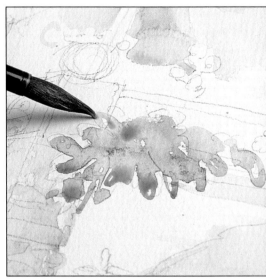

◀ **3** Work over the background trees, this time adding some of your blues and raw sienna to your green mixes to make a variety of cool and warm tones.

Work across the page on dry areas. Be careful not to create strong tones or details on the left side of the page – you don't want to draw attention away from the turret, which is the main focal point. Instead, allow the background to fade into the distance.

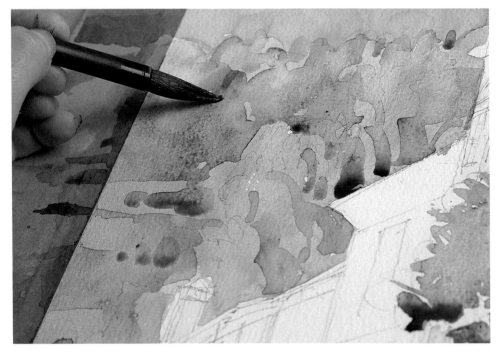

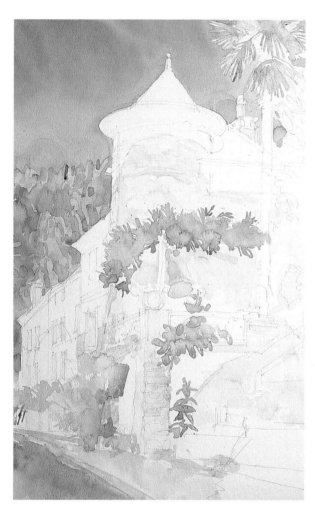

◄ **4** Paint in the road with a wash of Prussian blue, indigo, a little orange and some raw sienna. Ensure the paint is completely dry before you continue, and make the best possible use of this drying time to stand back and assess what you've done so far – this continual assessment is a vitally important element in any painting.

Tip

Liquid watercolours
Ecoline liquid watercolours are bright and clear, drying to an intensity more akin to coloured inks than the granular finish of traditional watercolours. Try them out if you like this effect, but for the purposes of this painting, traditional watercolours give an equally good result.

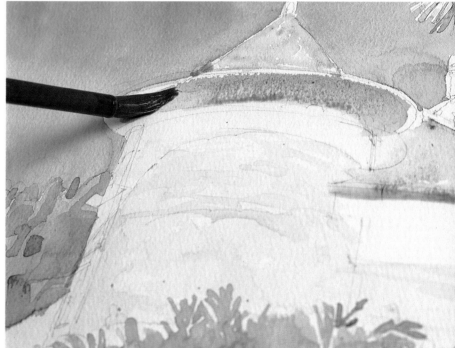

► **5** Make a warm wash of dilute Indian red and, with a bold single sweep of the brush, paint the overhanging eaves of the turret roof. Do the same with the eaves of the two roofs on either side of the turret. Mix a light blue wash for the rooftop on the right. Add a little of this to the orange/yellow wash you used in the first step for the turret roof.

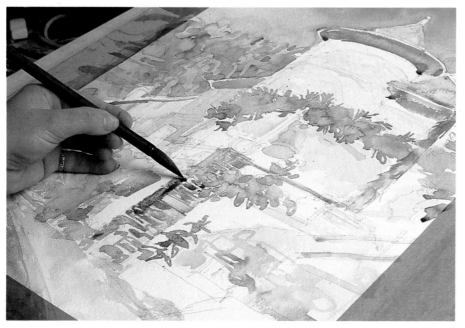

◄ **6** Dilute some sepia for the eaves of the turret roof. Paint them in below the band of Indian red while the paint is still a little damp so the colours blend. Do the same for the two eaves on either side of the turret. Use the sepia wash on its own for the longer eaves on the left. Let the Indian red and sepia washes mix on your palette and use the resulting colour on the balcony brickwork.

Mix some blues and greys, purples and ochres to create a variety of pale washes for the stone pillar. Paint some in outline and some as solid shapes with your washes. All you want is to create an impression of the stonework.

Paint the left side of the villa with pale bluish washes. For the bark of the palm tree, use raw sienna, adding Prussian blue on top. Use feathery strokes to suggest the bark's texture.

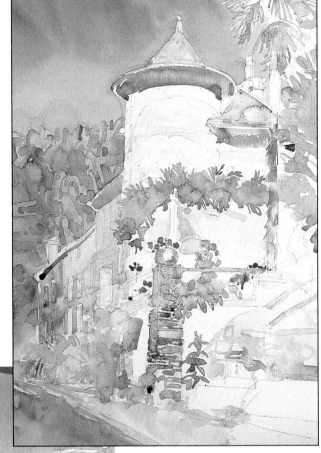

7 Mix some carmine with a little geranium lake for the flowers. Again, make quite general shapes to describe them. The very tip of the brush creates small dots; a little more pressure produces more of a blob.

8 Allow the paint to dry completely before you go on. Take advantage of these waiting periods to stand back to assess your progress and decide what to do next. The picture looks quite loose at this stage, but the darker shadows you'll add soon will pull the composition together with their crisp, dramatic shapes.

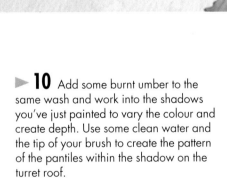

9 Mix a wash of ultramarine violet and ultramarine deep for the dark shadow of the turret roof. Use this for the shadow of the roof on the right, and the front of the villa on the left. Vary the strength of the wash by adding some more of one or the other colour to make the shadows more interesting. If you find it more comfortable, turn your hand around so you're working from the top of the painting. This can give you more control for finer details. Use the very tip of the brush for detailed work and for painting up to the edges.

10 Add some burnt umber to the same wash and work into the shadows you've just painted to vary the colour and create depth. Use some clean water and the tip of your brush to create the pattern of the pantiles within the shadow on the turret roof.
 Use a pale blue wash for the pantiles on the roof. Don't try to be precise about each tile – aim more for a general impression.

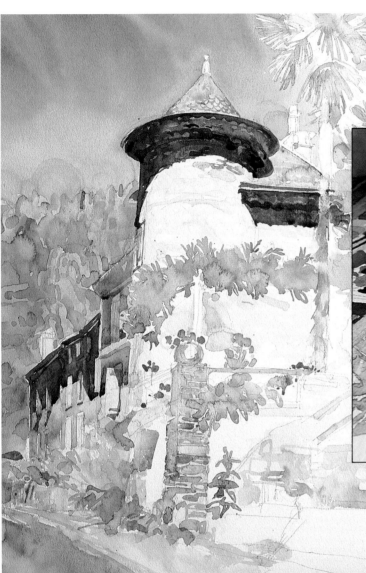

◀ **11** Now wait for the paint to dry. Notice how adding the shadow has pulled the picture into three dimensions and brought out the colours of the paler washes.

▲ **12** Gradually build up the dark tones around the whole painting. Start with the deep shadow in the balcony. Use variations of the ultramarine violet/ultramarine deep mix, adding burnt umber to deepen the colours or water to lighten them. Don't lay down one flat wash on each area – work into the shadows with your various washes to give them depth. For the balcony recess, don't forget to leave as white paper the areas touched by sunlight.

◀ **13** Our artist felt she'd made the shadow in the balcony too dark and flat, so she used a wash of forest green to pull out some of the shadow and add texture to the area. Use your No.3 round brush to lay quite wet areas of the wash into the dry paint. This has the effect of lifting the dry paint so it flows to the edges of the wet areas, creating some interesting tones.

When this has dried, add clean water to push the paint out again and create dark lines around the puddles of wet. (This is a good technique to remember for dark, flat areas that need more depth and texture.)

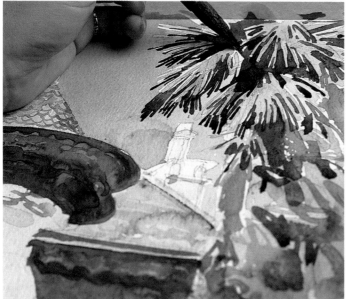

14 Make a strong, dark green wash with a mixture of permanent green, viridian and a touch of raw umber for the shadows on the palm tree. Use the tip of the Chinese brush to paint thin lines over the lighter green wash. In effect you are painting the negative shapes of the leaves, so bear in mind the general structure of the tree – spiky, and radiating from a central stem. Use dilute ultramarine violet with a touch of muddy colour from your palette for the bark of the palm tree.

Check for finishing touches. Our artist put details on the stone wall with mixtures she used on the pillar, and touched up the palm tree bark with the muddy ultramarine violet. She also used this wash to put shadows on the chimney next to the palm tree.

Tip

Pools and puddles
Dark tones needn't always be painted on. Here, the artist let

the paint run down the page from the tip of her brush to gather in a pool. This dries as a darker tone. Soak up any excess paint with a piece of kitchen towel, blotting paper or a dry paintbrush.

15 Strong perspective in this delightful painting complements the stark contrast between the bright light tones and the strong deep tones right next to them.

All the different textures are clearly brought out – on the stonework, the foliage and the roof tiles. The brushstrokes in the foliage, and the variety of colours give the painting a lively, energetic surface.

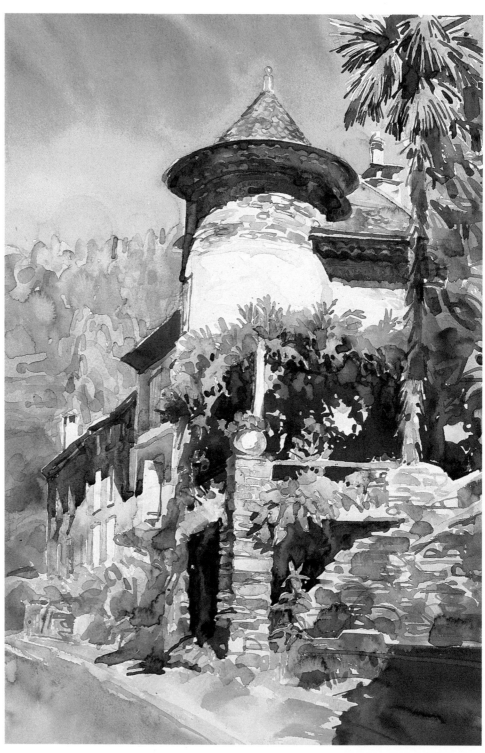

Watercolour field kits

Painting outdoors can be a very satisfying, inspiring way of working – as long as you haven't loaded yourself down with a whole heap of cumbersome, uncomfortable equipment.

If you're painting outdoors, taking vast bundles of gear with you can be an encumbrance – especially if you leave the well-trodden paths to explore the remote regions of the countryside. Not only that, if you take the time to set up a complete mini-studio on location, you'll waste precious time which can be better spent painting. With a portable watercolour field kit you can capture the beauty of nature in simple sketches or even complete paintings.

Ready-prepared paintbox kits

Some manufacturers produce highly useful ready-made watercolour boxes which are light, portable and compact – ideal for painting on the go. You can slip the smallest boxes (usually six or twelve half-pan colours) into a jacket pocket. Full or half pans have the edge over tubes because all the colours are instantly at your disposal – you don't have to fiddle around, taking the lid off the tubes and squeezing out blobs of paint, and you don't have to carry a separate palette for mixing.

Daler-Rowney produces Miniature Pocket and Compact Watercolour sets in black metal boxes with a range of artists' quality paints. Most have two palette flaps, offering plenty of space for mixing colours, and there are compartments for storing the brushes. The Combination Water Colour Boxes come with a built-in water bottle attached underneath the miniature half-pan paint blocks, and they include a water trough which clips on to the open lid. When not in use, the trough fits over the top of the bottle. A miniature sable brush with a detachable head is also provided. There are 12- and 18-colour versions.

Daler-Rowney also produce less expensive students' quality paints in a range of box styles and colours. For more information, consult your local art shop for their relevant catalogues.

Winsor & Newton has many portable watercolour boxes available. The Bijou Boxes are a 12- and 18-colour range of artists' quality paints. They come in handy wallets for easy storage and have a small sable pocket brush – but they don't include a water bottle. There's also a selection of Sketchers' Boxes in 12, 16 and 22 half-pan colours with internal mixing wells in the lids.

Winsor & Newton also produces students' quality paint kits. The Cotman Field Box is available with a water bottle. You can buy the plastic box on its own or as a fitted version with

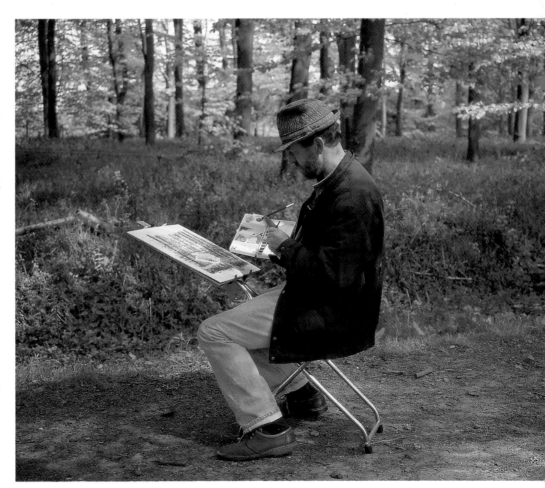

▼ Comfortable, and equipped with all he needs for outdoor painting, this watercolour artist has got it right! All his equipment is lightweight and fully portable. The golden rule is: don't overload yourself.

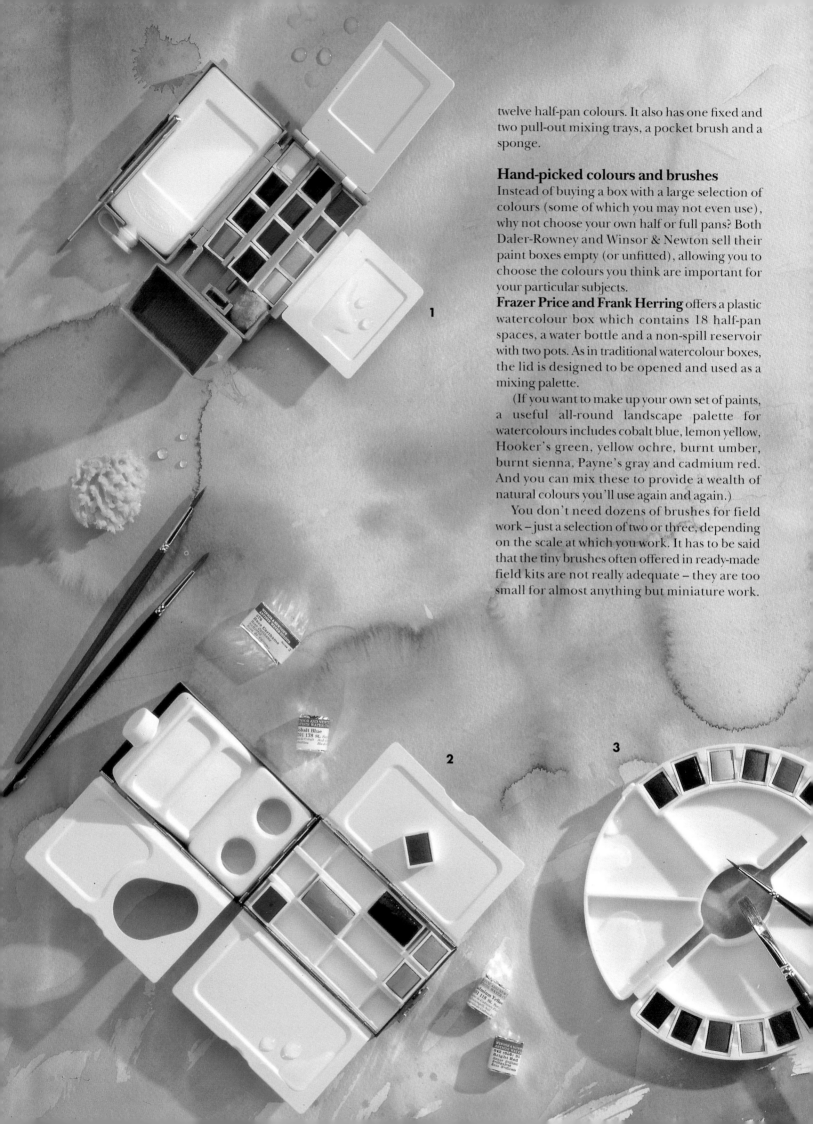

twelve half-pan colours. It also has one fixed and two pull-out mixing trays, a pocket brush and a sponge.

Hand-picked colours and brushes

Instead of buying a box with a large selection of colours (some of which you may not even use), why not choose your own half or full pans? Both Daler-Rowney and Winsor & Newton sell their paint boxes empty (or unfitted), allowing you to choose the colours you think are important for your particular subjects.

Frazer Price and Frank Herring offers a plastic watercolour box which contains 18 half-pan spaces, a water bottle and a non-spill reservoir with two pots. As in traditional watercolour boxes, the lid is designed to be opened and used as a mixing palette.

(If you want to make up your own set of paints, a useful all-round landscape palette for watercolours includes cobalt blue, lemon yellow, Hooker's green, yellow ochre, burnt umber, burnt sienna, Payne's gray and cadmium red. And you can mix these to provide a wealth of natural colours you'll use again and again.)

You don't need dozens of brushes for field work – just a selection of two or three, depending on the scale at which you work. It has to be said that the tiny brushes often offered in ready-made field kits are not really adequate – they are too small for almost anything but miniature work.

Brushes don't take up much space in a pocket or small bag, and it's worth travelling with the size of brushes you're used to.

A No.12 sable/synthetic round is very versatile – you can use it for washes as well as fine details. Combine this with a No.5 or 6 round and a No.2 round for very fine details, and that should do. Use a small natural sponge for making large washes quickly.

Protect your brushes by carrying them in plastic tubes which you can buy from Daler-Rowney. Alternatively, a modified piece of cardboard tubing works equally well. What about a short piece of plastic pipe (available at DIY stores)? Don't spend loads of money – improvise by finding out what works best for your needs.

Easels and watercolour blocks

If you plan to work outside regularly, a portable easel may prove useful to you. Daler-Rowney and Winsor & Newton produce many varieties which vary in price according to their material, weight and specification. They have telescopic legs and an adjustable working height.

Though handy, easels are by no means essential. A thin piece of plywood makes an excellent working surface – it's both light and rigid, allowing you to paint in a variety of different positions. Fix your paper on it with drawing pins or bulldog clips.

▼ ▶ **There are a wide range of watercolour field kits available with both artists' and students' quality paints – 1. Winsor & Newton's Cotman Field Box; 2. Frazer Price's Watercolour Field Kit; 3. Frank Herring's Dorchester Watercolour Palette; 4. Daler-Rowney's Watercolour Sketchers' Box; 5. Winsor & Newton's Cotman Pocket Box.**

5

4

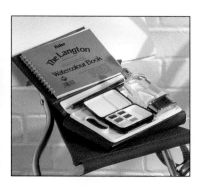

All-in-one set
Daler-Rowney, in cooperation with Alwyn Crawshaw, produces a field kit containing everything you need to begin watercolour painting outdoors. It comes in a folder which is easy to carry around.

There are many brands of watercolour blocks and ring-bound pads which are firm enough to use upright, reducing your load even more. You can buy them in a variety of surfaces (hot-pressed, NOT/cold pressed and rough).

Miscellaneous materials

Don't hike miles to a remote location expecting to find a bubbling brook along the way – there won't be one! Always carry water with you. You can invest in a specialist water bottle, or you can simply use small plastic juice or mineral water bottles with screw-on caps. And small yogurt cartons are perfect for washing your brushes in.

If you don't buy a watercolour box with mixing palettes, then you'll need a palette or two. Inexpensive plastic palettes are lightweight and readily available at art shops. But, again, you can improvise by making do with water-resistant (wax coated) paper plates.

If you prefer to sit while you're painting, a lightweight folding chair is the order of the day.

Shop around for the best prices, trying out a variety of art shops – and even fishing shops – for a selection of items. If you don't want to buy a chair, you could opt for a make-shift alternative, such as a plastic bag, newspaper, rug or towel – especially if the ground is likely to be damp.

Other essentials to complete your field kit include a pencil and fountain pen for sketching, a rag to wipe your brushes, a plastic bag or polythene sheet to protect your work in case it rains and waterproof clothing.

Cardboard tubes for posting fragile pictures are lightweight and excellent for carrying dry, finished paintings. Now you're ready to begin!

▼ **Many art equipment manufacturers produce lightweight, sturdy easels and seats. Though by no means essential, they're useful if you're working on a full-scale painting in great detail. It's important to try them out in your local art shop to see which is suitable for you before you commit yourself to buy.**

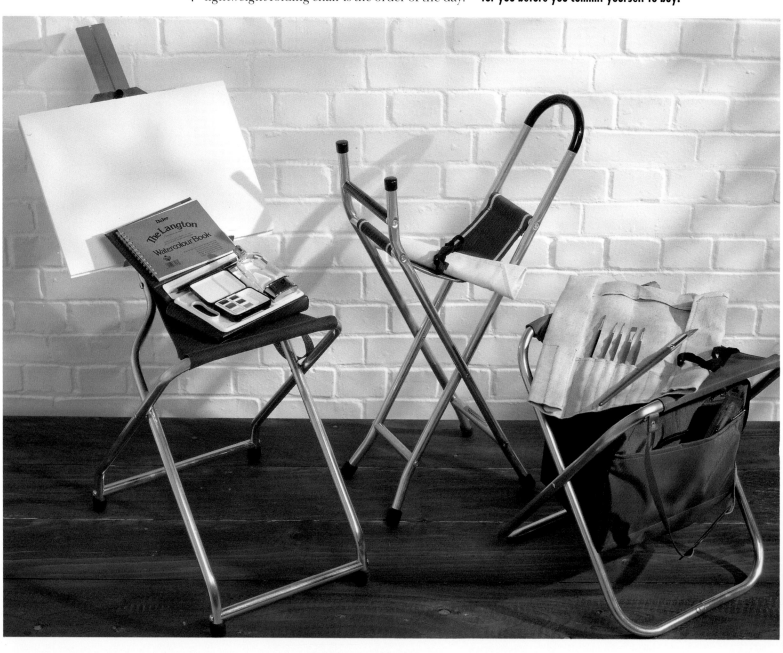

PART 2

Creative Techniques

Watercolour washes

Washes are fundamental to the technique of watercolour painting, bringing mood and atmosphere to your pictures.

Washes of various sorts are the basis of all watercolour painting. They can be laid over a broad area – to establish a basic tone for a landscape or seascape, for example – or applied in small patches of colour.

Always paint the background wash before starting the main features. This is infinitely quicker and easier than painting around the subject – especially if it is full of highly intricate detail. Imagine painting a vase of flowers, then trying to paint the background around every single petal, leaf and stalk!

Types of wash

Flat washes are the simplest and most versatile of all the washes – areas of uniform colour laid over part or all of the paper. They often play an important part in setting the mood or tone of a painting.

Graded washes are still of one hue, but vary in intensity. So, for example, you might start with a strong colour at the top of the paper, then dilute it with more and more water as you continue down. Graded washes are often used for still life, with the subject painted against the lighter part of the background.

Variegated washes are painted in two or more colours, enabling you to lay different backgrounds for particular areas of the same painting. For example, a landscape might include fields and sky – a variegated wash from blue to green could provide background colour for both of these.

Using flat washes

It's not often necessary to lay a completely flat wash – and some watercolourists never do. But practising laying a flat wash will improve your ability to control the wet paint. It will also help you understand how paint takes to the paper, the way particular pigments react and how the paint dries.

▼ **Soft washes for sky and foreground complement the graceful architecture in this 19th century watercolour of Worcester Cathedral.**
'Worcester, the Cathedral seen from the river' by William Callow, 1848, approximately 25 x 35cm

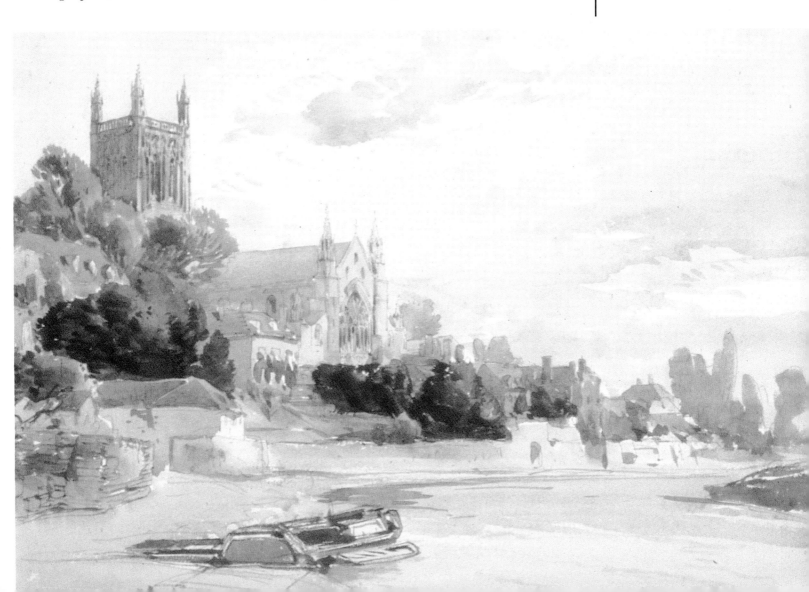

YOU WILL NEED

- [] *A No.20 round sable/synthetic fibre mix brush*
- [] *Sheet of paper (pad or stretched)*
- [] *Natural sponge*
- [] *A tube of Winsor blue*
- [] *Clean water*
- [] *Saucer*

Laying a flat wash

The secret of laying an even wash is to work confidently and without pausing. It is cheaper to use 90lb NOT/cold pressed paper and stretch it than to use heavier paper which doesn't need stretching. But, if you prefer, work straight on to a pad of 140lb NOT/cold pressed which is thick enough not to pucker when damp. Remove any dirt from the paper with a putty rubber.

Work flat or angle the board slightly to help the paint flow down the paper. Don't angle it too much, though, or your wash will end up darker at the bottom. Choose a large brush which holds plenty of paint and covers the paper in a minimum number of wide strokes. You can't get an even wash over a large area with a small brush.

Keep your water, mixing palette and saucers together, so that you can move from one to another without carrying your brush over the paper. Water or paint spilt on to the paper can be removed but still affects the result.

▲ **1** Squeeze a dab of paint on to the palette and transfer a little to a saucer with your No.20 brush. Dip the brush into clean water and add some to the paint. Keep adding water until the puddle covers the bottom of the saucer. The more dilute your paint, the lighter your wash. If you want a darker wash simply add a little more paint from the palette. Mix plenty so that you don't run out half way through.

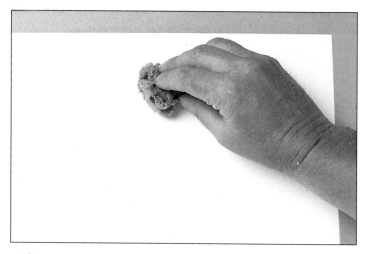

▲ **2** Soak the natural sponge in clean water and squeeze out the excess. Starting at the top edge, draw the sponge back and forth, working down the paper. Don't press too hard or water will run from the sponge, flooding the paper. Use just enough pressure to wet the paper evenly. Don't worry about going right up to the edge. If the paper is very absorbent you may need to go over it again.

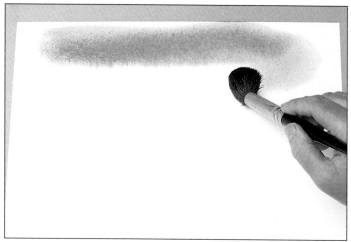

▲ **3** Apply the colour wash before the paper dries. Using the No.20 brush, stir the paint and mix it well. Load the brush with paint and, starting at the top left hand corner, draw it across the top of the paper. When you reach the end, draw the brush back below the previous band. Overlap only slightly so you catch the paint above just enough to coax it down the paper. Don't stop until you reach the end.

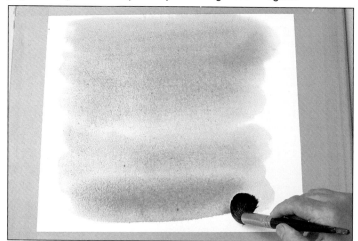

▲ **4** When the wash is finished, put the board on to a level surface and leave the paper to dry. This might take about an hour – it depends on how thick the paper is. Don't worry about small gaps between the bands of colour; the dampness of the paper helps to close them. Any attempt to rework the surface while it's still damp results in flaring. As the paper dries the wash gets lighter and more even in tone.

Beached boats in the estuary

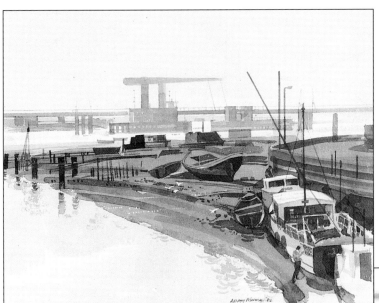

◁ **The set-up** The starting point for this exercise was this print of a watercolour specially commissioned from the artist. It celebrates the opening of Breydon Bridge across the River Yare in 1986.

In the demonstration, the image is not copied but is used instead as the starting point for a much simpler image where the flat wash covers the whole of the paper – rather than only part of it as on the print.

YOU WILL NEED

☐ *Sheet of stretched paper or pad (14 x 10in)*

☐ *Three round brushes: Nos. 20,10, 7*

☐ *One B pencil*

☐ *Two jars of water; sponge; saucer*

☐ *Mixing palette*

☐ *Four colours: yellow ochre, Van Dyke brown, Winsor blue, burnt umber*

☐ *Scalpel; ruler*

▷ **1** Work on stretched lightweight paper or a pad of heavy paper. Lightly draw in the outlines with a B pencil. Just sketch in the main areas of interest – the hills on the horizon and the bridge, the mudflats and harbour wall in the middleground, boats in the middle and foreground and the water line in the foreground. Don't worry about excessive detail.

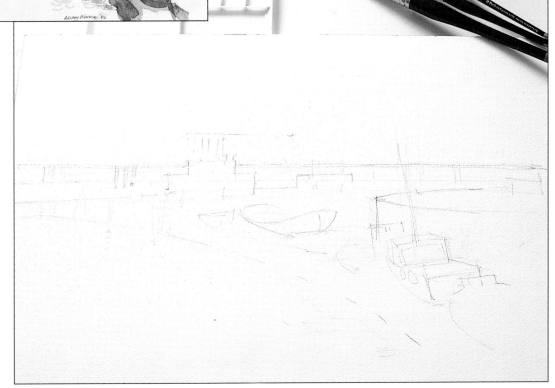

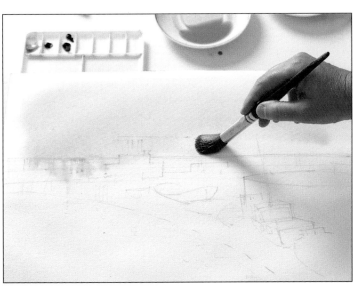

◁ **2** Mix a dilute wash of yellow ochre and Van Dyke brown in a clean saucer – exactly as you did in the exercise previously. Test it to see that it isn't too dark. Dampen the whole surface of the paper with a sponge and apply a flat wash using the No.20 brush. Put the paper on a level surface and leave to dry.

Tip

The true colour
It's hard to tell from the paint in the saucer what it will look like on paper. So try some on a scrap of paper first. Bear in mind watercolour becomes lighter as it dries. Don't be put off by these qualities. The only way to become familiar with the paint is to use it.

3 Change your water, and mix a grey for the mudflats and bridge in a clean saucer. Mix roughly equal amounts of yellow ochre, Winsor blue and Van Dyke brown. Using the same brush, paint in the bridge on the horizon and then start on the middleground between the beached boats.

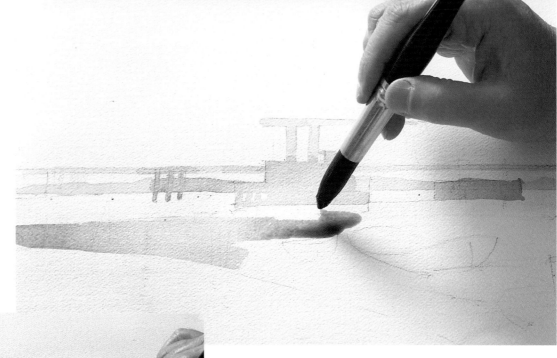

4 Paint around the boats, leaving areas of light paper to work into later on. A few flecks of grey in the foreground break up the monotony of the mudflat and help to suggest the waterline. Put in the windows on the boat in the foreground. Leave to dry.

5 Make a fractionally darker grey by adding a dab of each of the previous three colours to your existing grey. (The artist here felt his grey was a little too dark. If you aren't sure, then do a test.)

Using the same brush, strengthen parts of the bridge and buildings but leave the hills so that they recede into the distance. Don't overpaint the whole bridge – tonal variation adds interest.

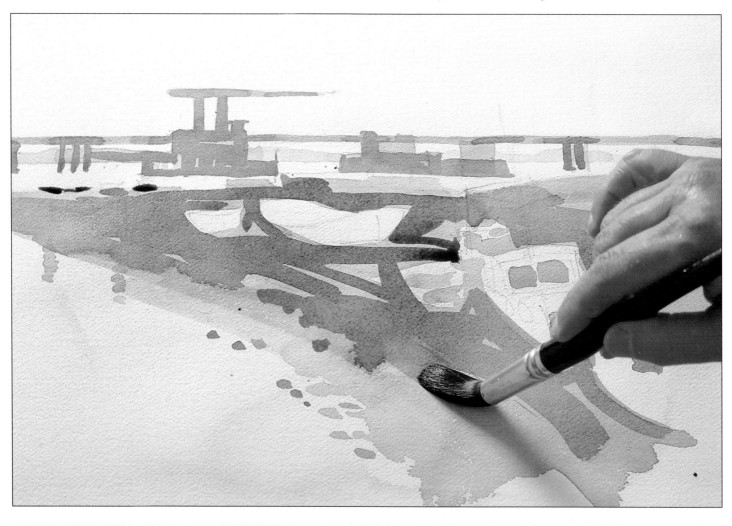

SOLVE IT

Making adjustments

The artist decided he had painted the bridge too dark in relation to the mudflats. Instead of trying to remove the paint and risking damage to the paper, he adjusted the tonal contrasts by making the mudflats darker.

▶ **6** Change your water and, with a clean No.10 brush, mix all four colours to make a dark olive green. Use more yellow ochre and Winsor blue than burnt umber and Van Dyke brown. Put some warm blocks of colour into the harbour wall behind the boats and lay some long, bold strokes along the front and back of the mudflats to establish the foreground area.

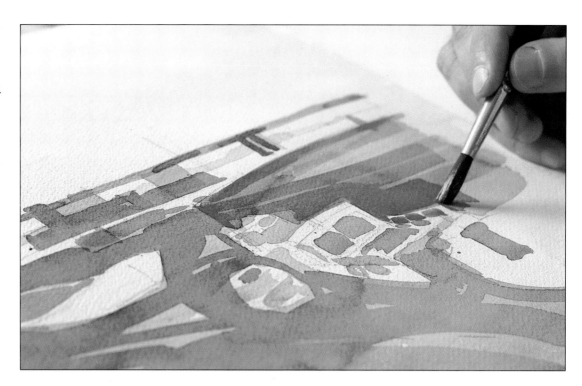

▼ **7** Now mix a dark brown-grey from Van Dyke brown, burnt umber and plenty of Winsor blue. Try to make the colour swing more to the umber – so it has a warm feel. Put in some general detail with the No.7 brush – wooden moorings, the silhouettes of boats and buildings at the back of the flats. But remember you are just trying to convey an impression of detail.

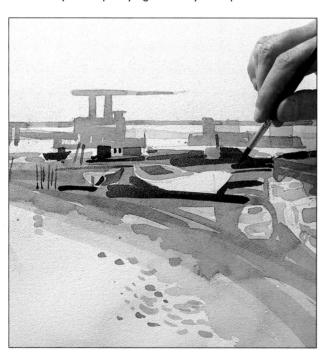

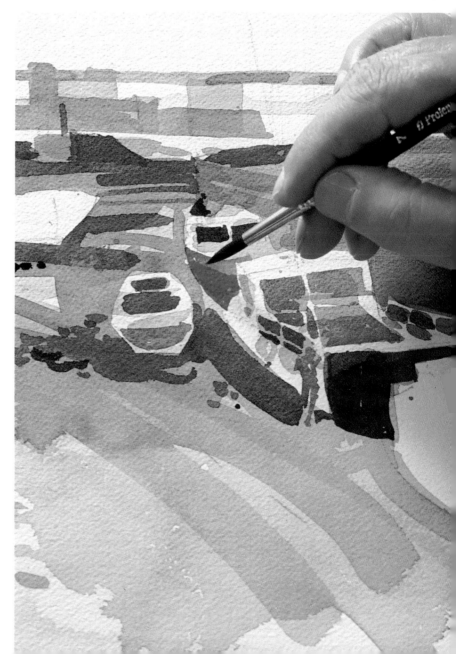

▶ **8** Now bring some vibrancy to your picture. Wash the No.7 brush and dilute some Winsor blue on a clean saucer. Paint in the boat hulls and the figure in the foreground. Notice how the blue shows up among the subdued greys, greens and browns but is still in sympathy with the colour scheme.

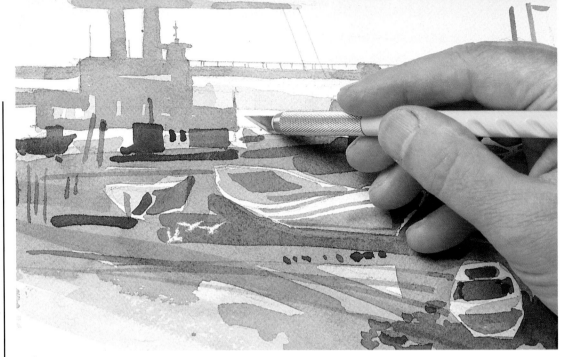

Tip

Breaking a rule
Here the artist used a No.7 brush and a ruler for the masts, and a 'rigger' brush for the ropes and rigging. Don't buy a rigger just for this; use the very tip of the finest brush you have.

▲**9** Often when laying a flat wash, an artist leaves a few areas of white paper unpainted – these could stand for clouds or water, for example. You can take a short cut back to the white of the paper by very gently scraping away the paint. Hold the edge of a scalpel flat on the paper and scrape away the wash under the bridge to give the impression of reflected light on the water.

▼**10** The painting is finished by adding a few ruled lines for masts, rigging and ropes on the bridge. The flat wash does a fine job, setting the mood of early evening or morning on the estuary. All the colours are derived from the limited palette of just four colours.

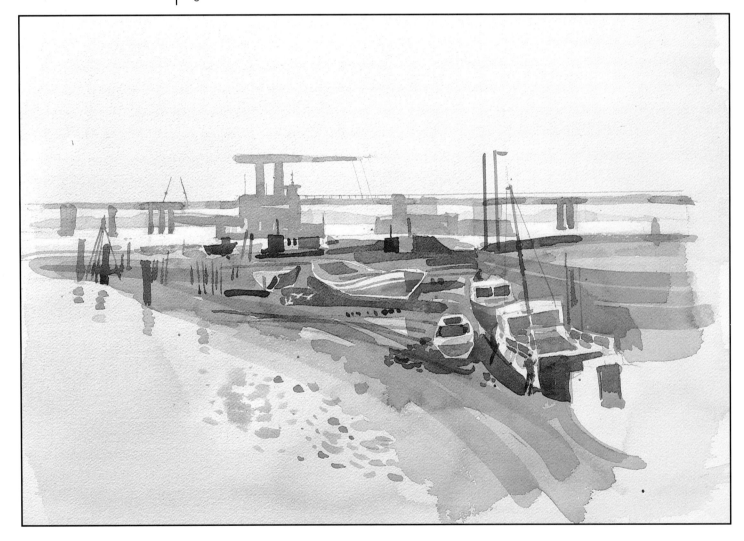

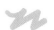

Graded & variegated washes

Expansive areas in a picture – such as sky – often call for a wash with some variation. This is where graded and variegated washes can help.

Although flat washes are the simplest type of wash, they are perhaps not used as frequently as the graded or variegated type.

Graded washes are of one colour but vary in intensity, in a controlled way, from light to dark (or vice versa).

There are several ways of producing this effect. One is to work as you would for a flat wash, dragging the brush back and forth, pulling the paint down the paper as you go but adding water to the paint – diluting it – as you work. Another is to take paint from your pans or tubes and add it to the dilute paint in your palette as you go so that you intensify the colour. Tilting the board you're

working on helps to blend the individual stripes of colour together. Sky and water can often be treated convincingly by laying a graded wash and then working over it.

Variegated washes are simply large areas of wet-in-wet – washes into which other colours have been dropped.

They are useful as backgrounds for complex subjects – woodland with clusters of leaves, for example. So for an autumnal scene you might imagine an ochre background into which patches of a richer colour – such as raw sienna – have been dropped. You might then paint individual leaves on top of the dry wash.

▲ The artist has used a graded wash as the basis for the paved area in the foreground of this harbour scene. The wash is lightest in the central area and grows richer towards the front of the picture. The paving slabs and reflections have then been painted over the top.

'Harbour activity, Hydra' by David Curtis, ROI, RSMA, watercolour on paper, 14 x 21cm (5 x 8in)

Laying a wash for a sky

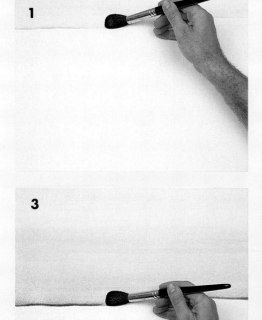

Work on stretched 200lb NOT/cold pressed watercolour paper. Make two mixes of alizarin crimson and cadmium red – one watery and one stronger – and a fairly weak wash of ultramarine. Load your No.20 brush with the watery mix and work down the paper, dragging the brush back and forth in bold strokes (**1**). Overlap each stroke a little to encourage the paint down the paper.

Don't stop – keep the wash going! About every third stroke, re-charge your brush from the watery wash. Introduce the darker red one-third of the way down (**2**). Continue this wash in just the same way.

When you've gone about two-thirds of the way down, introduce the ultramarine wash (**3**). Don't bother to clean your brush before dipping it into the blue. You want a soft transition between the two colours – so a red and blue mix actually helps.

Keep going, dipping your brush into the ultramarine blue every three strokes, until your wash is finished (**4**). Leave to dry. You should have a wash that might serve as an evening sky.

YOU WILL NEED

- ☐ A 56 x 38cm (22 x 15in) sheet of stretched 200lb NOT/cold pressed watercolour paper
- ☐ Two round brushes: a No.20 and a No.4
- ☐ HB pencil, masking fluid
- ☐ Seven colours: dark cadmium yellow, cadmium red, yellow ochre, cobalt blue, light cadmium yellow, brown madder alizarin, Payne's gray, cadmium orange

Sunset over the lagoon

▶ **The set-up** The artist used a holiday snap of this scene of an island and lagoon approaching Venice. Although you might interpret it entirely in monochrome – using shades and tints – the idea is to use more than one colour.

Low in the sky, the sun provides a strong source of backlight. The buildings are seen in silhouette – as warm dark shapes against a lighter background. This means you will be concerned largely with shapes rather than forms.

1 Draw the outline of the buildings with an HB pencil. Then mask out the sun with masking fluid and leave the fluid to dry.

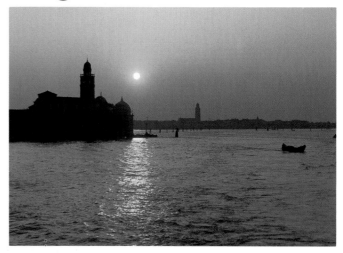

◀ **2** Make three mixes: a dusky orange from dark cadmium yellow and a touch of cadmium red; a deeper orange from cadmium red and yellow ochre; and a cool mix of cobalt blue with a hint of cadmium red.

Load your No.20 brush with the dusky orange and start your graduated wash, proceeding just as you did in the exercise.

3 About half way down the sky, introduce the darker orange, keeping the paint on the move all the time. As you approach the buildings, transfer just a little of the cobalt blue/red mix to the darker orange mix in your palette – so that the sky becomes cooler. Paint right over the buildings (up to the water). Leave to dry.

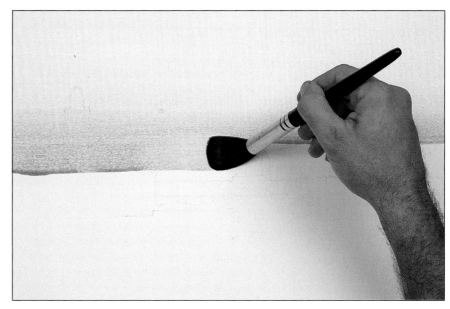

4 When the paint is thoroughly dry, remove the masking fluid. Rub it away with the tip of your finger – but make sure that your finger is clean and dry! Notice how the wash has dried to give quite a subtle graduation in colour.

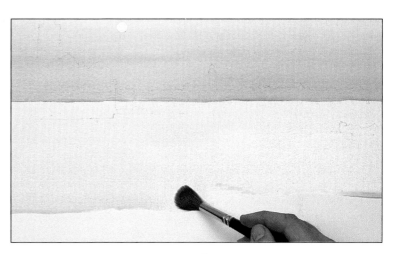

5 Now wash in the sea area with a mix of light and dark cadmium yellow. Tilt the board slightly towards you to make the wash a little richer in the foreground. Then let the wash dry.

This is a good stage at which to reassess the sky. You might feel – as the artist did – that it needs darkening a little towards the horizon.

6 Now paint in the distant buildings with a mix of brown madder alizarin and Payne's gray, using your No.4 brush. Look at the set-up and you'll notice that the buildings get darker as you move away from the sun. Try to capture this tonal change in your picture. Start with mostly brown madder alizarin with only a hint of Payne's gray.

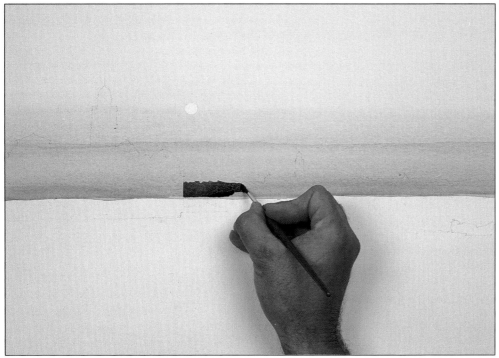

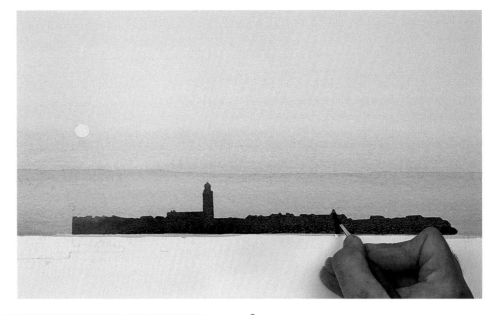

▶ **7** As you move across the buildings, introduce more Payne's gray. This makes them look cooler – pushing them into the distance.

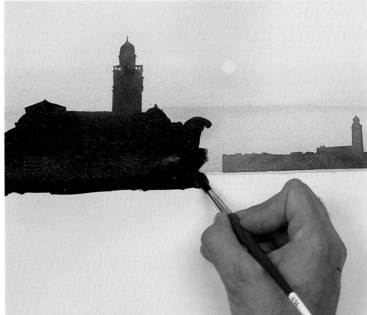

◀ **8** Make a slightly stronger version of the same mix by simply adding more paint to the palette. Then, using the same brush, put in the nearest buildings. Notice how just a slight variation of tone (within the tower) makes the buildings look solid rather than merely flat.

▼ **9** Put a little of the darker orange into the water just below the buildings and then make a mix for the rest of the water.

The water's surface is of one of those colours it's hard to put a name to. When this is the case there's nothing for it but to mix up colours and try them. Try a greenish grey mix of cobalt blue and light cadmium yellow. When you feel you've got it right, use your No.4 brush to skim the paint over the surface of the water. Leave gaps to stand for waves.

Tip

Let them dry
The strength of this painting lies in its crisp, clean shapes. The only way to get these is by letting underlying washes dry before painting over them. If you are impatient and attempt to put paint on to damp paper you'll make soft-edged shapes and the effect will be different.

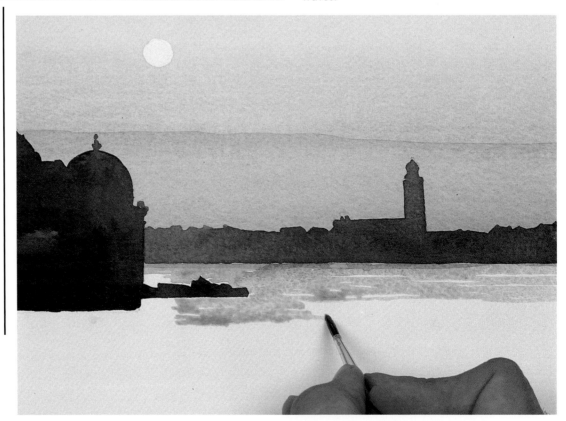

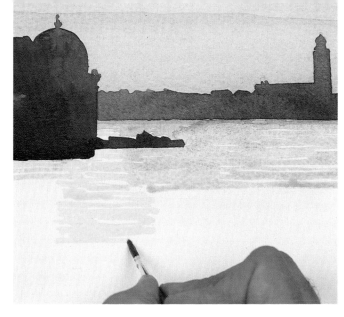

10 Keep the band of reflected sunlight on the go at the same time as painting the darker surface of the water. Use the same brush and some light cadmium yellow. Don't mess the paint about, just let the brush do the work. Again, leave gaps to let the lighter yellow show through, and make the gaps larger as the waves come closer to you.

11 If you paint the whole of the water using the same small brush, it will look laboured. Change to your No.20, darken the greyish green mix by adding a little more cobalt blue and then skim the brush boldly over the middle and foreground areas of your picture. Leave a few gaps to break up the grey. Let the paint dry.

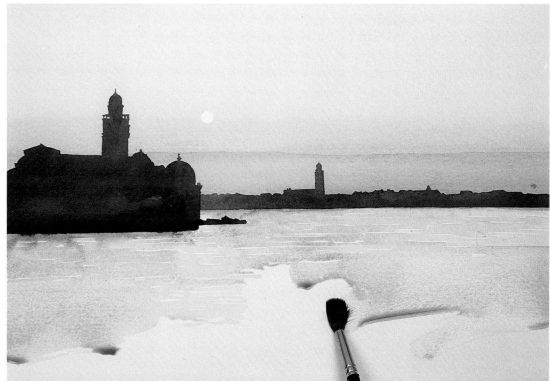

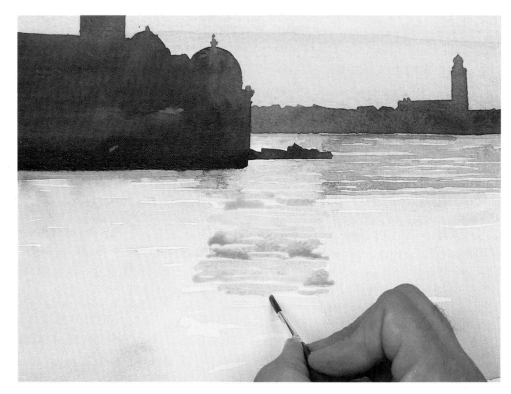

12 Now mix a little cadmium orange and yellow and, with your No.4 brush, strengthen the sun's reflections.

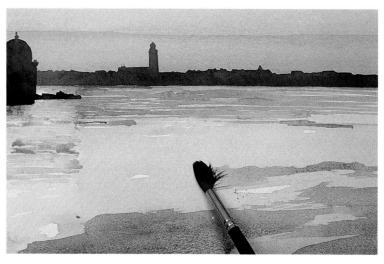

► **13** Make the foreground darker and stronger by skimming on some more of the cobalt blue/cadmium yellow mix. Use your No.20 brush – so that you make large marks – but keep the brush fairly dry so the colour breaks as you skim it over the surface.

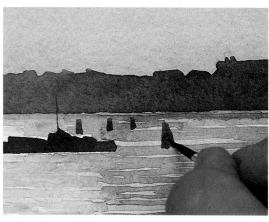

► **14** A little detail helps to lead your eye into the picture. With your No.4 brush and some brown madder alizarin and Payne's gray, just indicate the moorings.

▼ **15** The result is simple but striking and it's interesting to note that a similar effect might have been achieved by cutting out coloured paper and sticking it down as a collage. The graduated wash does a fine job of pulling the painting together.

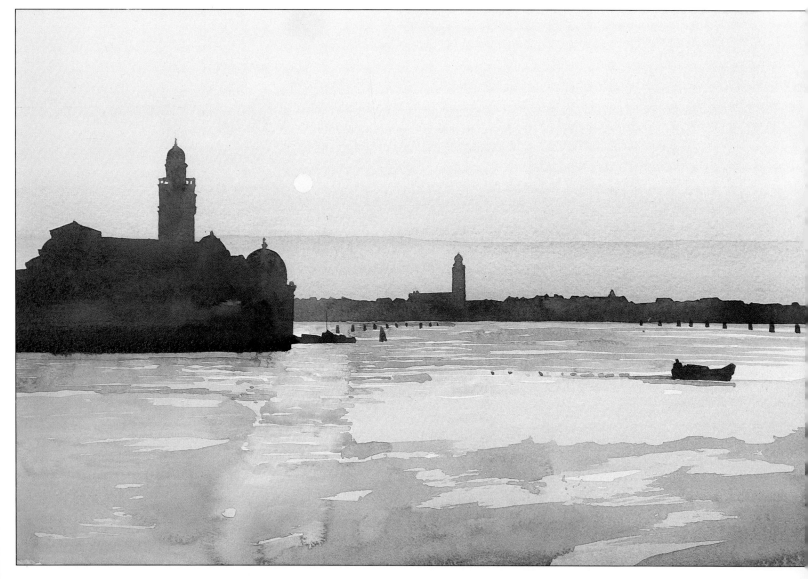

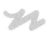

Making washes work

The joy of painting in watercolour is that you can start very loosely, gradually building up colours and tones in a series of washes.

Starting with large, pale washes, then overlaying them with a range of other colours, enables you to build up a rich, translucent quality you just don't get with other paints.

Building up washes isn't quite as simple as it looks, however. It's important not to overwork things – if you keep fiddling with them, the colours become muddy and lifeless. Once you have laid a wash, leave it. It will settle where it wants to, and you'll be surprised how different it will look when dry. (Remember: watercolour usually dries paler than when it is wet.)

You also need a bit of patience with your washes. One wash must be allowed to dry before you lay another over it. And the relative wetness, dampness or dryness of the paper is very important, too. If the paper – or the wash – is very wet, the next colour floods into it (wet-into-wet). If the paper or wash is damp, you get a soft, blurry edge; and if the paper or wash is dry, the edge is crisp and sharp.

It's perfectly possible to exploit all these factors to your advantage – but it can spell disaster if you haven't the patience to wait for a crisp edge on an overlaid wash.

It's important to keep your water clean. Have at least two jars: one for cleaning your brush and one for mixing colour. The alternative is to change your water frequently.

Finally, the texture of your paper – whether rough, medium or smooth – always influences the final picture since it affects the way the paint settles on the paper. In the demonstration overleaf, medium textured paper was ideal for a picture where broad washes – large areas of flat colour – are combined with closely observed detail.

▶ In this fresh, bright watercolour, pale washes for sky, sea, grass and foreground forest floor are overlaid with a series of darker washes applied wet-over-dry to give depth, tonal contrast and liveliness to the picture. Sparing use of white (the white of the paper left unpainted) adds light to the scene.
'Brixham Race' by Polly Raynes, 14 x 10in

Lake in Provence

In this view of a precipitous hillside running down to a clear blue lake in Cassis, Southern France, our artist started in the traditional watercolour way with pale washes, then gradually built up paint with more intense colours, laying one wash over another. As in all pure watercolour paintings, his final picture shows the importance of letting the white of the paper add a touch of extra sparkle.

Our artist used some very subtle colours. One was a basic permanent green and black mix for the dark greens, but he kept on changing the mix, either by using a stronger or weaker wash or by adding little touches here and there of gamboge, sepia and so on.

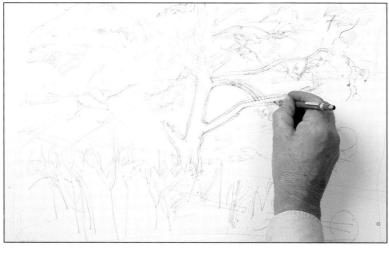

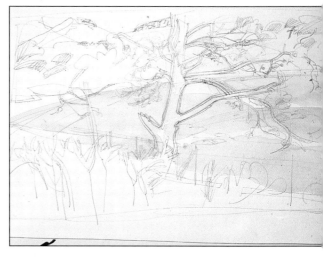

YOU WILL NEED

- [] One 400 x 570mm (16 x 22in) sheet of 140lb NOT/cold pressed watercolour paper

- [] One No.3 round sable brush, one ⅝in wash brush and a Chinese brush

- [] One 2B clutch pencil

- [] Nine half pans of Ferrario watercolours, or their equivalents (in brackets): turquoise/Turkish blue (or cobalt), lemon yellow, gamboge, permanent green (or Winsor emerald), phthalocyanine green (or viridian), lamp black, ultramarine, sepia, raw sienna

- [] Two Luma colour liquid watercolours: aquamarine and turquoise

▲ **1** Even though our artist was using watercolour in a traditional way, he decided to break one of the basic rules in composition by splitting the picture in half with the strong, dark silhouette of a tree trunk. This worked here, partly because the tree trunk didn't run entirely from the top to the bottom of the page, and also because the view makes us peer past the tree into the deep blue waters of the lake.

Draw in the basic shapes of the landscape with your 2B clutch pencil. The whole composition is strongly underpinned by the drawing at this early stage, but don't be too concerned with getting the exact line. The proportions and general shapes are more important. Look at the negative spaces to help you draw more accurately.

▲ **2** Using either the Chinese or the wash brush, mix a pale wash of turquoise/Turkish blue and lemon yellow in the palette and flood it on to make the basic shape of the lake. Allow the paint to dry completely before continuing.

▼ **3** Paint in the hills in the background with a pale wash mix of gamboge and permanent green. Then put in the general shapes of the foliage, using a slightly stronger wash of the same colours.

Don't worry if the paper isn't entirely dry since it's a good idea to have a few soft edges – but don't let them dissolve entirely.

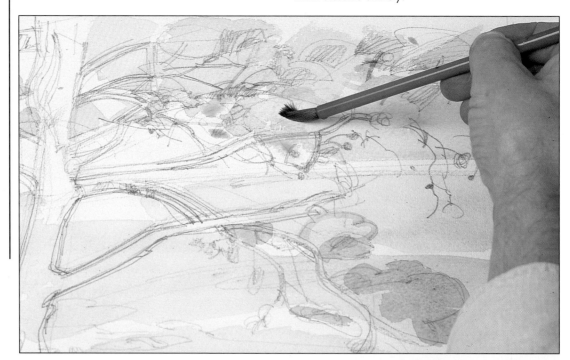

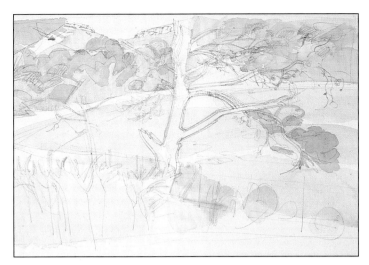

4 Use some gamboge for a pale yellow-green wash in the foreground, then mix some more with the original blue wash for the bank of bushes. These washes are pale and delicate and are there to give you some broad shapes on which to build more detail and colour.

5 Mix a strong wash of phthalocyanine green and ultramarine and paint in the deeper areas of the water. Don't make this wash too flat – if you do it will look boring. Add a touch more of either colour to your wash to vary it slightly and let the colours float together, wet-into-wet. Add a few dots and spots for the ripples on the water.

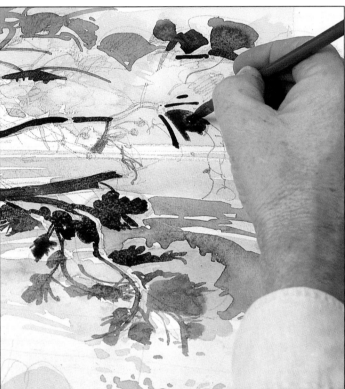

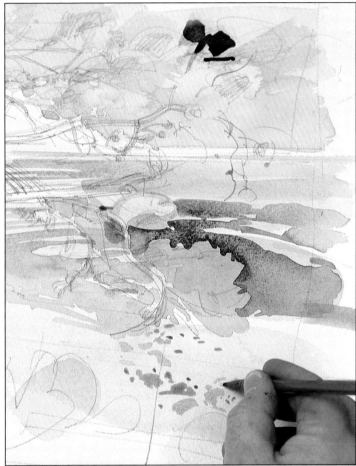

6 Mix a wash of lamp black for the trunk and branches of the tree. Don't make it too black since you will be painting over the tree trunk later to make a richer, deeper colour.

Add some of this black to a wash of permanent green for the foliage. Don't just paint in the leaves as random splodges. Bear in mind that they grow outwards from the branches.

7 Keep your initial painting of the foliage simple. Like the tree trunk, the leaves will be enriched by adding a further wash on top at a later stage. Make sure the first wash on the leaves is dry before you continue.

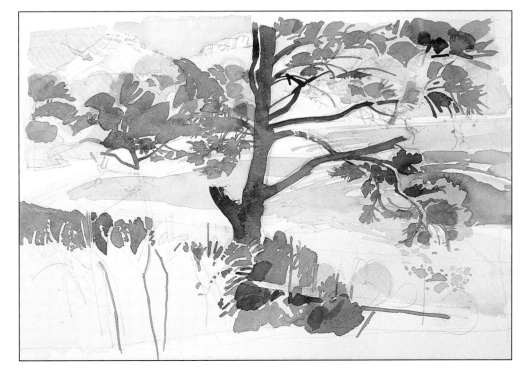

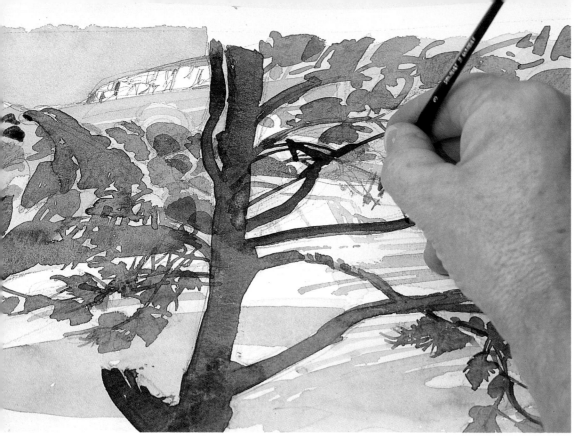

8 Use the small round No.3 brush to add the finer details in the distance. Hold the brush close to the ferrule to give extra control. (If you don't have a small brush, use the very tip of the Chinese brush as a substitute – you'll find it will come to a very fine point.)

Continue with the detailed work, using the same brush to paint the fine branches with a mix of lamp black, sepia and permanent green. Vary the colour mixture to keep it lively and interesting, but make the wash paler than the trunk, since the small branches shouldn't dominate the picture.

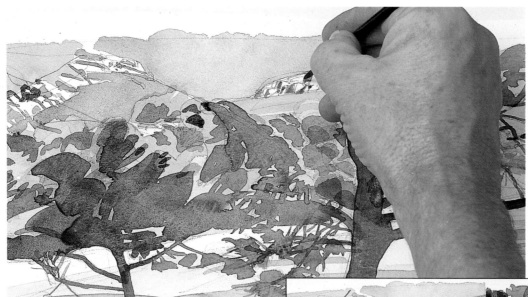

9 Add a few shadows to the distant cliffs, still using the No.3 round brush – the pencil drawing should give you some guidelines, and it also helps to hold the edges of the washes.

10 Adding some of the smaller branches has really built up the texture. Now strengthen the tree trunk by adding a second wash of lamp black warmed with a touch of sepia. Don't try to cover the first wash exactly; it's more interesting if you keep it loose and leave a few edges.

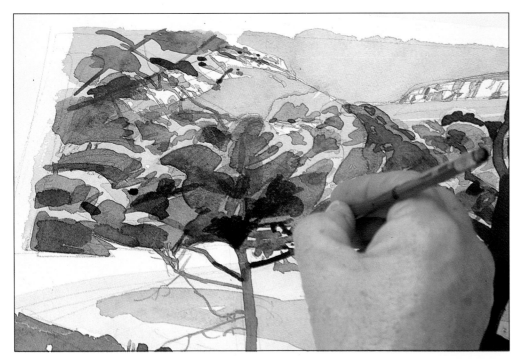

◀ **11** Make the trees richer and darker by adding another wash to the foliage. Our artist used his original permanent green and black wash, but touches of gamboge and raw sienna also crept in and helped to give subtle variations in colour in places. Keep the edges crisp by making sure you paint only over dry washes.

Tip

Try a Chinese brush
Most of this painting was done with a Chinese brush – which accounts for the exciting calligraphic blotches and lines – but our artist also used a smaller brush for finer details, and a larger wash brush for flooding the blue on to the lake.
Throughout he made great use of the versatility of the Chinese brush, using it on its side for broader marks, sometimes almost scrubbing the paper, and then using the very tip for finer, more detailed dots and dashes. He was painting from the wrist, holding the brush in many different positions and at different angles.

▶ **12** Our artist decided to unify the picture by using a much stronger colour than he originally intended. He put a wash of pure liquid aquamarine (Luma colour) over the lake, then allowed it to dry before painting over another wash of liquid turquoise. Apply a pale wash of gamboge and raw sienna for the shore.

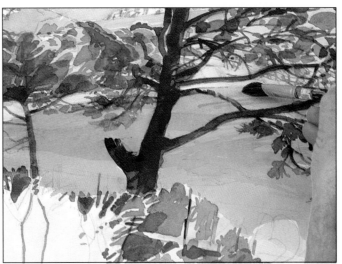

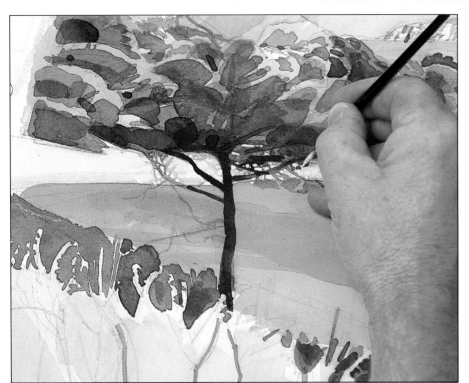

◀ **13** Now add the last details to the trees, using the same mix as before and the No.3 brush. Here the shore wasn't quite dry, so some of the leaf mix ran into the yellow. (This irritated our artist – but we rather liked the effect!)

14 Add the details in the foreground, using mixes of raw sienna, permanent green and lamp black. Make sure the overlaid washes are dry if you want a crisp edge.

Don't be tempted to overwork things at this stage. Keep it loose and fresh to provide a contrast with the overlaid washes and the intricate details in the top left of the picture.

Don't make your washes too strong, either. The picture shouldn't have the same intensity all over – the blue of the lake is fairly intense and strong, so the paler, looser washes provide some relief. The blobs can afford to be larger since they are part of the foreground and help to give a sense of perspective and depth.

15 The final result is a cool fresh picture – all the colours in the palette are on the blue/green spectrum of the colour wheel. The resulting washes are very delicate and wide-ranging in colour – lots of subtle mixes (both deliberate and happy accidents) and overlaid washes. Deliberate use of the white paper has helped to provide sparkle – there are no washes at all in some areas, such as among the spiky grasses in the foreground and the cliffs in the background.

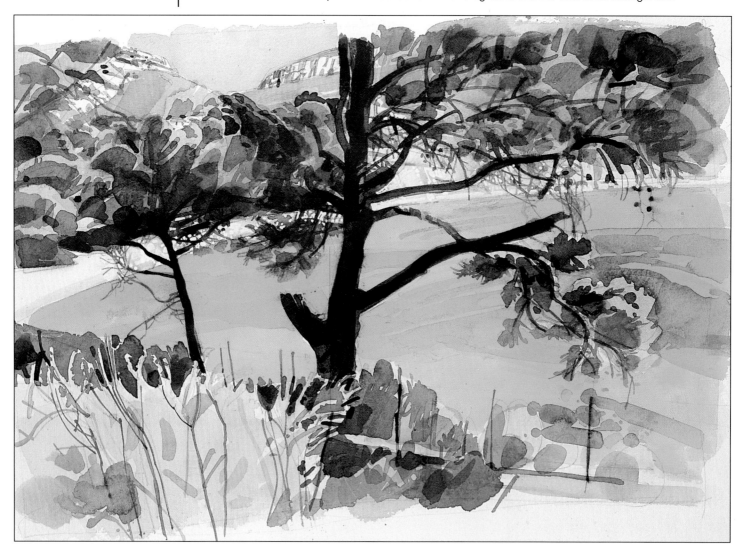

Exploiting hard edges

When precision is your primary aim, you need to be in control of your washes. Painting wet-on-dry gives you that control, enabling you to produce highly illustrative pictures.

There are times when you want to paint with great accuracy. Say you have a commission to paint a friend's house and he wants it to be exact, or you wish to make a study of a flower with botanical precision; then it is important to control your washes carefully. You can't afford those happy accidents that happen working wet-in-wet, when colours blend together before your eyes to create exciting new colours. Yet you can still achieve varied and intriguing results.

You'll give yourself a considerable head start when working wet-on-dry if you use good brushes – the best sables. Sable round brushes come to a fine point yet hold plenty of paint. By handling your brush in different ways you can create a variety of marks – from tiny pinprick spots made with the tip to wide, broad strokes wiped in with the side of the brush. And because a round brush is so versatile, you don't need many – just one large and one medium or small round brush are sufficient for most subjects. For added interest, use paint creatively, altering the amount on your brush so you travel from deep pools of paint to expressive drybrush work.

For the demonstration here our artist painted a friend's house in the sunshine. He allowed the paint to pool on the tree canopy but used tiny touches of colour for the pendulous wisteria flowers and leaves. He wanted an accurate picture – the hard edges of wet-on-dry washes are perfect for describing architectural details and for the crisp shadows cast by bright sunlight.

▶ **The set-up** When you want to work outdoors, you can often do no better than to go into your own garden – or a friend's – to paint. (Then you can run for cover if it rains or pop indoors for refreshment.)

Here the house itself provided a useful focus, so our artist sat at the end of the garden where he could see the back of the house with its beautiful conservatory. (He would have liked to have seen some washing on the line for colour, but it had already been removed in his honour – it doesn't always pay to be tidy.)

◀ **1** Sketch the house and path with your 2B pencil; with this done, you can relax when you apply the colour. Our artist didn't think it necessary to sketch in the greenery but he did put in the main tree trunk and suggest a few branches.

Using the No.10 brush, apply a thin wash of yellow ochre over the house, then put in the main brickwork with raw sienna tinted with Payne's gray. (Our artist tried raw sienna on its own first, but when he tested it on scrap paper he found it too light, so he added some Payne's gray.) Let the paint form pools to make the brickwork more realistic.

◀ **2** Clean your brush and apply a cobalt blue wash to the sky with free, loose strokes. Don't worry about skirting around the tree branches – you can apply these over the dry sky wash, but make sure you leave most of the leafy areas unpainted so the leaves look fresh.

Use a light wash of Indian red for the house roof, strengthening it for the red cherry tree on the right. Then add a touch of Winsor red for the darker tones of the tree. Dab on touches of colour with the tip of the brush for individual leaves around the edges of the tree.

YOU WILL NEED

- ☐ *16 x 20in block of Bloxworth Rough 140lb watercolour paper*
- ☐ *2B pencil; ruler*
- ☐ *Watercolour palettes*
- ☐ *Two jars of water*
- ☐ *Two sable round brushes: No.10 and No.4*
- ☐ *Sixteen watercolours: cadmium yellow, yellow ochre, raw sienna, Indian red, cadmium red, Winsor red, mauve, cobalt blue, ultramarine, sap green, olive green, Hooker's green, burnt umber, Payne's gray, lamp black, Chinese white*

Tip

Finger painting
In this demonstration you'll notice our artist often

uses his fingers to smudge the wet paint. This helps to blend colour and it provides a little texture, ideal for stonework and rough undergrowth.

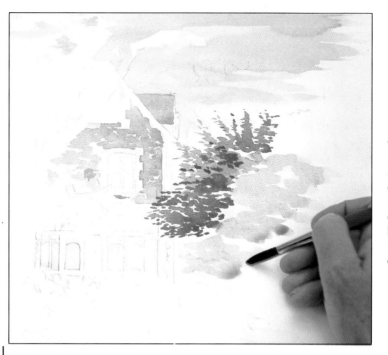

3 Add a little burnt umber to your red wash for the darker tones in the cherry tree, putting on a second layer of the wash in some areas to deepen the colour further.

Mix a wash of sap green and dab in the body of the light green lilac tree, letting the paint form into pools of colour. These dry to create soft variations in tone.

4 Add a touch of cadmium yellow to the green wash for the grass. Start to apply it at the house, with the No.10 brush, then strengthen the wash as you move to the foreground by adding more sap green. Use this to darken the lilac tree while you have the colour on your brush. Leave to dry.

Mix a wash of olive green and a touch of Payne's gray for the branches of the large sycamore tree on the left. Boldly sweep in the colour with the side of the brush, leaving gaps where leaves go over the branches.

It's a brave move, so think carefully about the position of each branch before you put it in. Go over dark areas a second time and put in some of the main wisteria stems with the same wash.

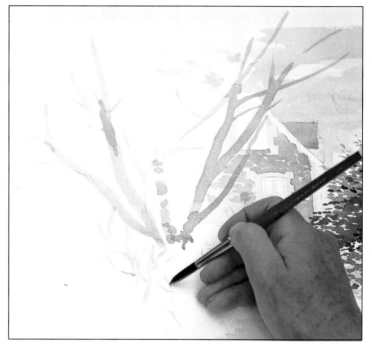

5 Add the ivy round the base of the tree with sap green tinged with black, using the tip of your brush.

Use your yellow and sap green mix for the lighter tones in the sycamore tree, adding a little more yellow if you think it needs it. Holding the brush at the end – you are working loosely and quickly – touch the colour in with the side of the brush, letting the colour pool on the paper. Use the tip of the brush for smaller leaves on the sycamore and wisteria. Leave to dry.

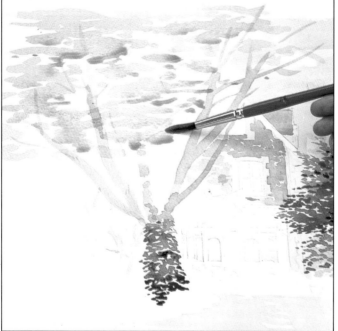

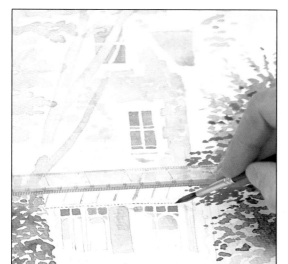

6 Change to the No.4 round sable and use a fairly strong wash of Payne's gray to fill in the house windows and define the sills; use a thinner mix for the windows and door inside the conservatory. To help you get straight lines, rest your hand and brush against a ruler. Do the same when you dot in the shadows of the cornicing, as our artist is doing here.

7 Stand back to assess the painting. Our artist decided to do a bit more work on the house before he progressed to the garden. He added a little more grey to the conservatory, then used the same mix on the shady side of the house, filling in between the leaves of the red cherry tree and lilac bushes. He added the drainpipe in Payne's gray, again using the ruler to steady his hand.

Use the same grey, fairly dry, to draw in the brickwork behind the pipe and to define the roof and tiles, making light, short strokes. Smudge the grey of the brickwork slightly so it doesn't look too harsh. Now blob grey over the house and smudge it with your finger to add texture.

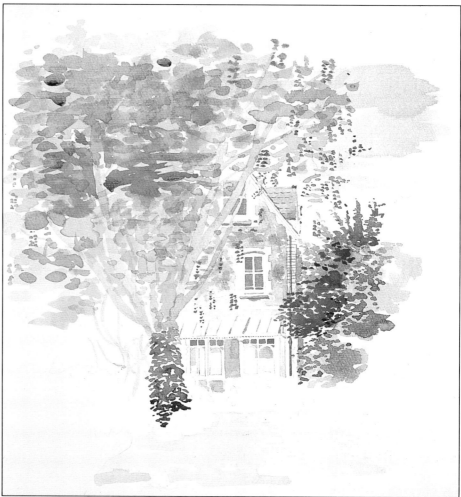

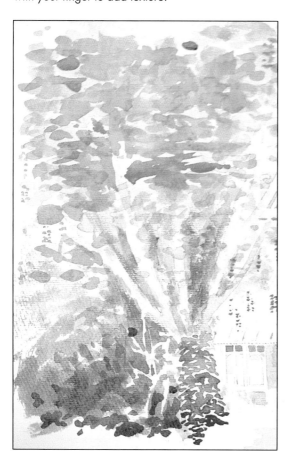

8 Change back to the No.10 brush and add more green to your sap green and yellow wash. Use this to put in darker tones on the sycamore tree canopy, enthusiastically dabbing on the paint, and killing the white gaps in the green so the wisteria flowers show up when you put these in later. Use the point of the No.4 brush to put in the trails of wisteria leaves.

9 Add more olive to the olive wash and a little black to darken it, then put in shadows behind the wisteria stems with the No.10. Don't use much paint; rub it on with the side of the brush for texture. Then rub some on to the shadowy sides of the tree branches.

Add a touch of ultramarine to the olive wash to put in the next bush on the right (see step 10 overleaf). Make short strokes to show the direction of growth. Then use some of this mix to deepen the shadows on the right and blend it with your finger. Use the same colour between the branches of the sycamore, again smudging with your fingers.

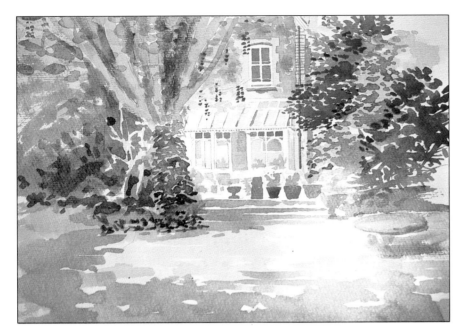

◄**10** Work on the lawn, diluting the darkened olive mix for the shadows on the grass. Ripple the brush over the grass for dappled shadows, making the brushstrokes bolder as you reach the foreground. Allow the paint to form into small pools in the foreground – these bold shadows add drama.

Put in the stone ornament with the same mix, smudging in some Hooker's green underneath it and yellow ochre behind it to draw the eye. Use Hooker's green/yellow ochre for the plants inside the conservatory.

Change to your No.4 brush and put in the pots with a mix of Indian red and Payne's gray. Vary the mix for interest. Use olive green for the geranium plants in the pots. Then mix up some Payne's gray and sap green to go over the ivy on the tree, knocking back the white spaces between the ivy leaves.

►**11** Using the No.4 brush, shade in the stepping stones with Payne's grey. Mix some Indian red into the grey and wash in the patio. Then add the geranium flowers with spots of cadmium red.

Our artist wanted to darken the left side of the tree canopy to help the wisteria flowers show up, so he went over it with a mix of Payne's gray and sap green. Then he put in the wisteria flowers. To ensure these show up well, use Payne's gray and mauve where the flowers stand out against the sky, and Chinese white and mauve where the flowers go over the leaves, dotting in the individual flowers with the brush tip. Now make any other finishing touches you wish.

12 Compare the finished painting with the opening photo to see how accurately the artist has captured the details of the house and garden. Notice the crisp shadows on the lawn, typical of a sunny day. Wet-on-dry washes are perfect for these.

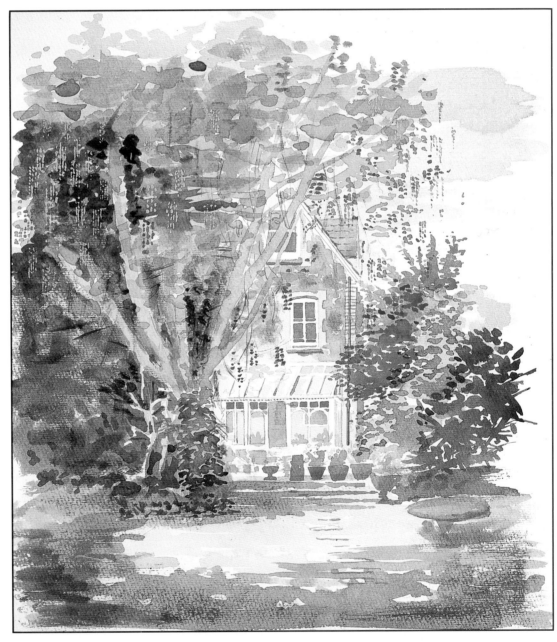

Exploiting hard & soft edges

By combining both hard and soft edges within a painting, you can indicate crucial differences between objects – and the variation creates interest too.

When you work wet-on-dry, the paint travels only as far as your brush takes it, leaving crisp, hard edges. But dampen the paper first, or lay a wash into wet colour (wet-in-wet), and you'll find the pigment bleeds, producing a soft, fuzzy edge. The wetter the paper, the more the paint runs, until there's hardly an edge at all, but a gently fading colour, or two colours merging seamlessly.

Hard and soft edges can suggest differences between objects. In the demonstration here our artist used hard edges mainly for the man-made, geometric forms (the buildings) and soft edges for the organic elements (the trees). These different edges are also useful for emphasizing spatial relationships, echoing the way the eye sees them. Close (foreground) objects are seen in sharp focus, so they can be painted with hard edges. Distance tends to blur your focus, so you can give the background elements softer edges.

The set-up Our artist had painted a scene like this before, and used that painting to help with this picture. She wanted to organize her composition to encourage the viewer's eye to zig-zag through the buildings, down the steps and into the rich foreground hues of the trees.

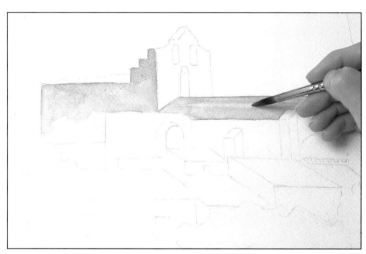

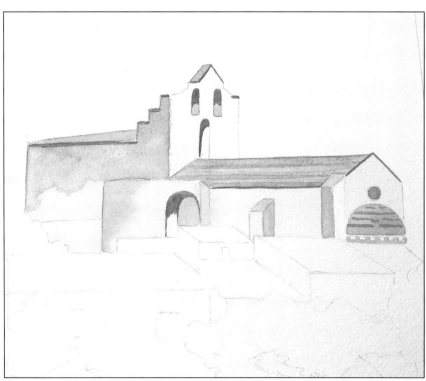

▲1 Outline the buildings and trees with the HB pencil. Then make a dilute mix of lemon yellow and yellow ochre to stain the lightest areas of the church walls and side roof, using the No.10 brush. When this has half-dried, mix a grape-purple colour with carmine and cerulean blue for the darker roof tones and the shadow on the wall. On the semi-dry paper, the washes merge only slightly, leaving a semi-hard edge.

Fill in the light tones in the church windows and the top of the portico on the right (see step 2). Let the paint dry so subsequent washes form crisp edges.

◀2 Put in the dark tones in the church widows, the arch of the wall in front, the tiles on the portico and some fine outlines around the building, all with varying dilutions of the purple mix and the No.4 brush. Notice how, because you're working wet-on-dry, these tones form sharp edges when dry.

Use the lemon/ochre wash on the wall with the arch. While the paint is still wet on the paper, strengthen the wash with the same colours and put in a darker tone towards the left, allowing both tones to merge softly. Strengthen the wash again for the main church roofs.

YOU WILL NEED

- ☐ *50 x 36cm (20 x 14in) fairly rough NOT/cold pressed watercolour paper*
- ☐ *Two round watercolour brushes: Nos.4 and 10*
- ☐ *Palette, jars of water*
- ☐ *HB pencil*
- ☐ *Eleven watercolours: carmine, cerulean blue, yellow ochre, Vandyke brown, viridian, sap green, Indian red, burnt sienna, cadmium orange, gamboge and lemon yellow*

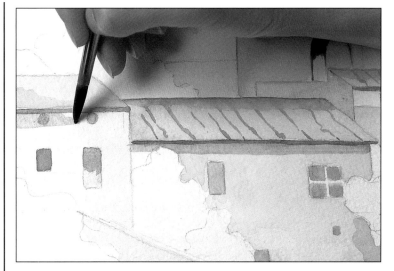

◄ 3 Now paint the other buildings, working your way down into the middleground. Stick to pale washes – browny oranges, peachy pinks, lilacs and pale, cool blues. You'll use stronger colours to establish the foreground later. Give the shadows either hard or semi-hard edges for variation.

► 4 Stand back and take a look at your painting. Our artist wanted the buildings to look like geometric blocks, with mainly hard edges and clean, flat washes. On the tiled roofs, for instance, she let the paint dry completely before adding the crisp tile shapes. In other areas (for example, the shadows on the wall in the middleground right), she applied colours on to damp paper, so the edges became blurred and soft.

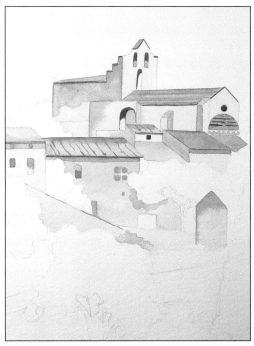

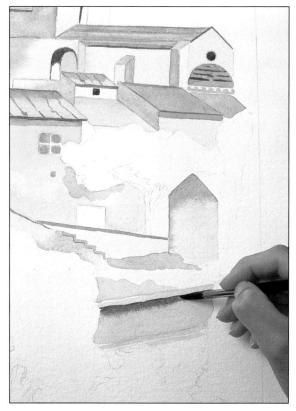

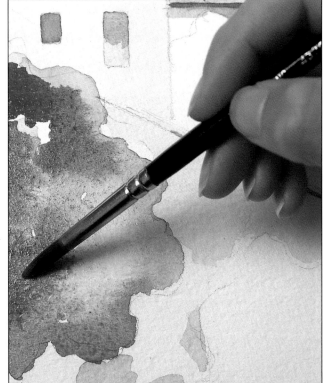

▲ 5 Put in the grass on the roadside with pale mixtures of sap green and lemon yellow. Mix a pale grey to paint the road, then brush in one of the yellows for the yellow line at the road's edge. Bleed in a strong, warm grey to suggest the shadow on the side of the kerb.

◄ 6 Put in the rest of the road (left of the tree) with similar, but stronger washes. Paint these wet-on-dry to create a different pattern from the other side of the road.

Now paint the tree wet-in-wet, starting with a pale green wash around the edge, followed by a yellow patch towards the middle, then apply a strong mix of cadmium orange and gamboge. All these blended tones suggest the irregular, organic look of foliage.

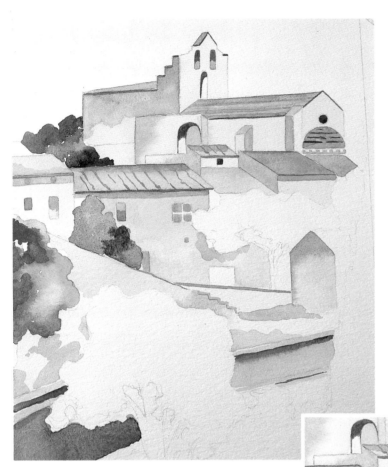

Controlling the spread of your washes

▲ **7** Using the purple colour, and some greens and yellows, make a variety of mixes for the small middleground and background trees.

Notice how our artist has allowed the edges to blur within each tree, and yet distinguishes the trees from each other clearly, either by leaving small gaps where the paper shows through or, as in the middleground, by painting adjacent trees with very different tones.

▲ By flooding deep orange into yellow, wet-in-wet, you create soft, blurred edges which suggest delicate tonal gradations in the foliage.

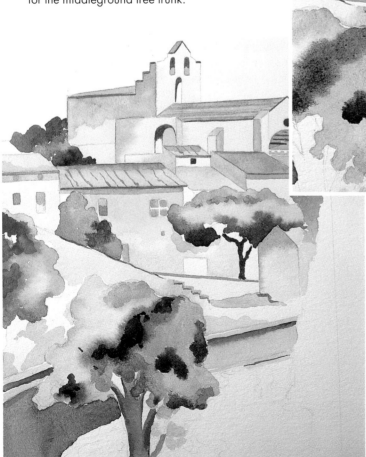

► **8** Now add the remaining trees – in the middleground and foreground. Create a series of greens and yellows for this. Lay the colours into each other when they are semi-wet, so the edges are a little soft, but still well defined. The strong colour, tonal contrast and fairly soft edges give a sense of the light playing through the trees.

Add some Vandyke brown to the purple mix for the middleground tree trunk.

▲ Placing wet colour over semi-dry creates fairly soft, but still defined, edges. You have more control over the wash than working wet-in-wet.

◄ **9** Dilute the tree trunk wash to paint the larger foreground trunk and branches. Once dry, strengthen the wash slightly for the shadows.

▲ Applying wet colour to an area where a wet wash meets a dry one creates a band of colour with one soft edge and one hard one.

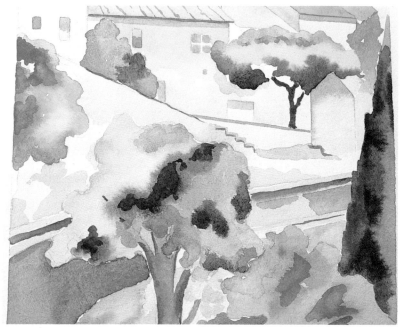

▶ **10** Add the grass behind the foreground tree, then put in the orange bush to its right with the strong orange wash used before. Vary the strength of the wash, allowing the tones to blend. Once dry, add strong orange shapes with sharp edges to indicate shadows.

Create a few intense green washes (green/yellow mixes) for the fir tree on the right and the bush under the main tree. Aim to produce a greater tonal contrast in the foreground than the middleground and background in accordance with the rules of aerial perspective. Add a touch of Indian red to the mixes to enhance the hues. Fill in any areas you may have missed and leave to dry.

If any areas appear too light once dry, apply supplementary washes on top to enrich them. However, take care not to overwork the painting or muddy the colours.

▶ **11** When the painting is dry, colour the sky. Use the larger brush and very pale cerulean blue. Wet the paper in places first so the wash bleeds and the edges fizzle out. The paper to the left of the church roof wasn't wetted, so the colour dried with a harder edge, giving shape to the cloud. Make a very pale mix of carmine and viridian and flood this into areas of the sky for variation. Add any final touches to finish off.

The artist's interpretation is not literal in this painting. She has deliberately simplified the forms and the tonal contrasts in order to play up the abstract qualities of the subject.

The viewer is made aware of the surface of the support and the two-dimensional pattern-making aspects of the buildings, seemingly piled on top of one another. The contrast between the soft edges of the foliage and the hard edges of the buildings adds interest.

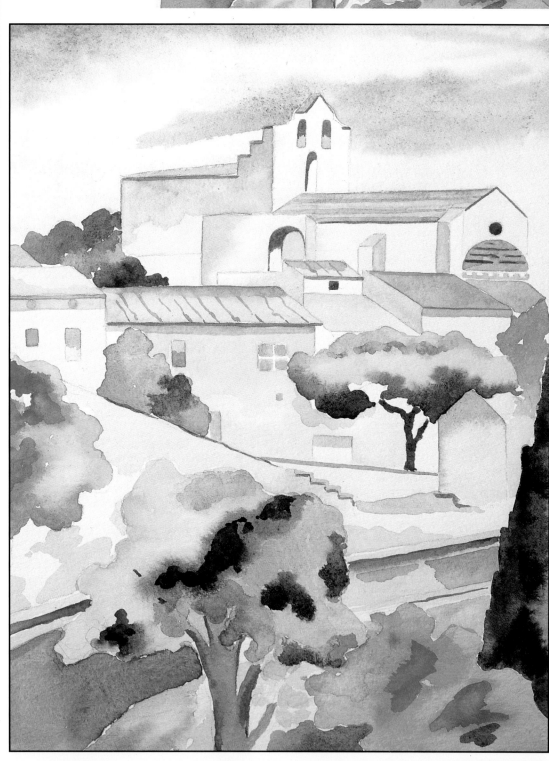

Using resists: masking fluid

If you want to keep the original colour of the paper for details, highlights or even whole foregrounds, use a resist such as masking fluid which covers well and peels off easily when dry.

Candle wax, masking tape and masking fluid are some of the 'resist' materials used in watercolour painting. They are called 'resist' simply because they resist the paint, stopping it from reaching the paper. Of course, you can lift off areas of colour with warm water, but they won't be as bright and pure as the colour of the original paper nor have the crisp edges of areas masked with tape or masking fluid.

Using masking fluid and a fine-point brush gives absolute control of the area you want to leave unpainted. Masking fluid is essential for preserving small details such as leaves and foliage in the foreground of an autumn landscape, for example, or round objects such as boulders in a stream. It's also useful for keeping sharp lines and hard edges.

You can even use masking fluid to retain very large areas of the paper which need to be white – if you're painting a chalk cliff, for instance, you can block out the area with masking fluid before covering the rest of the paper with washes for sea and sky.

There are two types of masking fluid available – coloured and colourless. The coloured fluid is pale yellow, so it's easy to see where you've applied it after completing a light wash or two. However, it could stain the paper if left on for, say, over a week or two. The colourless fluid doesn't stain.

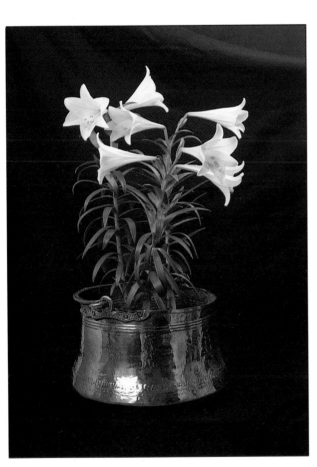

◀ **The set-up** Capturing the simple beauty of lilies is deceptively difficult. Light falling on the horn-shaped flowerheads creates many subtle tones – from bright whites to dark greys.

Using masking fluid is a useful way to preserve a crisp outline and retain the brightness of the paper.

1 Sketch the composition with the HB pencil, making sure you render the correct proportions for the flowers, stems and pot.

Paint colourless masking fluid on to the flowerheads with the No.5 synthetic brush. Apply the masking fluid carefully over the flowerheads, so you retain their exact shape – you can't add white later if the shape is wrong at this early stage.

Look where the light falls on the pot and apply masking fluid to keep the highlights. It's essential to leave the masking fluid to dry before continuing.

▲ **2** Using the sponge, flood the stem area with water and then apply several tones of Hooker's green wet-in-wet with the No.12 brush. Make a few long, narrow leaf-shaped marks with the tip and middle section of the brush.

Mix a touch of cadmium yellow pale with Hooker's green to create a few yellow-green leaves where the stems enter the pot.

▲ 3 Wet the whole copper pot with the sponge. Mix cadmium yellow pale and cadmium red to produce a coppery orange, and apply wet-in-wet. While still wet, drop in touches of yellow and red.

Use burnt umber to suggest the dark reflections on the pot. Don't be afraid to cover the masking fluid with paint. You'll find the paint gathers into dots and blobs over the masking fluid. Leave this as is – it makes a most attractive feature.

YOU WILL NEED

- ☐ *A 22 x 30in sheet of rough 300lb paper*
- ☐ *Three brushes – Nos.6 and 12 round; No.5 round synthetic for the masking fluid*
- ☐ *An HB pencil*
- ☐ *Colourless masking fluid*
- ☐ *One palette*
- ☐ *An eraser*
- ☐ *One natural sponge*
- ☐ *Two jars of water*
- ☐ *A clean rag*
- ☐ *Eight watercolours – cadmium yellow pale, Hooker's green, Payne's gray, burnt sienna, burnt umber, cadmium red, raw sienna, alizarin crimson*

▲ 4 The composition is beginning to take form. The individual stems and leaves will take shape once you have put in the background. Step back and assess your overall picture before continuing.

◄ 5 Mix a large amount of Payne's gray, and create the background cloth with the sponge. Don't apply a heavy, flat coating of paint – allow light and dark tones to show through to provide a sense of depth.

▶ **6** Quickly and loosely paint around the flowerheads with the sponge – the masking fluid will resist the paint, protecting the paper underneath.

◀ **7** Don't get too close to the leafy area with the sponge on the left side. Instead, use the No.6 brush to paint in dark negative spaces (background), forming individual leaves.

▼ **8** Continue forming the stems and leaves with the No.6 brush and strong Payne's gray. Think carefully before you apply the paint to reduce the chances of making mistakes.

Tip

Masking fluid brushes
A word of warning about brushes – make sure you use cheap ones because masking fluid damages the fibres if it's allowed to dry on the brush. Synthetics are the best choice because they're cheap. Even with care – washing the brush immediately after use in warm, soapy water – fluid can build up near the ferrule and clog the fibres over a period of time.

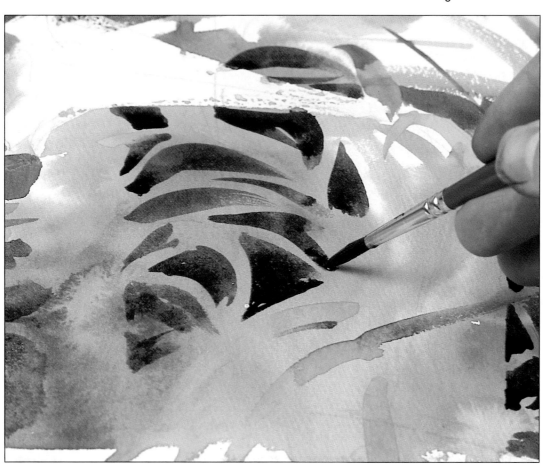

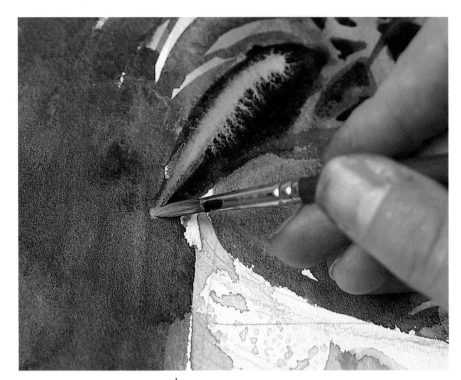

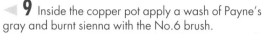

9 Inside the copper pot apply a wash of Payne's gray and burnt sienna with the No.6 brush.

Here our artist uses a mix of Hooker's green and cadmium yellow pale to add a few leaves.

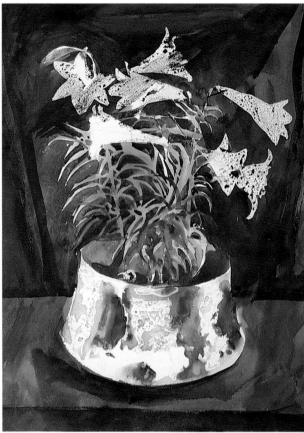

10 Apply a dilute wash of Payne's gray with the sponge to create the table top and foreground. The No.12 brush is useful for adding the shadow at the base of the pot and the dark strokes which suggest the folds of the background cloth.

Our artist dropped alizarin crimson into the background cloth near the top right-hand side of the flowerheads – this reinforces the idea that dark colours aren't at all flat and lifeless: there are hints of other hues showing through if you look for them.

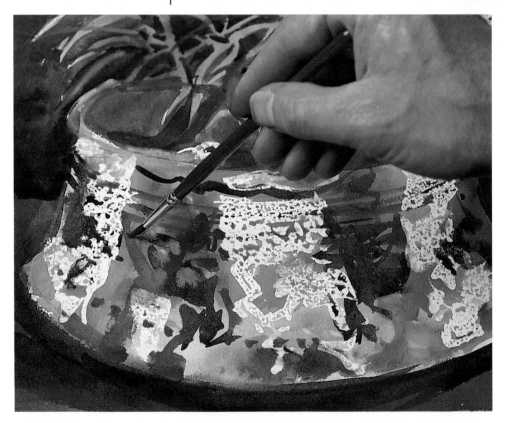

11 Continue adding more orange (cadmium red and cadmium yellow pale) and burnt umber to the copper pot. Use the No.6 brush, holding it towards the end to help you work quickly and freely. The artist liked the stippled effect of the paint on the masking fluid, so he decided to leave it on.

Lightly wet the bottom of the pot; then add single dots of cadmium yellow and alizarin crimson to describe the dotted pattern on the pot. If the paint is forming a pool, use blotting paper to remove the excess. Paint the rim of the pot with cadmium yellow pale.

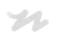

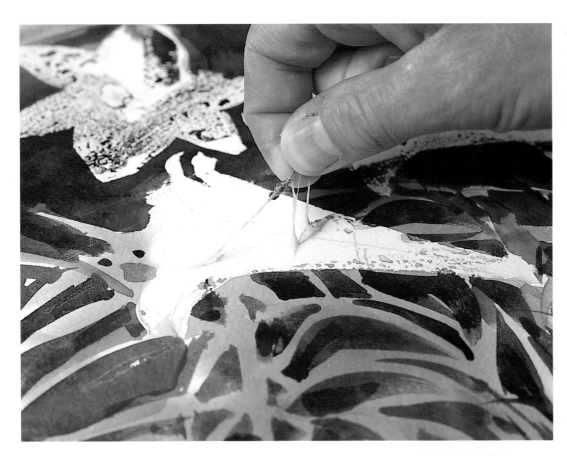

◄ **12** Use an eraser to remove the masking fluid, or carefully peel away an edge with your fingers and gently pull it off. Dry areas of paint cover the masking fluid – so be careful not to dirty the white paper when taking it off.

▶ **13** It's critical to make the flowerheads appear fresh and alive. Look at the originals all the time to see where you need to add the different tones.

▼ **14** Wet the flowerheads with the No.12 brush. Make a light, dilute mix of Payne's gray and raw sienna, and then drop in wet-in-wet. Also add hints of yellow to warm the flowers. (If you try to describe the subjects exactly, they will look laboured.)

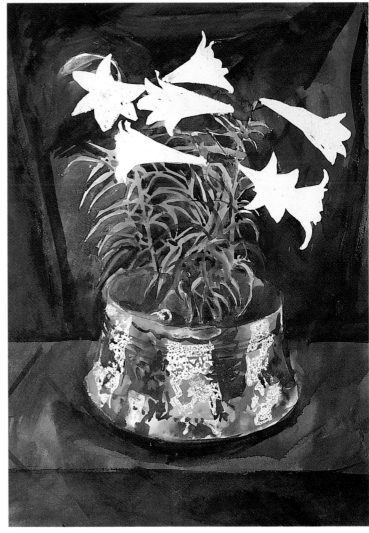

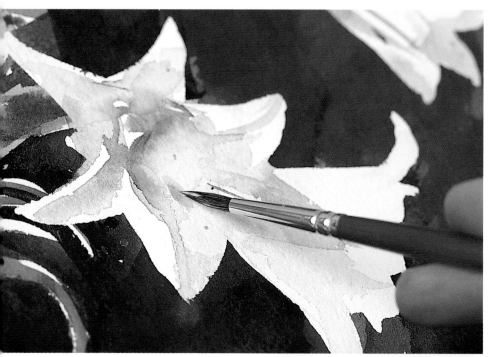

15 For the bright yellow stamens dab strong cadmium yellow pale into the centres of some of the lilies. Take care to place them in a position that leads the eye into the flowerheads.

Tip

Scraping the edges
Though you can use masking fluid to create hard edges, you may wish to add more details

after you've finished a painting. A sharp craft knife does the job nicely — scrape carefully into the paper to remove the paint.

16 Our artist now added a few final details. He darkened the inside of the pot slightly with Payne's gray and then used a variety of mixtures of Hooker's green and cadmium yellow to create more tones in the leaves.

With the help of the masking fluid, he has captured the freshness of the lilies and the shimmering appearance of the copper pot; both really stand out against the dark background.

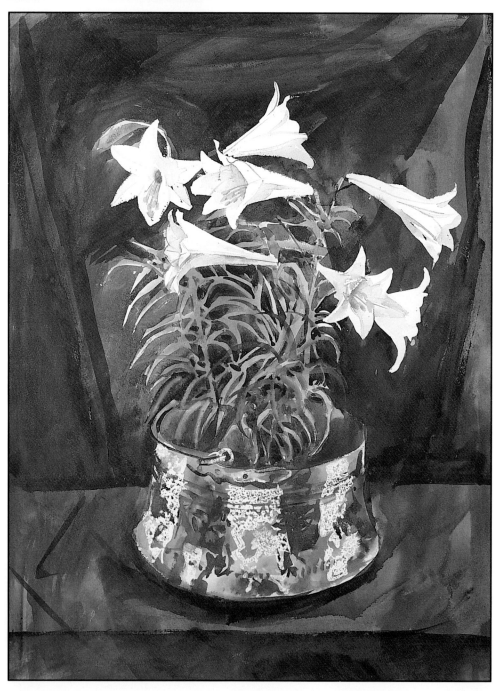

Doorway in Venice

Use masking fluid and soft washes of colour to capture the faded grandeur of a canal-side doorway in Venice.

Venice must be the world's most painted city – and with good reason. Not only are there magnificent sights, such as the Doge's palace and the Grand Canal to delight the artist's eye, but there are also enchanting scenes around every corner, like this sun-drenched doorway.

Our artist delights in painting details of old buildings – doors, windows, balconies and gates, weathered and crumbling, make a fascinating subject for study. This canal-side doorway, for example, contains a wealth of textures, from flaking plasterwork and crumbling bricks to the wooden doors, bleached and cracked over the years by sun and water. The water itself is smooth and glassy, creating a pleasant contrast.

Many of the textures in this painting were achieved with the help of masking fluid. As you have already seen, masking fluid can preserve areas of white paper when a surrounding wash is applied. In this demonstration it is also used in a similar way to wax resist. On the wooden doors, for example, the effect of wood grain was created by applying ragged streaks of masking fluid – which are never removed. When washes of colour were applied, they adhered to the paper but were resisted by the waterproof mask, accentuating the effect of age and weathering.

▼**1** There are lots of intricate details here, so start with a careful outline drawing of all the elements with the HB pencil. With an old paint brush apply masking fluid to the parts of the picture you want white, such as the metal grill on the windows and the arch above the door. Apply ragged streaks of masking fluid to the door and the stonework around it. Wash your brush thoroughly in soapy water and leave the masking fluid to dry.

Mix a very dilute wash of raw sienna and, holding your board at a slight angle, brush this over most of the picture, leaving small areas of white paper here and there on the stonework and geraniums.

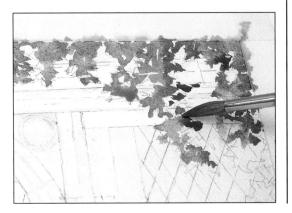

▲**2** Mix a range of olive greens for the foliage over the doorway, using varying proportions of raw sienna, French ultramarine and a little burnt sienna. Add more French ultramarine for the darker foliage. Using the No.8 round brush, paint the Virginia creeper along the top with small dabbing strokes, leaving tiny gaps between the leaves to keep the foliage light and airy.

A treasured possession
Our artist still uses a very old paint box, given to her many years ago. It has a handy thumb hole and the lid folds out to provide eight compartments for mixing washes.

The two brushes at the top are squirrel hair mop (wash) brushes with the traditional quill fitting instead of a metal ferrule. These brushes are inexpensive and available from art shops. They have good colour-carrying capacity, making them ideal for applying large washes.

3 With the same brush, mix a dilute wash of light red, adding a tiny spot of French ultramarine. Use this to wash in the windows lightly, leaving small flecks of the undercolour showing through in places. The masking fluid will preserve the intricate pattern of the window grills.

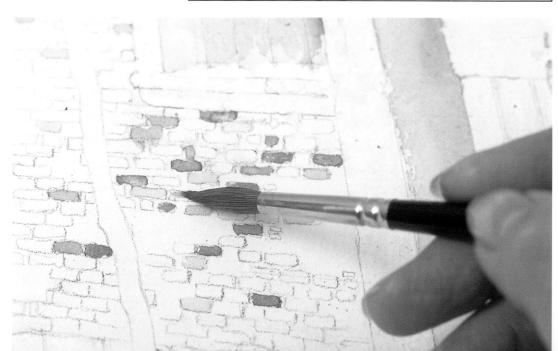

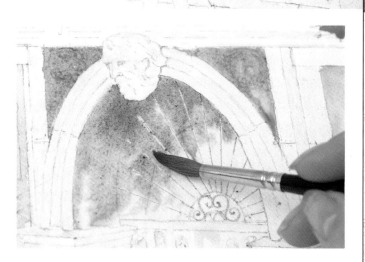

4 Now paint the dark parts of the door surround and the inner arch above the door. First dampen the areas to be painted with clean water, then apply Venetian red, varying the tone of the colour to create a sense of light and shade playing on the surfaces.

5 Continue painting the surround, using a slightly paler wash for the shadows on the supporting pillars, then work down into the reflections of these shadows in the water with an even paler wash.

Deepen the tone of the windows with further wet-in-wet washes of light red and French ultramarine, grading the tone from dark to light to indicate light bouncing into the shadows from the surface of the water.

6 Switching to the No.6 round brush, paint the warm-coloured bricks, using Venetian red for the darkest ones and raw umber for the lightest ones. Modify the tones of these colours from light to dark to add variety and to suggest the play of light on the walls.

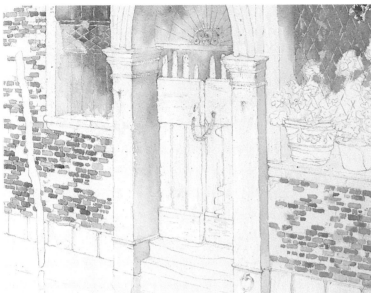

7 Continue to build up the pattern of brickwork on the walls. Aim to make the colours of the bricks warmer than the shadows inside the windows and doorway – this helps to bring the bricks forward and thus increases the impression of depth.

Tip

Uneven brickwork

When painting individual bricks, avoid neatly filling in the drawn outlines, as this creates an unnatural effect. For a more natural look

make your strokes slightly misshapen and ragged. To suggest the weathered look of these mellow old bricks, the artist softened some of the strokes with her finger.

8 Apply a wash of Winsor blue to the wooden doors. As if by magic, the texture of weather-beaten wood appears – the result of the resist effect of the masking fluid left underneath.

With the No.6 mop brush, wet the entire area of the water in the canal. Mix a fairly pale wash of light red and raw sienna and apply it to the water on each side of the reflections of the doorway – make vertical strokes to indicate the reflections of the building. Using the No.6 round brush, paint the steps and their reflections with the same colour. Then paint the reflection of the doors with a pale wash of Winsor blue mixed with a little cerulean blue.

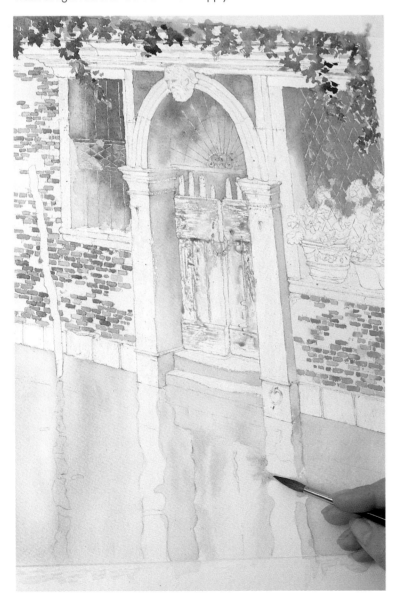

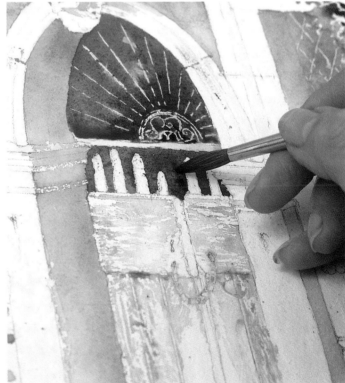

9 Paint the shadows of the stone head above the doorway in Venetian red. Then mix a dark wash of light red and French ultramarine for the dark, shadowy area inside the arch. Lift out some of the colour with a clean brush to vary the tone and give the shadow life.

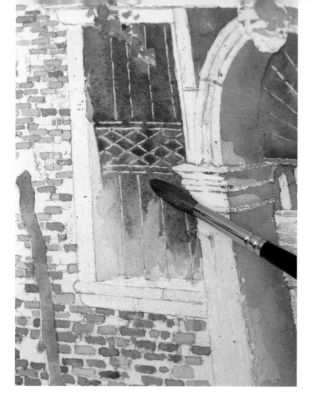

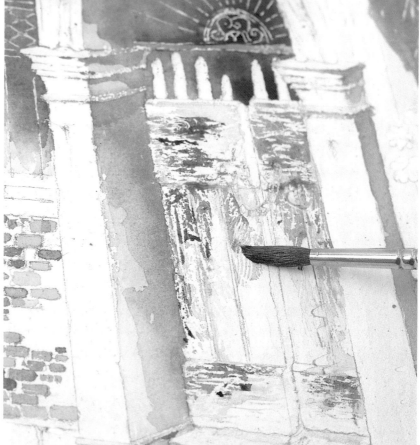

10 Paint the wooden pole sticking up out of the water with a wash of raw sienna and sepia. With the No.8 round brush, deepen the shadows in the windows with a second wash of light red and ultramarine. Notice how the combination of washes gives depth to the space behind the window.

11 Add flecks of burnt umber to the wooden doors to enhance the aged effect, then deepen the colour with some washes of Winsor blue and cobalt blue.

12 With the No.6 round brush, paint the dark shadow between the doors with a mix of light red and French ultramarine. Continue building up the texture and tone on the doors with superimposed washes of Winsor blue and cobalt blue. Notice how the artist has graded the tone, from dark at the top to light at the bottom, to give the impression of watery light reflected up from the canal.

Paint the terracotta pots on the right of the doorway with mixtures of light red, Venetian red and French ultramarine. When this is completely dry, use the corner of a plastic eraser to remove the masking fluid from the entire picture, except the door.

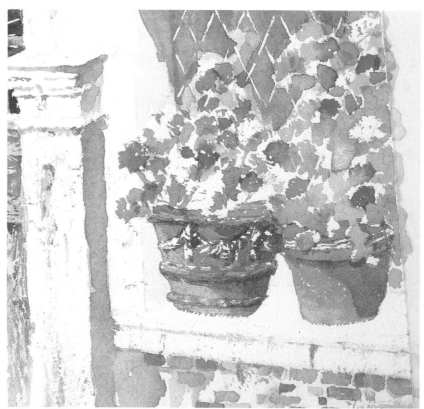

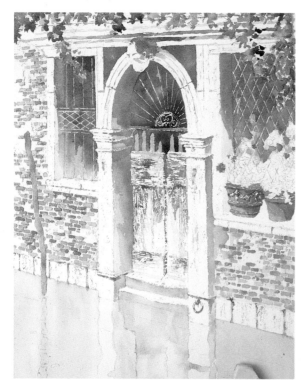

13 Mix a dark and a light tone of cadmium red and paint the geraniums. For the leaves, use mixtures of raw sienna, raw umber and ultramarine diluted to make a variety of delicate greens.

Leave areas of white paper which act as breathing spaces and enhance the delicacy of the flowers.

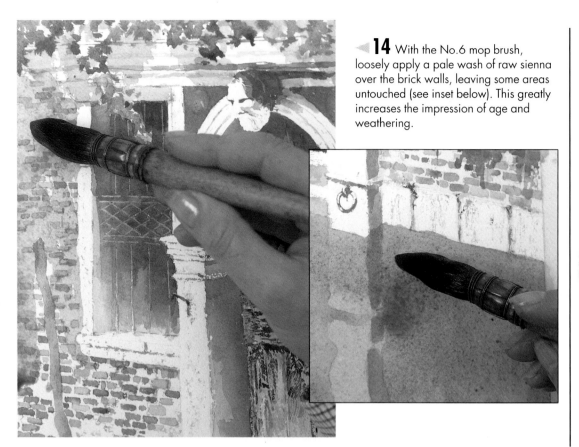

14 With the No.6 mop brush, loosely apply a pale wash of raw sienna over the brick walls, leaving some areas untouched (see inset below). This greatly increases the impression of age and weathering.

Tip

Flecks of colour
To create the effect of crumbling masonry, splay the end of your brush between finger and thumb and apply tiny flecks of colour at random.

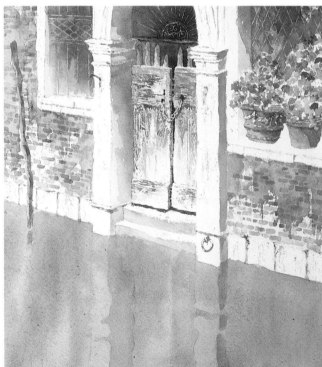

15 Mix raw sienna and cerulean blue on your palette. Dampen the area of water and paint the canal with vertical, downward strokes using the No.8 mop brush. Allow the strokes to spread softly, to suggest a still surface. These two colours, when mixed, create a granular effect which adds a lively surface texture.
 Mix light red and ultramarine to paint the shadow on the wooden pole with the No.8 round brush.

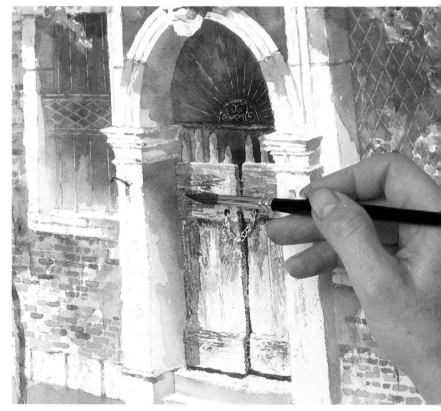

16 Using the same brush and wash, paint the shadow on the left wooden door. This helps to push it back and adds to the quiet atmosphere of the place.

◄ **17** Mix up more raw sienna and cerulean blue, adding a little sepia to darken the colour and to encourage the granular effect. With your No.8 mop brush, build up the dark areas in the water with further wet-in-wet washes.

▶ **18** Continue to deepen the tones in the water with the same mixture you used in step 17, until the water looks quite dark yet retains a feeling of transparency. The build-up of these multiple wet-in-wet washes is very effective in conveying the depth of the water and the silky sheen on its surface.

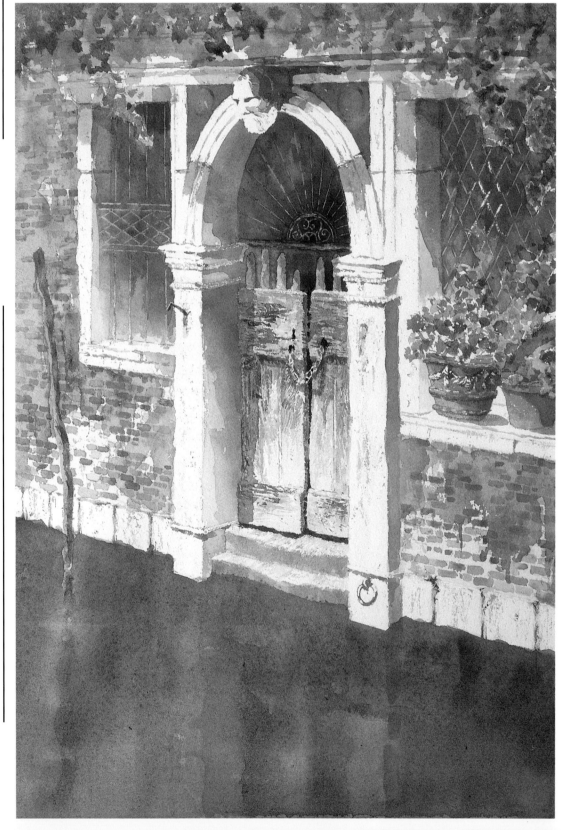

Lifting out: five fresh mackerel

Don't feel that once you've put watercolour paint on the paper you are past the point of no return – you can always take off paint.

With watercolour you work from light to dark, but there are times when you want to lighten painted areas. You can do this by applying some absorbent material – such as a paint brush, piece of blotting paper or cotton bud/swab – to the wet area. This technique is known as lifting out. The degree to which you are able to remove paint depends on how dry it is, on the pigment (some stain more than others), on the dryness of the material and how firmly you apply it, and on the quality of the paper and how much it has been sized.

You can use the technique to make corrections – such as removing excess paint, for example – but you can also create some highly convincing effects. For example, you might draw into painted water with a cotton bud to create rippling reflections or use a damp sponge to lift out the clouds in a sky. Remember to avoid relying entirely on technique, though, or you might end up with a shallow – gimmicky – result.

▲ Our artist prepared three dilute colours but only used two with any regularity: viridian/Prussian blue (top), and cobalt violet/crimson (bottom). You might add a sap green/Prussian blue mix.

YOU WILL NEED

- ☐ A 22 x 15in sheet of stretched 200lb NOT/ cold pressed paper
- ☐ An HB pencil
- ☐ Three round brushes – Nos.2, 4 and 10
- ☐ Sponge; cotton buds
- ☐ Twelve colours – viridian, Prussian blue, cobalt violet, sap green, crimson, Payne's gray, burnt sienna, turquoise, cadmium red, cadmium yellow, brown madder alizarin and ivory black

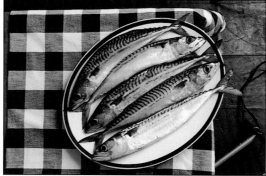

▲ **The set-up** A plan view of five fine mackerel on an oval plate makes a strong design against a bold-patterned tablecloth. It helps to choose a subject where you can see an obvious application for the lifting out technique. Here the artist intends to use it to capture the opalescence of the fishes' bellies, gill covers and jaws.

1 Make a light drawing with an HB pencil. Locate the main components – the fish, the plate and the stripes on the cloth, for example. Indicate only the most significant details – such as the fishes' stripes, gill covers, fins and eyes.

▲ **2** Look at the set-up. All five fish slope diagonally from top right to bottom left and are darkest at the lower end. Work with your board tilted slightly towards you so that the paint collects naturally at the bottom of each fish. Load your No.4 brush with the viridian/Prussian blue mix and put a very wet wash over the back of the top fish. Paint around the eye. Wash in the pinkish belly with the same brush and a cobalt violet wash.

▶ **3** Dip a small piece of clean sponge into clean water and wring it out until slightly damp.
　　Now dab off the excess paint. Be decisive but press lightly. Aim to 'fix' any interesting effects – where the paint has run, say – rather than obliterating them.

Four ways to lift out

▲ **For lifting out large areas of paint, roll up a piece of kitchen towel, tissue or cloth and wipe it boldly across the paper. Notice how the end of the towel gives a clean edge.**

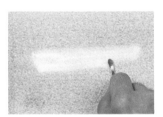

▲ **Cotton buds/swabs, perfect for precision work, can also be used to draw into the wet paint. Discard when filled with paint or the plastic stem might damage the paper.**

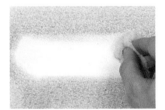

▲ **The open pores of a sponge or a piece of foam rubber leave a slight residue of paint in the lifted out area. Unlike the rolled towel, a sponge produces a soft edge.**

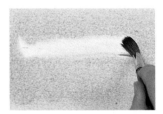

▲ **The fine tip of a clean dry brush is a convenient tool for taking out excess pools of paint. But by stroking the paper you can lift out large areas for a more subtle effect.**

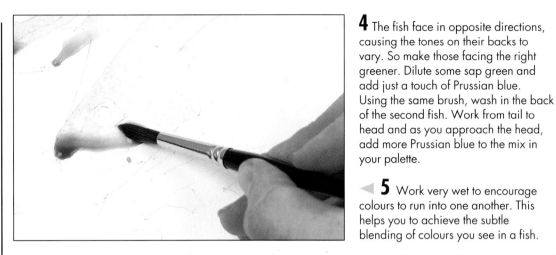

4 The fish face in opposite directions, causing the tones on their backs to vary. So make those facing the right greener. Dilute some sap green and add just a touch of Prussian blue. Using the same brush, wash in the back of the second fish. Work from tail to head and as you approach the head, add more Prussian blue to the mix in your palette.

◀ **5** Work very wet to encourage colours to run into one another. This helps you to achieve the subtle blending of colours you see in a fish.

▶ **6** Work downwards without waiting for the paint to dry. Remember to alternate the colour of the fishes' backs – viridian/Prussian blue for those facing to the left, sap green/Prussian blue for those facing to the right. But look carefully at your subject and adjust colours while they are still wet. For example, if the belly looks particularly pink, run in a little dilute crimson so that it mixes on the paper. Where you want the pink more subdued – pearly – add a little Payne's gray or Prussian blue.

◀ **7** With the fifth fish washed in, the first – highly fluid – stage is nearly complete. Notice how subtle the blending of colours is now that the paint is drying. Following the principle of watercolour – working from light to dark – the next stage is to strengthen the washes.

▶ **8** Dab off any glaringly excessive pools using the sponge (see step 3). But remember that the paint dries much lighter. If you want to preserve any attractive watery effects, it's best not to touch them at all.

9 Now add a hint of burnt sienna to some sap green. Still using the same brush, paint the outline of the back of the second fish. Again – add Prussian blue as you work towards the head.

10 This is the point at which you must strike out for yourself – looking carefully at your own subject and adjusting washes to suit.

As a general guide, mix stronger versions of the washes you used earlier. Strengthen the heads of the fish facing to the left using your sap green/burnt sienna mix. If you want your viridian/Prussian blue mix to look more steely, add a touch of turquoise.

11 Indicate the fins with a wavy line of the sap green/burnt sienna mix, using the tip of the No.4 brush.

12 A second wash of the viridian/Prussian blue/turquoise mix makes the top and middle fish look solid and reflective. The sap green/burnt sienna mix lends some weight to the fourth fish. Another wash of cobalt violet/crimson maintains the pinkness of the fishes' bellies.

DID YOU KNOW?

Gum arabic

Gum arabic is used along with other substances as a binder in the manufacture of watercolour paints. But you can buy it in solution in bottles and use it as a painting medium.

It's particularly useful for lifting out. Just the tiniest drop added to the dilute paint in your palette makes it all the easier to remove – this is the case even when the paint has dried.

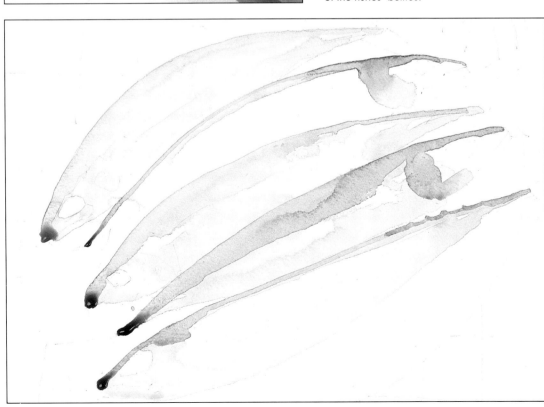

Tip

Eraser brush
You can use the tip of a brush to erase dry paint. Wet the area you want to remove. Wash out

the brush and squeeze out the excess water. Then massage the paper lightly with the tip of the brush. Keep rinsing the brush, squeezing it out and massaging until all the paint is removed.

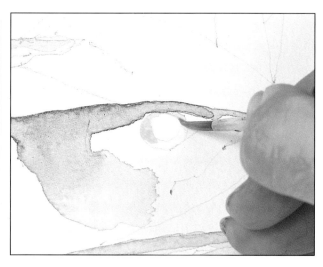

13 Mackerel are most beautifully coloured fish – beside all those wonderful greens, blues and silvers there is the complementary bright orangey yellow of the eye. To get this, mix a touch of cadmium red to some dilute cadmium yellow. Paint in the iris – the outer part of the eye – with the No.2 brush.

14 Now make a brownish green for the tail fins. Add more burnt sienna to the sap green/burnt sienna mix you made earlier. Paint in the fins with the same brush.

A fish's fins are extremely delicate – very thin, almost transparent. Look carefully at the fins on your subject and convey their delicacy by letting the paper stand for splits between the rays. Put in all the fins.

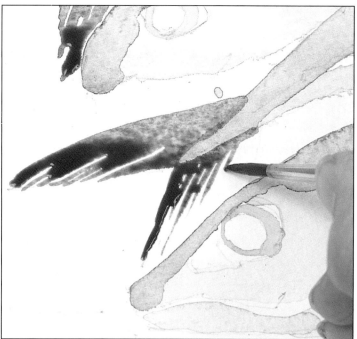

15 Now put in the fishes' pupils. Use the tip of the No.2 brush and a dark Payne's gray with a touch of black. Look for the little speck of reflected light in the pupil. Let the paper stand for this and leave a slight gap between the pupil and the iris.

16 Before you paint the stripes, mix some brown madder alizarin and cobalt violet and put in the bronze patches below and behind the eye. Tick in the mouth with sap green/Prussian blue. Now mix Payne's gray and viridian and put in the stripes.

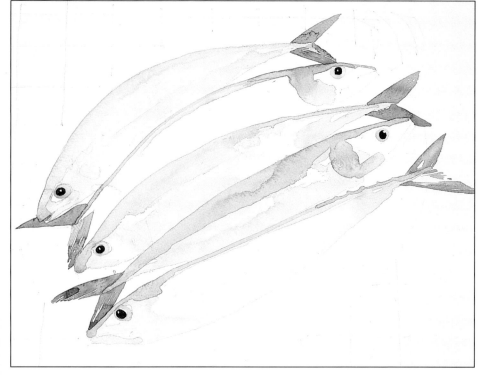

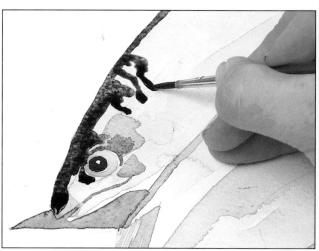

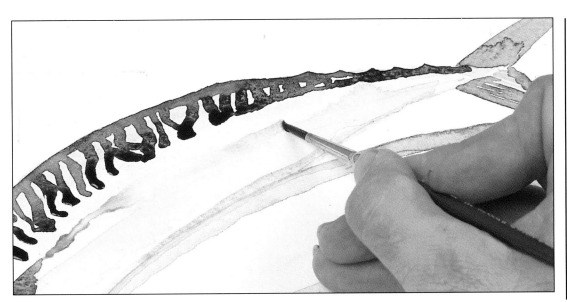

17 Mix some burnt sienna and brown madder alizarin and use the same brush to paint the pectoral fin (just behind the gill) and the lateral line which runs down the flank.

18 For the stripes on the second fish, aim for a lighter, more greeny version. Try adjusting your sap green/burnt sienna mix by adding a touch of Payne's gray – and perhaps a little more sap green. Increase the Payne's gray towards the head and pull the paint down, over the gill cover.

Paint the gill cover, mouth and stripes of the third fish in the same way as you did for the first. (Here our artist used a more dilute version of the Payne's gray/viridian mix for the stripes.) Then continue with the fourth and fifth fish.

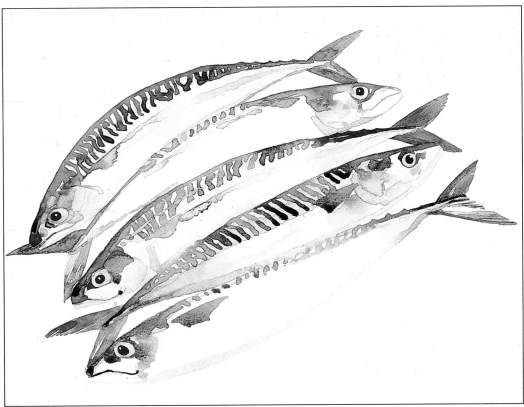

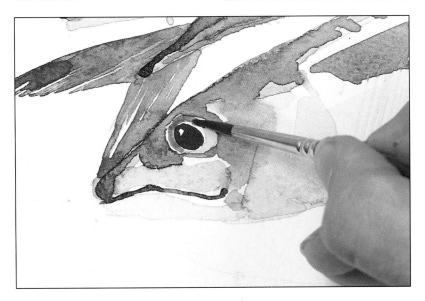

19 If you need to make the fishes' irises a little darker, just add a hint of brown madder alizarin with the No.2 brush as the artist does here.

Darken the heads with a mixture of Prussian blue and Payne's gray and use the sponge to lift out areas of reflected light. But don't just copy the artist's picture – your subject is unlikely to be lit in exactly the same way. Look very carefully for the highlights in your own set-up.

20 Once the fish are completed, move on to the plate. Paint in the rim with Prussian blue and your No.4 brush. The strong oval is important to the composition of this picture, so try to produce an even curve with a smooth edge. A tense arm is more likely to produce a shaky curve, so relax.

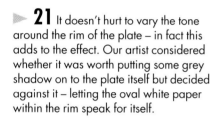

21 It doesn't hurt to vary the tone around the rim of the plate – in fact this adds to the effect. Our artist considered whether it was worth putting some grey shadow on to the plate itself but decided against it – letting the oval white paper within the rim speak for itself.

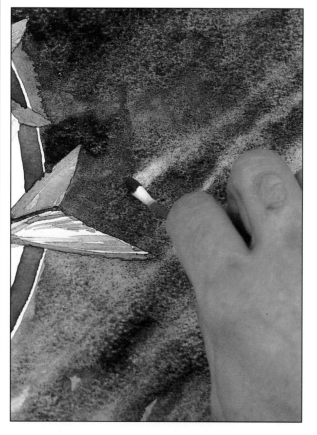

22 For the floor, make a mix of Prussian blue and Payne's gray and add just a touch of burnt sienna. Wash it in with the No.4 brush – or a larger one if you wish – and then, before the paint has time to dry, lift out some stripes by stroking the paint lightly with clean cotton buds. (These enable a high degree of control, but the idea here is to use them fairly loosely just to give the impression of some reflected light.) Then let the paint dry.

▶ **23** The abstract surface of the floor now provides a perfect contrast to the sharply defined patterns of the mackerel and plate. This principle – of balancing closely observed detail with much looser handling – is one that often works well in both painting and drawing.

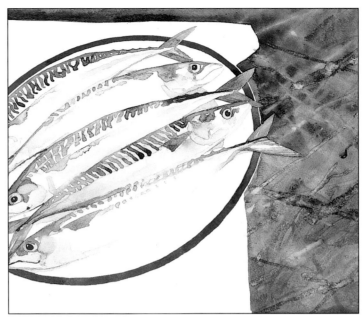

◀ **24** Paint the shadows on the tablecloth before putting on the pattern – it's much easier. Make a very watery mix of Payne's gray and drop in some ivory black. Paint the shadow on the left side of the plate with the No.10 brush. (The shadow helps to lift the plate away from the table top.) Then use the same wash and brush to put in the creases on the cloth.

▶ **25** Now paint the tablecloth's vertical stripes with some dilute ivory black and the same brush. Leave a slight gap between the stripes and the edge of the plate.

(You might say that the floor and stripes are both black – but notice that there is, in fact, a marked difference between their colours.)

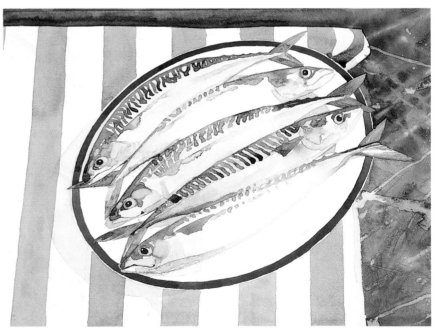

◀ **26** Now turn the board through 90° and paint the horizontal stripes with the same brush and colour. (Turning the board around makes it easier to paint the stripes because you can work with more control – pulling the brush down towards you – rather than pulling it horizontally across the paper.)

27 Where the stripes cross, they form a dense black square. Achieve this by giving these squares another wash of the same colour using your No.4 brush. If they aren't quite dark enough, go over them again.

28 Look closely at a mackerel and you'll see that the fins have thin supporting rays running through them, and that the belly has fine diagonal parallel lines running across it. Rather than painting these, draw them in with an HB pencil. (Never be afraid to use pencil – as here, it can bring an entirely new quality to your work.)

29 The lifting out technique has been used sparingly to give the highlights on the heads, gill covers and fins and, in a more abstract way, on the floor. But notice that the painting does not rely on this technique for its overall effect, but rather on its strong design, subtle blending of colours and clean, crisp shapes.

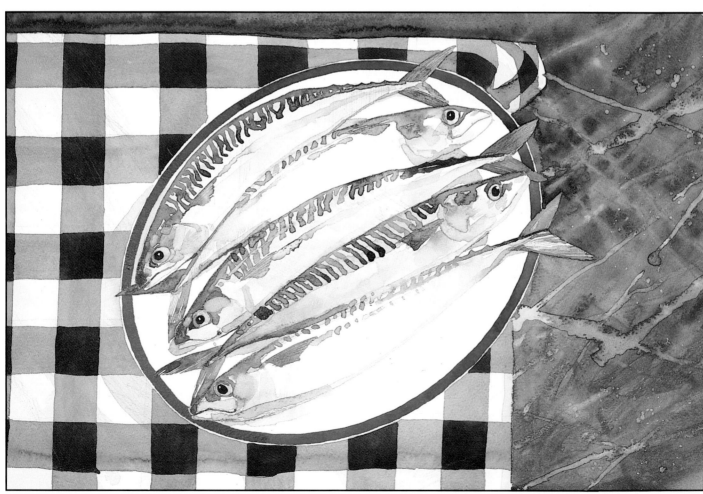

Drybrush textures: old mill

Brush effects

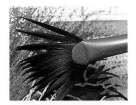

▲ **Use a dry fan for reeds and grasses.**

▲ **A dry flat creates excellent ripples.**

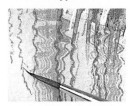

▲ **Add reflection details with a No.2 round brush.**

Used with confidence, drybrush techniques lift an ordinary watercolour into a fascinating and richly textured painting.

Most watercolour techniques depend on the skill with which you handle fluid paint. Drybrush is different – you use a brush which is starved of water and has just the minimum of paint required to leave a mark. This allows you to create a range of feathery broken textures. The marks can be used descriptively to add precise details such as feathers, grasses, fur and hair. Or you can use them boldly and broadly to build a web of delicate colour – to add scumbled depth in clouds for example, or texture to a landscape.

For successful drybrush work, the trick is to drag a little watercolour lightly across the surface of your paper with a dry brush. The paint is laid down on the peaks of the paper's texture – leaving the 'valleys' untouched. Different types of paper surface give different textures, and the effect can be exaggerated by varying the pressure you apply to the brush.

Drybrush can be applied directly on to the paper so the white of the support shows through, or it can be laid over washes so that it modifies the underlying colour. You can emphasize the graphic qualities of the technique by using it alongside areas which have been retained with masking fluid, so you have a crisp edge.

Catching the brush at just the right dryness is difficult to begin with, so you need to practise – you'll find it gets easier. Dip your dry brush in a wash, then gently squeeze out the excess water using your fingers. Flatten the hairs into a fine fan shape and try dragging this along a spare piece of paper to check the type of texture it gives. It's not a quick movement; a careful, calm stroke produces an even texture. (It can help to wipe the brush on a clean cloth to remove water.)

In the demonstration below, our artist used a fan brush for some quite striking strokes to suggest reeds and grasses. The old watermill and surrounding pond gave an ideal opportunity for him to show the drybrush technique. The buildings are perfect for introducing texture, and the watery washes around the sky and mill pond give great contrast. The scratchy quality of the foreground reeds is ideal for masking out using either a ruling pen or a dip pen.

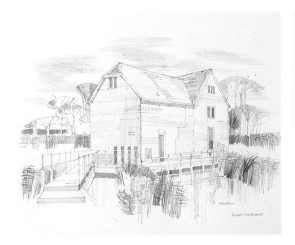

▲ **The set-up** Our artist takes his sketchbook everywhere; each page has fascinating drawings, some with colour notes and light directions. He decided on a sketch of a watermill, set in a rural landscape. Cloudy skies, ponds, trees, reeds and the building itself all lend themselves to interesting textural effects.

▲ **1** Sketch your outline, using the clutch pencil for controlled fine lines. Take time to get this right – it is the 'skeleton' holding your picture together.

Apply masking fluid to the outlines with a ruling pen adjusted to a medium line – dip it in the fluid or load it from a brush. Use a dip pen for details, putting in the reeds in quick strokes and bending them at the ends. Then pen in the railings – and their reflections.

Tip

Keeping a steady hand

When you are painting horizontal bands of colour it can help to place your hand against a ruler to steady your strokes. An acrylic ruler is quite flexible, so it's easy to handle.

YOU WILL NEED

- [] *11 x 15in stretched NOT/cold pressed watercolour paper*
- [] *Drawing board and gummed tape or drawing pins*
- [] *Masking fluid*
- [] *A natural sponge*
- [] *Three round sable brushes: Nos.2, 6 and 14; two flat sable brushes: ¼in and ³⁄₁₆in, and one No.2 synthetic fan*
- [] *Eleven watercolours: Payne's gray, light red, sap green, burnt umber, cadmium lemon, Winsor blue, alizarin crimson, cadmium orange, cadmium red, ivory black, Davy's grey*
- [] *Clutch pencil and 0.5 ruling pen*
- [] *Dip pen with medium round-hand nib*
- [] *24in acrylic ruler*
- [] *Small dropper*
- [] *Putty rubber/rubber cement pick up*
- [] *Linen cloth*

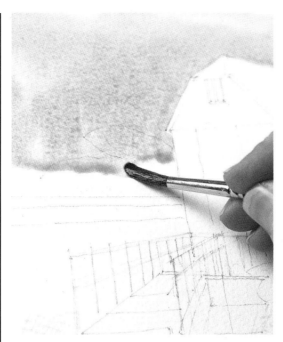
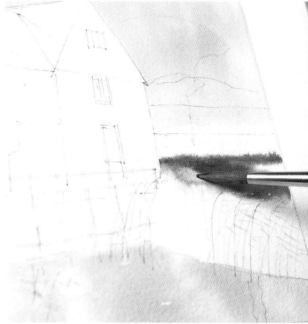

▲**2** Wash water over the sky with your No.14 round brush. Before the water dries, sweep over the sky with a thin wash of Payne's gray and Winsor blue. The texture of the paper shows through and the clear, wet wash underneath aids the movement of the colour, and softens it as well.

▲**3** Paint in the mill pond in the same way: water underneath, colour wash on top. For the lower pond, mix up a darker blend of the same colours and allow the wet-on-wet strokes to bleed out a little. Our artist preferred to work flat since it stopped the washes from moving too much.

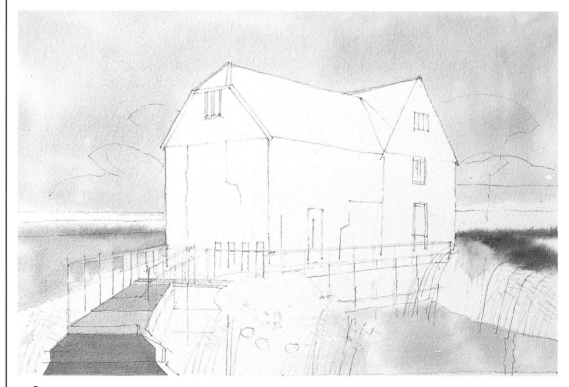

▲**4** The bridge is next – it calls for tighter, more controlled brushwork. Use a cool grey to paint dry washes across the planking, getting darker towards the foreground. You'll see quite a difference in these matt areas, compared with the wet-on-wet areas. Add a slightly heavier blue wash to the horizon, letting it blur on top of a water wash.

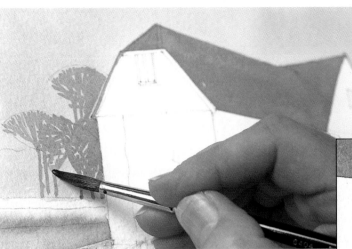

5 Mix light red with a touch of burnt umber to make a reasonably strong mid-tone and apply to the roof with your No.6 brush. Control the paint in horizontal bands.

Now paint in the trees on either side of the house with sap green mixed with Payne's gray for a light grey-green colour. Draw with the brush so that you can get the lace-like texture of the trees' outlines.

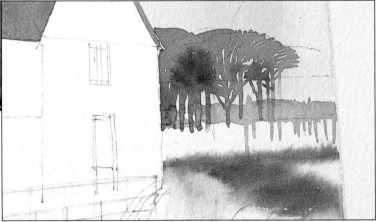

6 Still on the trees, darken the mix with a little Winsor blue. Using a wetter application, blur in the more intense middle shadows and pull some of the paint down from the grass to create reflections.

7 Dilute the roof wash a little, then wash it over the mill walls, again in horizontal strokes. Intensify the tone a little by overlaying the main body of the house with the wash; subtle changes in depth of tone are achieved in this way. A dropper is useful here for adding controlled amounts of water.

Paint a green wash over the foreground reed area, wetting the area beforehand as you did earlier for the sky and water. Allow this wet-on-wet green to blur out at the edges and begin to pull out small flicks of colour to indicate the reeds. Curve these, following the bend in the reeds you introduced with the masking fluid at the beginning. This helps to create movement.

8 At this stage it's a good idea to stop and check the overall balance of the preliminary washes. Extend the horizon trees along a bit, painting the soft fan shapes as they tail out. While you have the pale wash on your brush, pull out more reflections of the trees.

Mix Payne's gray and alizarin crimson into a light wash and paint over the gabled end. Tint the windows with the same wash to add this tone to other parts of the building. Carefully leave white edges to the doors and windows. This controlled use of tone and texture needs some neat brushwork.

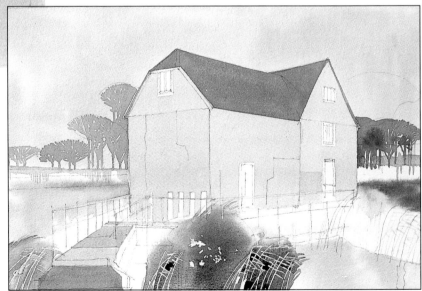

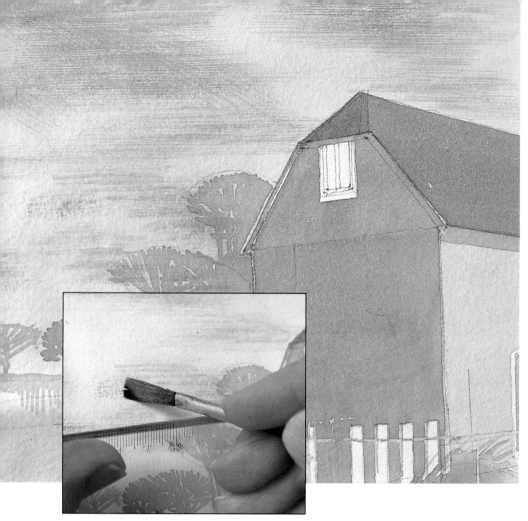

9 Now move on to some drybrush work on the sky, using the wash you originally painted over the sky.

Load your ¼in flat brush with wash then squeeze out the surplus and, after experimenting on a spare sheet to get the right dryness and colour, gently pull the brush across the sky. Rest your brush handle on the ruler to guide your lines (inset). Gradually – and patiently – build up patches of fine drybrush lines. Slow, gentle strokes are best.

Turn the painting upside down and go over the area again to balance the slight shading you get from repeatedly starting from one side. To break up the texture and tones in the sky, try some cross-hatching with diagonal drybrush strokes.

Unlike the colour tone changes you get with wet-on-wet as it dries, what you are doing with drybrush work changes very little when dry. You can begin to see what shades your final painting will have.

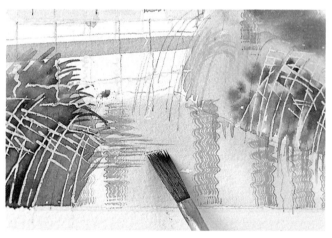

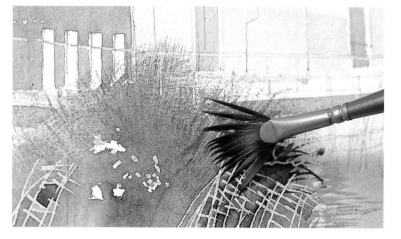

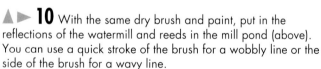

10 With the same dry brush and paint, put in the reflections of the watermill and reeds in the mill pond (above). You can use a quick stroke of the brush for a wobbly line or the side of the brush for a wavy line.

Mix up some sap green and Payne's gray with a dash of blue and paint it on to the paper palette. Wipe your fan brush into the drying paint. Now tease the hairs apart gently to give a jagged look to the brush. Stroke the brush upwards and outwards over the reeds, softening the edges of the clumps and emphasizing their stiff, grassy quality (top right).

Things get a bit more exciting as you intensify the insides of the reed clumps. Paint some of the darker green wash on to a wad of linen and print this directly on to the painting, dabbing several times to build up texture (bottom right). Use a natural sponge to soften the edges in places. (You can use more heavily textured fabrics for bolder effects.)

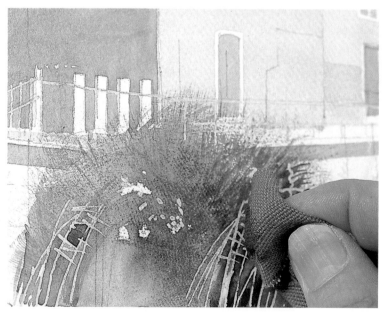

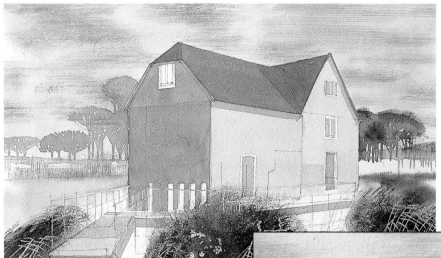

◄ **11** Stand back and assess the tonal balances. You can see how the foreground has been brought together as the elements become more richly textured. The trees on the horizon need strengthening to balance the reeds, so print some stronger sap green over them with the sponge. You can use the tip of a flat brush to print broken lines, which add fine-lined texture.

Our artist then moved on to add details to the watermill.

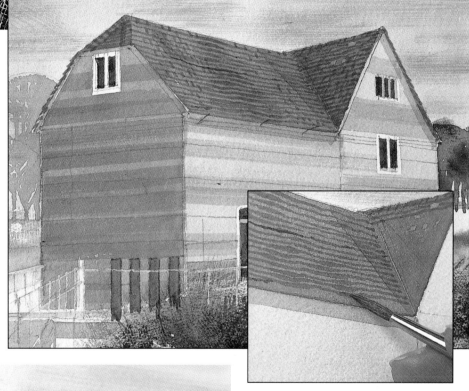

► **12** Using your No.6 sable brush, lightly draw across the roof with a mix of cadmium orange, cadmium red and a touch of Winsor blue (inset). The lines needn't be too straight as the old roof sags a little in the middle. Thin out the mix to paint the adjoining area of roof, overlaying washes for the shadow where the two parts of the roof meet. The door and window spaces need darkening to bring them down in tone.

Use the same wash for the vertical sides of the roof tiles, painting randomly and not forgetting the tiles that stand out against the skyline. The brick textures can be painted with the same wash diluted a bit more and painted on in horizontal lines. Slight variations in colour (adding browns and reds) and several layers of wash give the varied patches of colour on the wall.

◄ **13** Brush in the tiny blocks of bricks, using the narrow ³⁄₁₆in flat brush – this slightly longer brush holds more paint than the other flats. Paint in the brick rows randomly, varying the texture and using the ruler to steady your hand. When they are completely dry, gently rub off the masking fluid using your clean fingers and the soft putty rubber/rubber cement pick up. Pass your hand over the whole painting and feel for any odd bits left over.

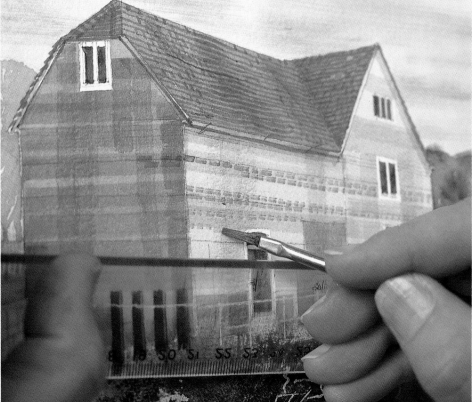

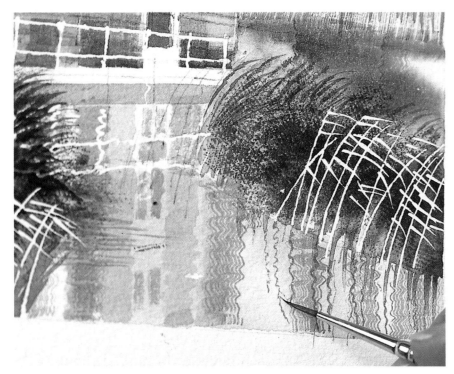

14 Now add the reflections of the mill in the pond using dilute washes of burnt umber next to washes of Davy's grey. Paint the reflections of the windows with very dilute Payne's gray. Using your No.2 round brush, individually pick out some of the reed reflections, giving them a very slight wobble.

15 Take a long look at the painting before deciding if it is finished. Look for tonal balances of colour and make sure nothing jumps out at you. Add a shadow under the bridge with a dark mix of light red and black and use the same mix to highlight a few bricks. The reflections of the trees may need thickening – use watery washes of pale grey.

After looking at the painting for a while, our artist decided that the foreground reeds were too strong, the white contrast too great. With an inspirational wash of cadmium lemon and sap green, he painted them in. It was a perfect touch to complete the foreground.

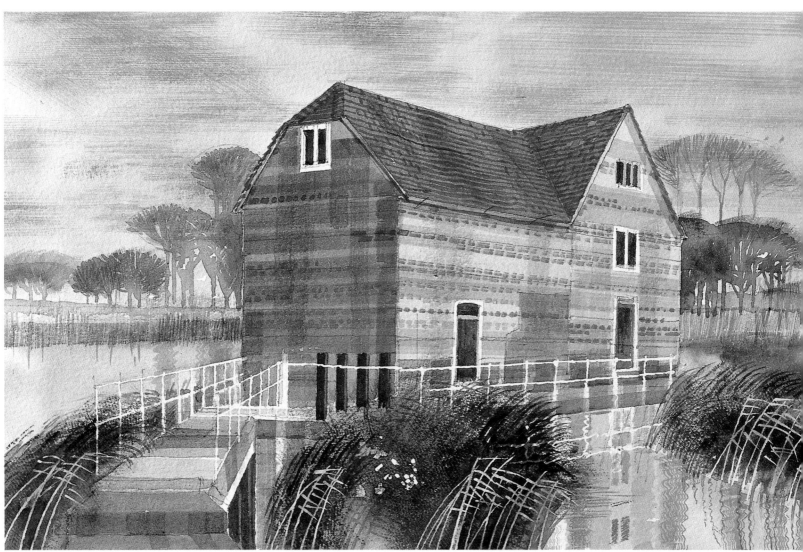

Drybrushing – rusty ship

Exploit the bold, textured finish of the drybrush technique to capture the weather-beaten character of a ship in dock.

Drybrushing is one of the simplest and most effective ways of adding textural character to a watercolour painting. Achieved by dragging a brush which is only slightly wet with paint across the paper, it can be used to create a wide variety of life-like touches, ranging from the intricate details of a feather to the flaky roughness of rusting metal, as demonstrated in this project.

For the stronger effect featured here, you need to use Rough watercolour paper, since the uneven surface helps to exaggerate the rasping motion of the brush. This creates a more striking 'scratchy' finish, ideal for suggesting the mottled look of rusting metal.

Drybrushing used in this way has a powerful effect and needs to be balanced with softer washes. Here, the watery wash of the sea and sky, combined with the shaded detail on the ship's deck, perfectly offset the interesting texture of the rusty hull.

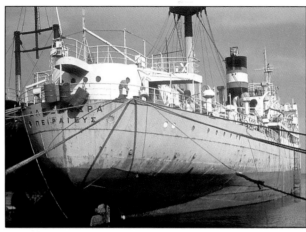

△ **The set-up** Our artist thought the rough, textured effect of drybrushing was ideal for depicting the rusty hull of this old ship. The rusty area dominates the picture, giving ample opportunity to experiment with this interesting technique.

▶ **1** Lightly draw the main elements of the scene on the stretched watercolour paper with the 2B pencil. Since you are using a soft pencil, the marks should be faint, and won't show through excessively in the finished painting. You can even allow yourself the luxury of gently hatching in the darkest areas as a guide to tonal values.

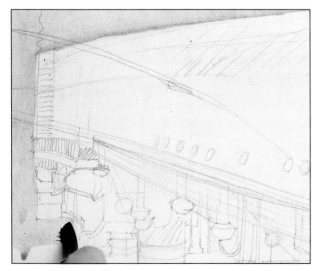

◀ **2** Start by applying a wash to the sky and sea area. To capture the natural effect of the sky receding towards the horizon, you want the colour to be more intense at the top. So turn your paper upside down and then lay your first wash.

Tilt the paper and, using the wash brush, apply a pale wash of Prussian blue over the sea and then the sky, allowing the colour to pool at the bottom, in the sky area. Leave the wash to dry, then paint the same pale colour in the gaps between the ship's railings with the No.6 brush.

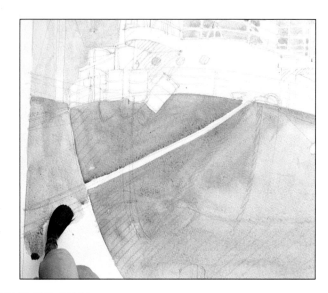

3 Turn the paper the right way up. Mix a wash of Prussian blue, ultramarine and cadmium red to make a purple-grey and apply it to the hull of the ship with the wash brush. Don't worry about the wash being perfectly flat at this stage, since any unevenness only adds to the effect later on.

Paint the side of the harbour wall on the left with a wash of burnt sienna to give a base colour.

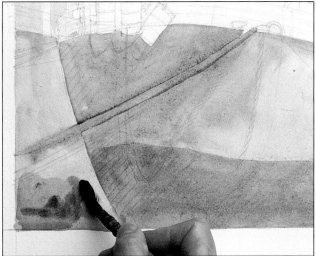

4 While the harbour wall is drying, wash burnt sienna over the lower section of the ship's hull, then down into the water to represent the shadow of the boat. Now use burnt sienna to paint the large rope at the front of the boat.

Return to the dried harbour wall and apply a second wash of burnt sienna to the lower section. Overlaying in this way creates a vast range of tones, giving greater depth.

5 Using your No.6 brush, lay a wash of Prussian blue over the bands on the funnel. Before the paint has a chance to dry, repaint the left side with more Prussian blue. This wet-in-wet process creates a soft blending which reproduces the curve of the funnel perfectly.

Next, use a light wash of yellow ochre and burnt sienna to put in the mast.

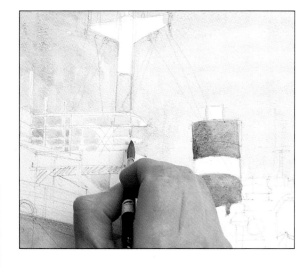

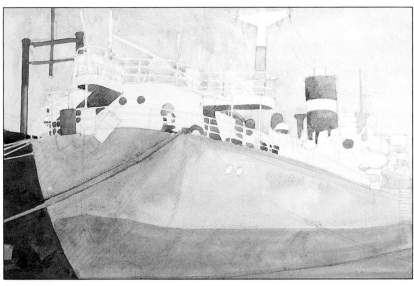

6 Continue to fill in more of the features on the deck with the No.6 brush. Use the light wash of yellow ochre and burnt sienna to paint the mast at the rear of the ship, then increase the amount of burnt sienna in the mix to paint the large porthole towards the front. Make up a wash of cadmium red to paint the large barrel. Then use a wash of ultramarine mixed with burnt sienna for the shadows on the top of the boat and the crane on the dock.

Now mix a little Prussian blue with burnt sienna and paint over most of the harbour wall – leave small areas of undercolour showing through to add interest.

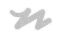

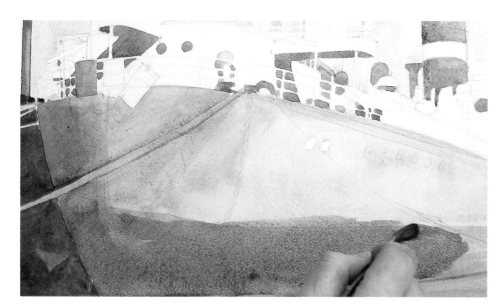

◀ **7** Using the wash brush again, sweep a film of water over the whole hull of the boat. Then immediately switch to the No.6 brush and, with an equal mix of ultramarine and burnt sienna, paint over the darker sections of the hull. The new wash blends with the film of water to give a soft, feathery edge.

▶ **8** Make a denser, less watery mix of ultramarine and burnt sienna to produce a warm black to paint further dark tones on the boat, such as the portholes and the shadows under the barrels. Use the mix to darken the deepest shadows – including the top of the crane – and to add the bands around the main funnel.

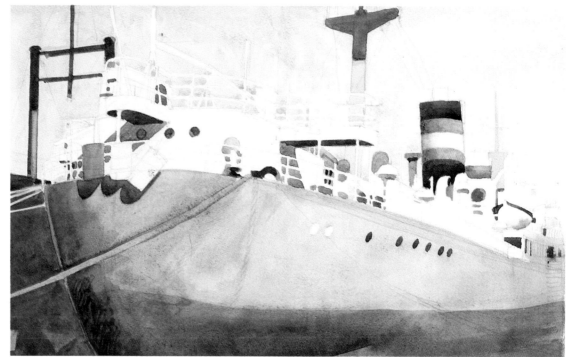

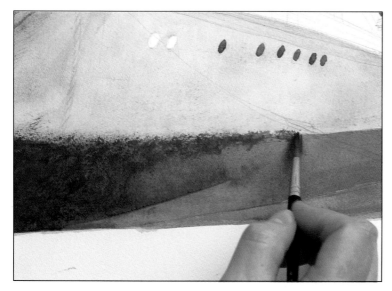

◀ **9** Allow the painting to dry fully, then start on the drybrush work. Using very little water, mix some ultramarine with burnt umber, and some ultramarine with burnt sienna.

Load the dry No.4 brush with ultramarine/burnt umber. Now drag it across the rusty area of the hull with small, circular strokes. As you work, you will find that the hairs of the brush fan out so the paint goes on in an almost scratchy manner, allowing the underlying colour to show through. This scratchy quality becomes more pronounced as the paint on the brush runs out.

Gradually work over the rusty area, switching between the two mixes of prepared paint to build up an attractive two-tone effect.

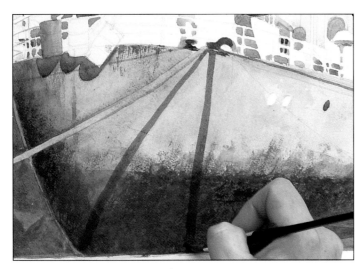

10 Dilute the ultramarine and burnt sienna mix to a thin wash, then dab it over the drybrushed area with the No.6 brush. This tones down the drybrush work so that it doesn't look too overpowering against the wash painting.

Dilute the ultramarine and burnt umber mix, keeping a fairly dense tone, and use it to paint the shadows under the ropes and the lines between the panels on the boat's hull.

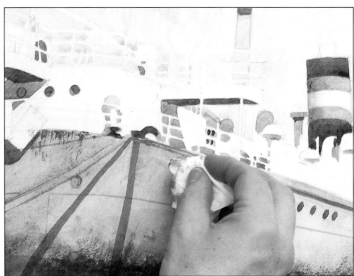

11 Our artist enhanced the weather-worn look of the ship even further by simply dabbing a watery wash of Prussian blue and burnt sienna over small sections of the hull and then sponging the wet paint lightly with a wad of tissue.

12 Finish the painting by picking out the final details on the deck with the two ultramarine mixes used in step 10. Alter the balance of colour in the two mixes to vary the tones. Then add the remaining ropes and rigging. In the final picture, see how the drybrushing has perfectly captured the texture of the rust.

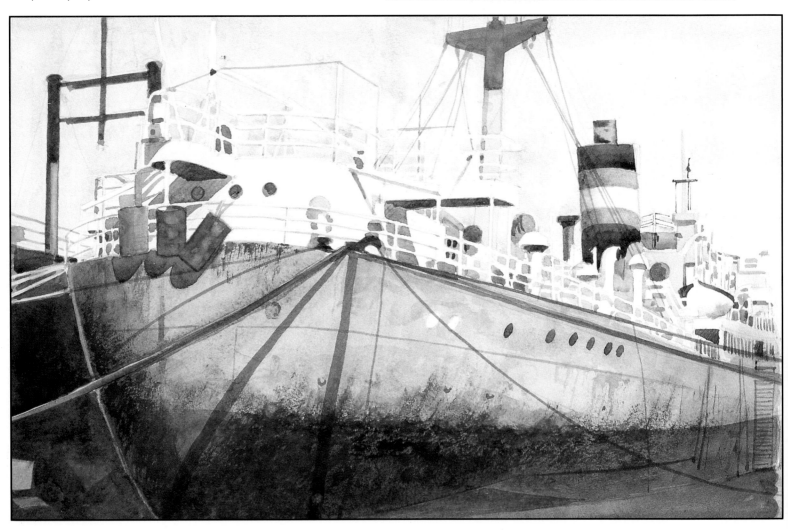

Capturing shadows

Shadows aren't simply flat, grey masses, loosely repeating the form of an object. They are often quite colourful and can tell us a lot about light, its strength and direction.

Shadows are often regarded by the beginner as an afterthought, quickly brushed into a composition at the last minute with a wash of dull grey. But in fact they are an important element of any painting. They show the direction of the light and its intensity, indicate mood, help to convey a convincing three-dimensional image, and can even bring out the colours of the main objects.

It is more accurate – and more exciting – to paint an object's shadow in its complementary colour rather than in a dull grey. But you can take this further. Shadows often contain more than one colour – they reflect colours from round about. Have a look around you to see how this happens; you'll notice it more if the shadows are cast on to a light surface.

In the painting overleaf, our artist has taken great care to render shadows, and the result is a very convincing image. A large part of the painting is bare paving, yet the colourful shadows of the palms turn this area into a highly decorative part of the picture. And look at the detail that has gone into the accurate rendering of the shadows on the seated man's shirt. The artist used many colours to achieve this effect (see steps 8 and 9).

Notice that the cool colours of the shadows help to convey the impression of a warm, sunny day. (This is contrary to what you might expect, but it's their contrast with the warm areas which makes those areas look warmer.)

If you are painting or sketching *in situ*, watch out for the change in direction and length of shadows as the sun moves round. They must be consistent within the painting for a convincing image. A good way of ensuring this is to put the shadows in at the beginning and stick with those positions; or, if your medium allows it, change the shadows on your painting as they move – but make sure you alter all of them. And remember, the shadows are sharper and darker on a bright day, softer and more diffuse on an overcast day.

This artist likes to attach his watercolour paper to mount board with spray mount, rather than stretching it. It's quicker than waiting for stretched paper to dry. He prepared his paper for this painting in the same way.

▼Shadows can give away much about a scene. Here, the ladies must be under some trees because the shadows are dappled; the sun is on the left because the shadows stretch to the right. Also, the strength of the shadows shows it is a very sunny day. And notice how the two ladies on the left seem to dissolve into the paving, where the intermingling shadows confuse the shapes.
'Gitanas in Festival Attire at the Salamanca Bull Market' by William Russell Flint, watercolour on paper

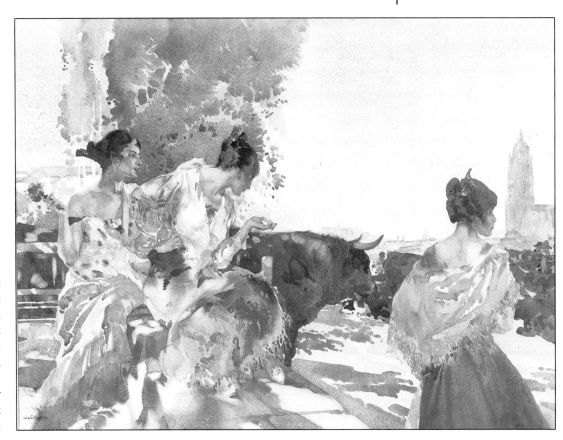

Sea front in Turkey

The set-up On holiday on the Turkish coast, our artist made several sketches of this scene, with detailed notes describing the colours and lighting – once back home, he knew it would be hard to remember them exactly.

▶ **1** Use the pencil to sketch the composition with as much detail as you can. Apply masking fluid over the lamp posts and the boats across the bay. Then apply a dilute wash of raw sienna over the whole picture with the ⅞in flat, holding the board at a 30° angle so the paint pools at the bottom of each stroke. Don't paint over the areas in bright sunlight.

◀ **2** Wash over the hills, trees and cloud with watery aureolin. Now go over the tree trunks with the aureolin wash tinged with rose madder alizarin and cerulean blue, allowing the paint to pool in the concrete palm beds.

Still with dilute paint, go over the hills and cloud with burnt sienna, wet-in-wet, with the No.12 brush (see below). Sweep across the sky and down to the sea with a mix of cerulean, Winsor blue and a touch of Indian red. Let it merge with the hill, but dilute it to go over the trees, leaving the undercolour to show through for highlights.

▶ **3** Add plenty of cerulean and Winsor blue to the mix to enrich the sea, and use the same mix and the tip of the brush to block in the boards leaning against the boats advertising sailing trips. While the paper is still wet, drop in some purple (a mix of cobalt blue and rose madder alizarin) on to the hills and deepen the sea with more of the sky wash. Leave to dry.

If there are any hard edges between the washes on the hills, go over them with a damp brush or a very dilute mix of burnt sienna to soften them (see right).

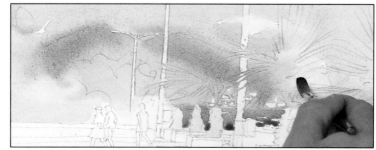

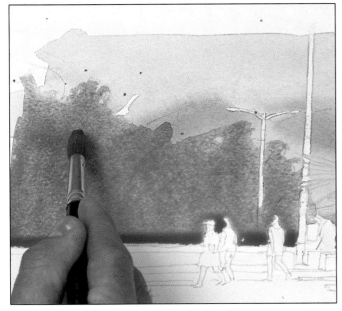

◀ **4** Turn to the clump of trees on the far left. Wash clean water over them with the No.12 brush, flicking the brush at the top to create leafy shapes. Go over it with a mix of olive green, raw sienna, aureolin and rose madder alizarin, working from the centre outwards so the paint spreads over the wet paper. As the paint dries, go over it again and again, letting the colour pool near the bottom. Finally, drop in dots of strong burnt sienna and cobalt blue to suggest the forms of different trees.

▼ **5** Because there's so much of the bare promenade in the picture, make it interesting. Sweep in bands of watery raw sienna and cerulean blue, working forward, but leaving the white areas untouched. Put in more blue in the background to make it recede, then make bolder brushmarks and use stronger colours as you come forward, sometimes dropping in more of either colour for shadows or sunlight. Add a little rose madder alizarin and cerulean blue to the mix for the area between the planters and the boats.

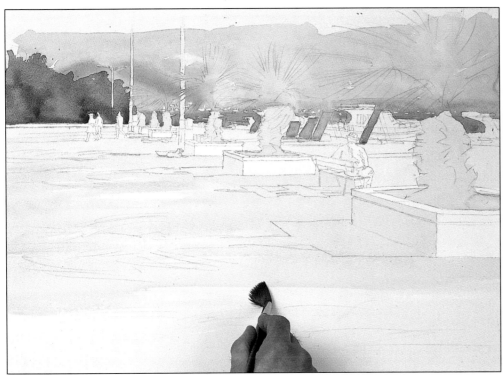

▼ **6** Change to your No.4 brush to paint the wood on the cruise boats with mixes of raw sienna, Indian red and rose madder alizarin. Start on the boats in the distance, then move to the larger boats, adding cobalt blue for the shadows and more raw sienna in the warmer areas. Leave white areas to show the design of the boats.

Apply some rose madder alizarin and cadmium red deep to the deck of the large motor boat, then dip into the different washes on your palette for the seated figure on the deck.

◀ **7** Now work on the figures walking in the distance. Start with a mix of cadmium yellow and cadmium red deep for their suntanned skin. (It looks dark, but it will dry lighter.) Use cerulean blue for the shadows on their shirts, and cadmium red mixed with rose madder alizarin for the lady's dress (neat cadmium red always looks flat). For the man's shorts, apply rose madder alizarin and a touch of cobalt, letting the colours merge on the paper.

▶ **8** It takes skill to paint the seated figure this well. There's a mix of Winsor violet and Winsor blue on the left arm, raw sienna on top, raw sienna and cerulean on his back, with drops of rose madder for deep shadows, and a pale wash of Winsor violet and Winsor blue on the shadows of his trousers.

Use a mix of rose madder alizarin, cadmium red and cadmium yellow on the man's face, then mix burnt umber, cobalt and rose madder for his hair, applying it while the face is still wet so the colours merge – otherwise you'll get a hard edge which would make it look like a badly fitting wig!

For the hat, drop in a dot of cerulean on the left, then add raw sienna and rose madder next to it, so they merge. Leave a white line round the brim. See how the blue stands out against the red boat behind the figure.

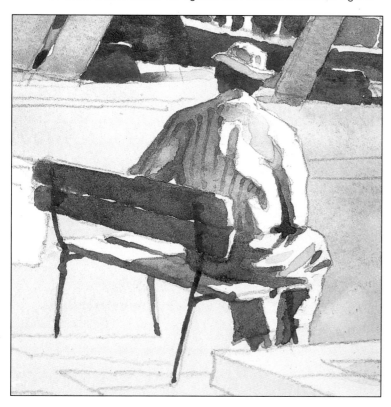

◀ **9** Shadows can be full of colours reflected from other surfaces, so build up the shadows on the man, adding cobalt blue, rose madder alizarin and raw sienna to his trousers. Put in the stripes on his shirt with a mix of rose madder alizarin and Winsor blue, making them follow the curve of his back.

Now make a deep, burning colour for the bench with Winsor violet, raw sienna, burnt sienna and cobalt blue. Place the colours next to each other, letting them merge naturally, instead of dragging one colour into the next. Put a touch of these colours on the man's back and underarm to show the bench's reflection. Leave to dry.

▶ **10** When the paper is *completely* dry, rub off the masking fluid with clean hands. Use the tip of the No.4 round brush to paint the left sides of the lamp posts with raw sienna, darkening these shadows with rose madder alizarin. Change to the No.8 brush, and softly put in the shadows around the boats in the distance with a very dilute mix of raw sienna and cobalt. Be careful not to leave any hard edges. If you do, soften them as in step 3.

◀ **11** In contrast to the carefully painted figure, the palm trees are put in with wild, free splashes of colour, casting lacy shadows on the promenade. Work from the centre outwards with clean water, flicking the No.12 brush to make leafy shapes at the ends. Paint over them with a mix of olive green, raw sienna, rose madder alizarin and a touch of aureolin. Let the paint spread over the wet paper.

◀12 Working fast, put in the palm branches with various strengths of olive green, rose madder and cobalt. Add burnt umber for the darkest shadows, especially in the palm nearest to you which needs strong colour to bring it forward. While the paper is wet, add other colours.

Then work on the trunks, putting in raw sienna and rose madder alizarin, and adding olive green. Drop in some strong cobalt and then burnt umber for the shadows.

▼13 Start on the distant shadows with the No.4 and a rose madder alizarin/cobalt mix. The front shadows are stronger, so add cerulean and Winsor blue to the mix, feathering in the shadows loosely. Change to a larger brush as you come forward to make your strokes stronger.

Put rusty washes of raw sienna along the top left side of the palm beds, with a line of burnt sienna through them. Let the shadows on the ground run up on to the shadier sides of the beds. Drop some cerulean blue on to the shadows. Where it mixes with the raw sienna it turns a delicious shade of green. Work on the other shadows.

▶14 Our artist wanted the shadows of the palm beds to reflect dozens of colours. So while the paper was still wet, he added touches of cerulean and Winsor blue, rose madder alizarin and more raw sienna.

Paint the shadow of the man and bench with your shadow mixes. Then put a pool of Winsor violet at the foot of the shadier sides of the planters and on the ground for the deepest shadows.

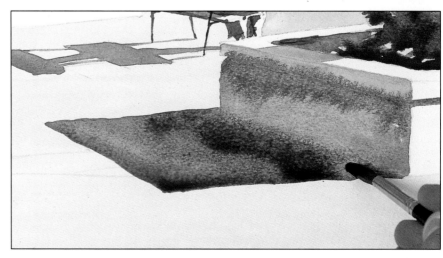

► **15** For the shadow of the nearest palm, wet the paper first so the colours can expand naturally. Use your strongest colours here – cobalt, cerulean blue and rose madder alizarin – to bring the area forward.

Wet the bottom of the planters, then lay in a wash of cadmium yellow and raw sienna, letting it spread naturally. Put a strong wash on top, then add a very fine, uneven line of rose madder alizarin and burnt sienna to sharpen the edge (see the picture below).

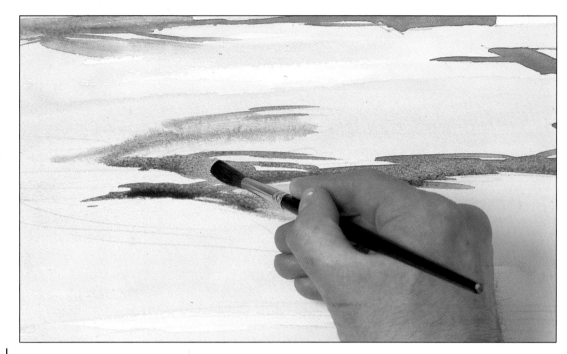

▼ **16** As a finishing touch, our artist painted a dog resting in the shadow with cobalt blue and rose madder alizarin, adding raw sienna where its fur is lit up by the sun. He let the colours run together for a soft, natural look.

In the finished painting you can see how expertly our artist has blended complementary blues, violets, yellows and oranges. He invigorates the shadows by using many different colours which reflect the colours all around.

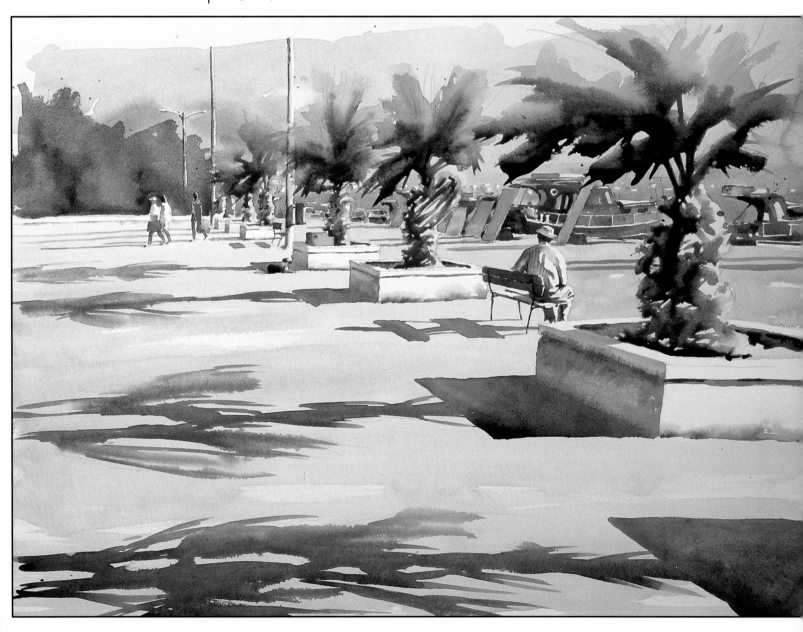

Details and generalizations

Don't be daunted by very complex subjects, such as this mass of beautiful flowers – there are many ways of dealing with them. Here is one artist's approach.

When faced with complicated subjects, some artists relish the opportunity to render every last stick and stone, while others go for a general approach with great sweeps of colour. However, most of us opt for something in the middle, showing a certain amount of detail, but not all.

There are two main ways of painting selective details in a picture. You can wash in the basic areas of colour and then tighten up key areas – working from the general to the specific – or you can put in the details first and then add the less focused areas of the painting – working from the specific to the general. For the demonstration that follows, our artist chose the latter course. She pinpointed the key flowers in the composition, then filled in the areas around them.

▼ **The set-up** A huge bouquet of irises makes a beautiful subject which our artist depicted as an explosion of colour. She included a wispy thread of ivy to lead the eye downwards, and a couple of patterned ceramic jars to balance the weight of flowers at the top of the composition and add contrasting shapes and textures.

There are plenty of shadows among the flowers, especially in the stems – look for these areas and try to convey their depth and recession. You may find it helpful to examine a single flower in detail.

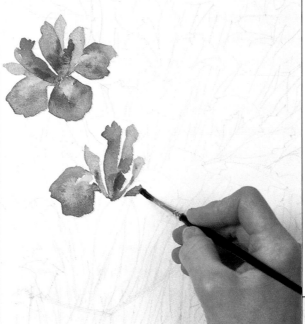

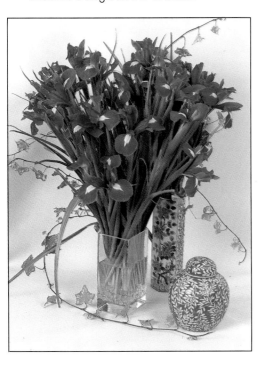

◄ **1** Draw a detailed outline of the set-up with your 2B pencil. Then, starting in the middle of your page with the No.3 brush, paint individual flowers in a mauve/ultramarine mix. Paint the crisp outlines of the petals, then work inwards, filling in.

Strengthen the wash with more of either colour or dilute it with water for different tones. Leave the centres unpainted and, while the surrounding blue is still wet, drop in some cadmium yellow pale, allowing it to bleed into the blue for the yellow petal pattern.

▶ **2** Once you've blocked in a couple of flowers, paint the leaves and stems above the rim of the vase. For these, use olive green, ultramarine and mauve in varying mixes. Put on colour, water it down and spread it, then take some colour off again with a wet brush. This creates a variety of subtle, unobtrusive tones, so the main emphasis remains with the irises.

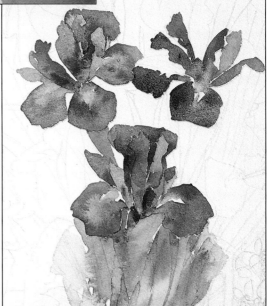

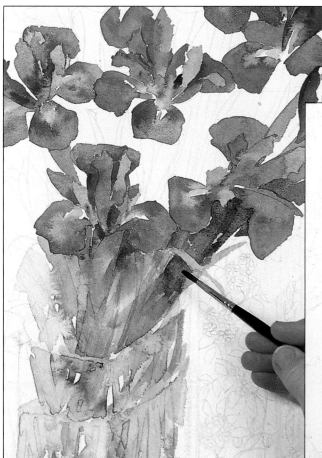

3 While the stems and leaves you just painted are still wet, wash over them with dilute ultramarine. Then paint the stems you can see through the glass vase above the water level with similar colours to those you used in step 2. Paint the stems below the water level – remember that they look distorted. Lift off colour with a wet brush to lighten the colours and create a soft-focus effect.

Mix ultramarine with olive green for the gaps between the glass beads at the bottom of the vase, then wash over them with a soft, pale olive green wash. Keep the leaves less distinct than the flowers.

4 Add some shadows among the stems in the vase to give them more depth, using thin washes of various mixes of mauve, cadmium scarlet and cadmium yellow pale.

Continue painting in the flowers. You might find it easier to follow up individual stems, adding bits of leaves as you go. Paint the petals as before, first making outlines, then filling in with varying purple and blue mixes of dilute ultramarine, cobalt blue, Winsor blue, Winsor violet, mauve and purple madder alizarin, overlaying and overlapping colours to show form. Use cadmium yellow pale for the yellow petal pattern, working wet-in-wet as in step 1.

5 Drop clean water into the centre of some of the petals to dissolve the colour, making it look as if they are catching the light. This makes the petal edges darker and richer by comparison, giving the petals a rich velvety texture and making them more three-dimensional – like curling, curving tongues.

Put in some dark shadows on some leaves and stems with alizarin crimson. Soften these with a wash of Winsor blue on top if they are too strong.

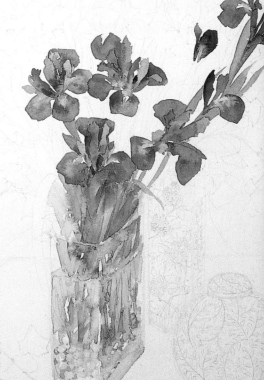

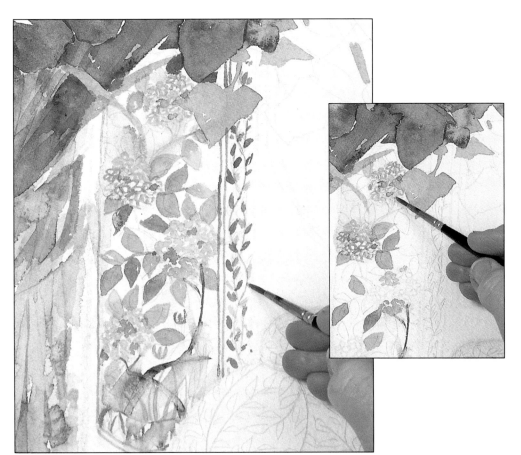

◀ **6** Now work on the Chinese vase. Paint the delicate pattern with an orange wash of cadmium yellow pale and a touch of cadmium scarlet, using your No.2 brush (see inset). Dot in the leaf pattern with mixes of olive green, cadmium yellow pale, ultramarine and Winsor blue. When dry, wash over the pattern with a watery mix of ultramarine and mauve to soften the colours and push the vase back into shadow. Notice that the darkest shadows are at the top and bottom of the vase.

Paint the climbing leaf pattern on the vase with a stronger version of your orange wash and the green you just used. Go over this with the 'shadow' wash.

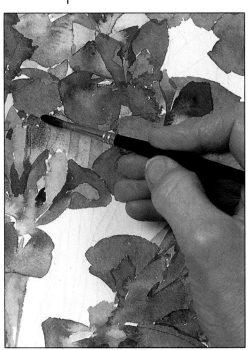

◀ **7** Continue to add more iris flowers with your No.3 and No.4 brushes, using every possible shade of blue and purple, light and dark, in the same way as you did before. Fill in between some of the main flowers to suggest more flowers behind them. Overlap the colours to create form and depth – some blue over purple, some purple over blue. Soften edges with a wash of clean water.

▶ **8** The effect you create on the less important areas should be almost a blur of colour. This suggests perfectly some of the flowers and stems at the back of the vase, parts of which you can see through gaps between the ones at the front. Paint these semi-visible flowers and stems quite generally.

Put a hazy Winsor blue wash over any chinks of white on the petals to tidy up the picture. Use whichever brush feels most comfortable.

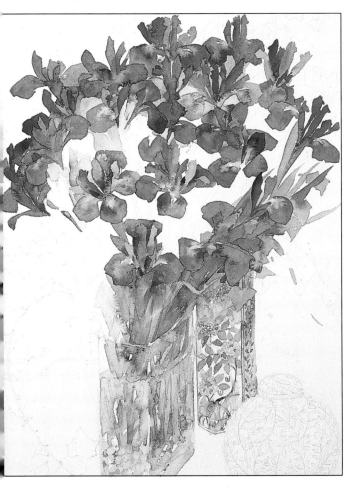

9 Use your No.4 brush to paint in more leaves with varying olive green and mauve mixes. Then wash a watery brush over them so they blend in deep among the flowers.

Look at the arrangement of flowers as a whole and add more flowers or leaves here and there. Paint lots of pointed iris leaves darting out around the edges using a mix of olive green and ultramarine, with some falling in elegant curves around the vase. Aim for an explosion of colours.

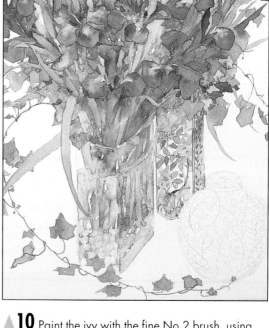

10 Paint the ivy with the fine No.2 brush, using varying, but very pale, mixes of olive green with touches of ultramarine and perhaps a little mauve. Add more olive green for the ivy in shade. Leave some white showing to suggest the variegated pattern. Remember the ivy leaves are all growing in different directions and at odd angles. Paint their little curling stems with rose carthame, olive green and mauve. Add Winsor blue and mauve to pick out a few shadowy leaves.

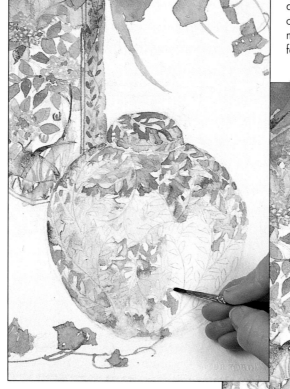

11 Use ultramarine with a touch of olive green and the No.3 brush to paint the negative pattern on the jar, leaving the leaf design white. To shape the jar, wash shadows over it in places with a wet brush, softening and blurring it.

It's important not to make the ginger jar appear too neat and symmetrical. To be able to sit comfortably beside the wild bunch of irises, it needs to look hand-glazed, with an uneven finish and mottled colours in light and shade. So touch into it with a piece of kitchen towel to remove some colour and prevent it looking too clean and new (see Tip opposite).

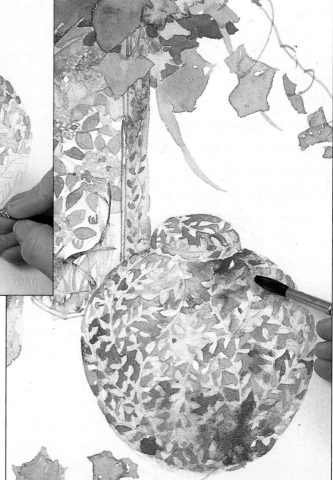

12 Mix a darker blue to paint the pattern on the parts of the jar in shadow – ultramarine with a touch of Winsor violet. Change the consistency of your wash, making it more or less watery, and dab some off with tissue to make it uneven. Now wash some water around the bottom and top right of the jar, then, with your No.6 brush, dab watery mauve on to the wet areas and let it spread for strong shadows.

▼**13** Make a series of very watery washes for the background, using tiny quantities of pigment – one with cadmium scarlet, the others with cadmium yellow pale, then Winsor blue, then ultramarine. Use these to soften the white of the background on the right side, applying them on top of each other, one at a time. With each wash, start beside the ginger jar and flowers and wash it out to the right, very loosely, splashing it around with the No.6 brush.

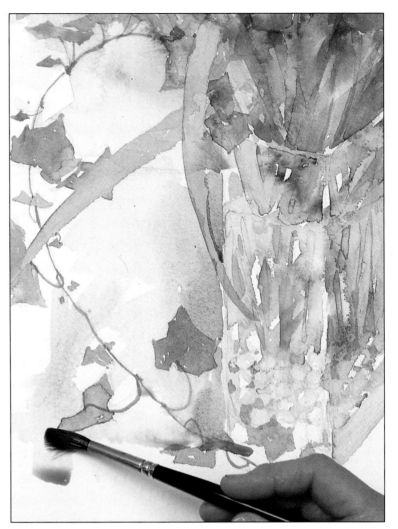

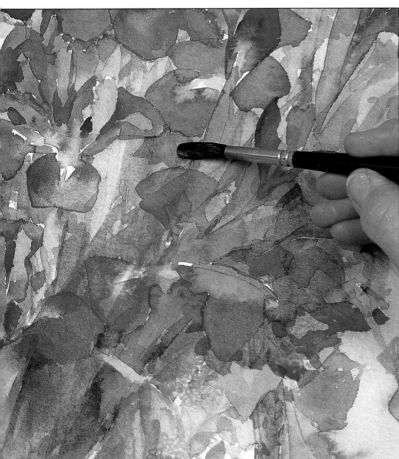

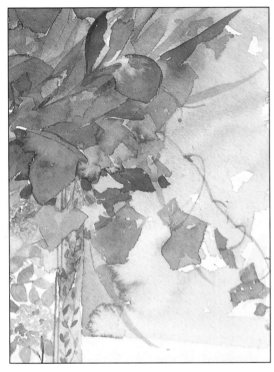

▲**14** For the background on the left side of the vase, make a watery mix of alizarin crimson and cadmium yellow pale, and apply this, starting at the vase, going out to the left and then washing downwards. Go over the ivy leaves, freely splashing the paint around.

◄**15** Build up more soft shadows over the flowers, leaves and vases on the right side by washing over them with thin layers of ultramarine and mauve.
 Go over all the background now, breaking up areas of unpainted white paper with very pale washes of different colours, and letting the watery paint puddle to form interesting water marks. Leave a few chinks of white paper for sparkle.

Tip

Colour correction
If you think a colour looks too strong, wash over it with a wet brush, then dab some off with kitchen

towel or a paper tissue. This is also a good way to show the highlights on the ginger jar.

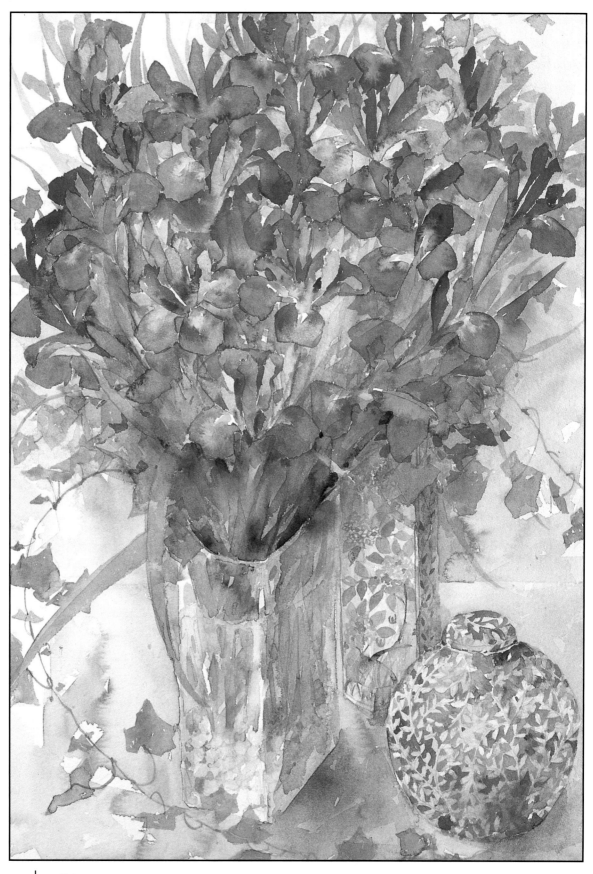

▲**16** To complete the picture mix mauve, alizarin crimson and olive green to make a really good dark purple shadow colour, and layer it over the leaves and stems going into the vase to give more depth and contrast. Then, with a mix of mauve and ultramarine, wash over the blossom pattern on the vase to tone it down and push it back a bit more. Add stronger shadows around the base of each vase.

Finally, put a wash of pale (but not too watery) ultramarine in among the irises as a last boost to strengthen the colours.

Using strong, bright colours

Many watercolour subjects benefit from a positive approach – strong, bright colours can pull the whole painting together.

Often pale wishy-washy colours come to mind when people think of watercolour paintings. All too often beginners' paintings can look insipid and their initial attempts are a disappointment. It's almost as if they are frightened to use strong colours! But brave use of watercolours can produce vibrant and exciting paintings. You can do this by adding plenty of paint to your washes, and also by making proper use of your colours – and by taking some bold decisions as well.

If you can afford it, use artists' quality paints which are more intense than student ranges, with better and more pigment. Liquid and tube watercolours are strong and wet. Pans don't release their colour so easily – you really need to work the brush into the pans to pick up sufficient pigment, especially when they are new and hard. With use they become softer as they absorb water.

You can exaggerate colours for vibrancy and energy in your paintings, or heighten their impact by pushing the paint towards primary and secondary hues. Look at the goldfish painting that follows. The artist has used violet madder for the water, where you might have expected a blue-green. The violet madder (a secondary) is complementary to the orange goldfish and greatly increases the feeling of depth in the water.

Mixing for strength

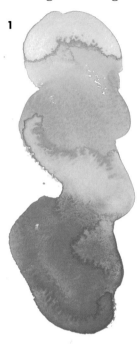

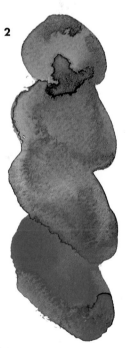

▲ Don't limit your watercolour paints to pale pictures. Use them boldly, with strong mixes, like the yellow/red combination of the goldfish in the painting overleaf (1), and the green/violet mix of the deep water (2). Combination 1 is complementary to combination 2 – this increases the impact.

▲ **The set-up** Our artist worked from two photographs of goldfish swimming around in a pond which had some waterlilies floating on the surface. Notice the way she has combined elements of both in her final composition.

When you make a wash, mix up plenty, adding paint picked up on your brush until it is the required strength. Many artists mix up a large amount to lay in a base wash and use the rest to mix with other washes as a way of 'tying' the picture together.

▶ **1** Begin with the goldfish. With the No.4 brush, paint a strong wash of Indian yellow, using touches of cadmium orange for the small goldfish. Use a pale wash of cobalt blue with an even paler wash of orange for the larger fish, allowing the washes to dry slightly so they don't bleed into each other too much.

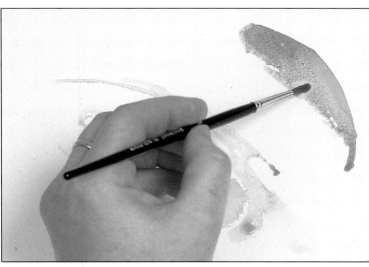

YOU WILL NEED

- [] *17 x 12in 140lb NOT/ cold pressed watercolour paper*
- [] *One Chinese brush and one No.4 Kolinsky sable or sable/synthetic brush*
- [] *Palette*
- [] *Jars of clean water*
- [] *Gum arabic*
- [] *Eleven watercolours: Indian yellow, cadmium orange, alizarin crimson, cadmium red, sap green, viridian, violet madder, cobalt blue, Prussian blue, ultramarine, Hooker's green*

► **2** Paint the waterlily leaves using sap green with a touch of Hooker's green. Painting the lighter areas first gives an idea of how the picture is developing. Our artist wasn't entirely sure of the final composition so she was keen to keep the picture fluid at this stage.

► **3** Mix plenty of strong violet madder, adding touches of sap green, and use it to paint around the shapes of the waterlilies with the Chinese brush. Add some gum arabic to a mixture of sap green and viridian, then drop it into the violet madder. The gum thickens the paint and stops the washes from bleeding and diffusing so much. It also helps the paint hold its shape. Our artist used this to suggest the mysterious depths of the pond.

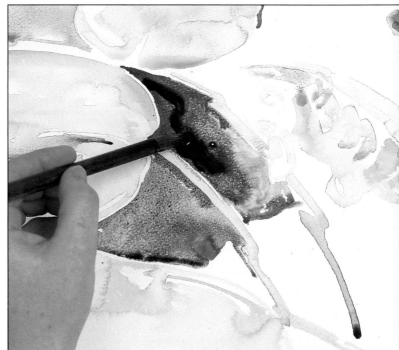

◄ **4** Using your cadmium orange and Indian yellow, paint in the other goldfish. Add alizarin crimson for the darker tones underneath (these strong colours contrast well with the violet madder of the water). Using the Chinese brush, add more washes of violet madder to increase the depth. This also stops the goldfish from standing out too much.

► **5** Mix some gum arabic and sap green and paint the waterlily leaf, then use pure Indian yellow for the fish. Paint the outline of the flower in cobalt blue and sap green, using your No.4 brush. For the murky washes behind the flower, use a mix of sap green, violet madder, blue and other washes from your palette.

Brush over the remaining water area with a wash of violet madder and a little sap green.

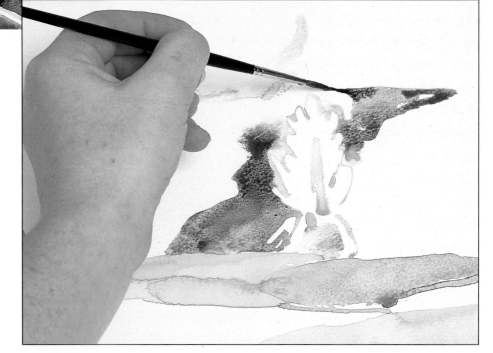

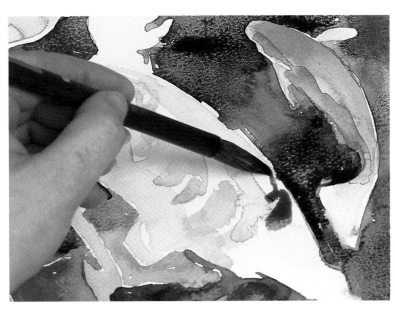

▶ **6** Deepen and darken the water area with a mix of viridian, Hooker's green, sap green and violet madder. Use gum arabic to thicken the paint, so it doesn't flow all over the place, but merges gently into the violet madder. Paint the markings on the large goldfish. Use the Chinese brush and washes of ultramarine, cobalt and a touch of Prussian blue for this – but don't forget to follow the fish's form!

Tip

Removing washes

When you make up the washes, don't worry that they may be too strong. You can lift out small areas with a clean brush or cotton buds/swabs or sponge out sections. If you mix your washes with some gum arabic the paint lifts off the surface of the paper more easily.

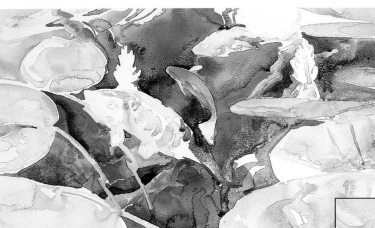

▶ **7** Most of the white paper has been covered by now, so it's a good time to look at the overall balance of the painting. Decide which areas need lightening or darkening. Do any areas need tightening up by adding more detail? Be careful with the reflections and the darker washes in the water. Try to keep them fresh – they can become muddy if you work on them too much.

▶ **8** Add more detail to the orange markings on the fish with Indian yellow and cadmium orange washes. Using the No.4 brush and clean water, wet some of the surrounding wash to flood over areas which are too bright. Here our artist is pulling some of the surrounding madder wash over a fish's tail to increase the illusion of depth. The tail disappears into the water.

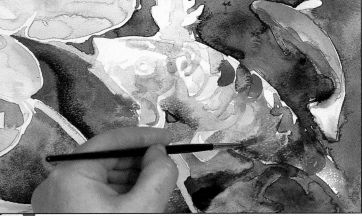

▶ **9** Continue to develop the colours of the large fish, controlling the washes so that some are dry, some almost dry and some still wet when you add extra touches of cobalt blue, Prussian blue and ultramarine to strengthen the markings and to paint the eye. This gives some well-defined edges and some variegated washes that melt into each other.

A wash of cadmium red, ultramarine and cobalt blue brushed over the back of the fish makes the tail recede further. Use the same colour for the fish's mouth.

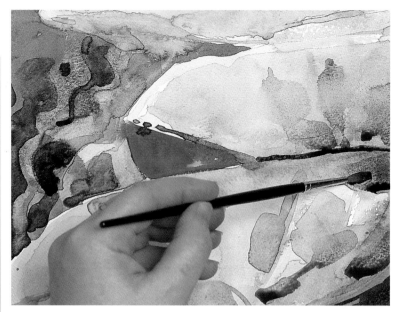

◀ **10** The bottom right waterlily leaf can be toned down using the viridian and sap green wash and adding some of the darker purple washes in your palette. Paint your brushstrokes so they radiate from the centre of the leaf. All this gives weight to the bottom of the painting.

▼ **11** The artist deliberately left the top of her picture pale to stop it 'tilting' forwards. The painting should fade away at the top to give the impression of distance – you are looking across the fish pond. Painting water ripples in a pale cobalt blue wash adds a further dimension to the top left of the painting. Our artist has used strong, bright colours – especially in the main focal area (the centre) of her painting, and she has picked out the shapes of the waterlily leaves with rich, luscious washes of violet madder. She has maintained a balance between the dark and light areas, and between the positive and negative shapes. Most of the washes she used are variegated, which intensifies the colours; very few are overlaid.

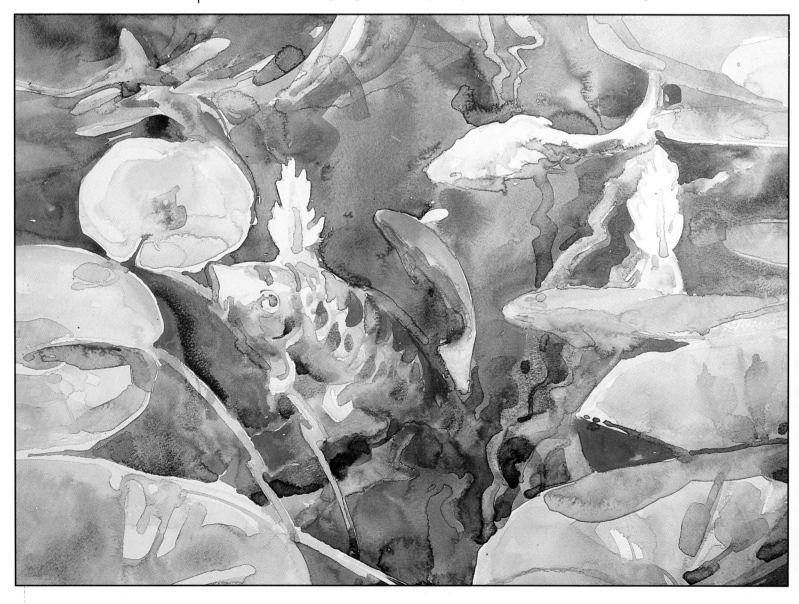

Reflections in the lake

Landscapes are always enjoyable to paint in watercolour – the range of colours and forms in nature is vast and gives you lots of scope to practise the techniques you've learned so far.

Capturing accurate form, tone and a sense of space in a landscape doesn't happen overnight. The more you practise your painting, and the more time you spend observing and interpreting what you see, the better an artist you'll become.

The overall forms of the trees, plants and landscape features in this project are quite straightforward – you simply draw what you see. But rendering their tones convincingly – so they look three-dimensional and lively – isn't as easy. Wet-in-wet, wet-on-dry and overlaid washes are all fundamental to achieving accurate tones. Take a look at the finished painting – the sky is lighter towards the horizon, and the foreground is dark and distinct while in both the middleground and the background you can see that the colours are muted very slightly.

All these 'tricks of the trade' help to give the composition a really convincing sense of perspective, which is one of the key elements in landscape painting.

YOU WILL NEED

- [] *One sheet of 21 x 14in stretched 140lb NOT/cold pressed watercolour paper*
- [] *Two round brushes – Nos.3 and 10*
- [] *A 2B pencil*
- [] *Putty rubber/kneaded eraser*
- [] *One palette*
- [] *Two jars of water*
- [] *Thirteen watercolours: French ultramarine, cobalt blue, cerulean blue, Winsor green, sap green, yellow ochre, Indian yellow, lemon yellow, Winsor violet, permanent magenta, scarlet lake, burnt sienna and sepia*

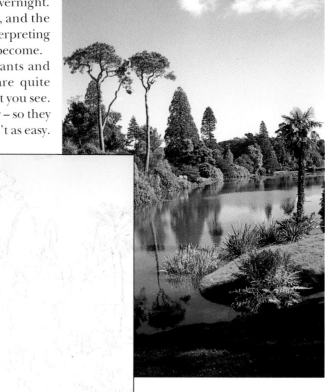

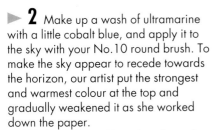

◄ **The set-up** Our artist had several photos of this lake scene. She narrowed down the best ones for reference, but didn't copy them slavishly, using them instead as a guide to help assess tones and forms.

◄**1** Lightly draw the main elements of the composition on the watercolour paper with the 2B pencil, checking all the time that the proportions are correct.

▶ **2** Make up a wash of ultramarine with a little cobalt blue, and apply it to the sky with your No.10 round brush. To make the sky appear to recede towards the horizon, our artist put the strongest and warmest colour at the top and gradually weakened it as she worked down the paper.

Work swiftly and loosely to keep the sky lively and not flat. Leave one or two white shapes to suggest high cumulus clouds.

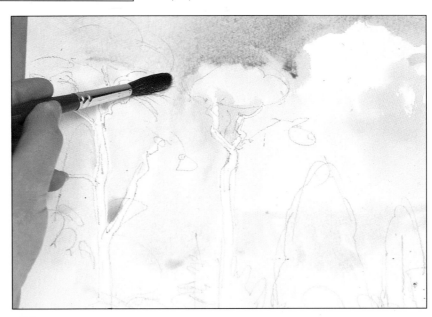

◀ **3** Using the same colour mix, with just a touch of cerulean blue, paint the lake with three broad horizontal strokes of your No.10 brush. Leave streaks and patches of white paper to indicate highlights on the surface.

While this is drying, paint the grassy bank on the right with a pale wash of Winsor green. For the grasses and ferns at the water's edge, use yellow ochre, Indian yellow, lemon yellow and Winsor green, mixed in different proportions to make interesting varieties of cool, sharp greens and warm yellow-greens. Use the No.10 brush for all these.

▼ **4** At this stage you can see the value of using a large brush for the initial stages of a painting; it encourages you to make broad, sweeping strokes which keep the painting fresh.

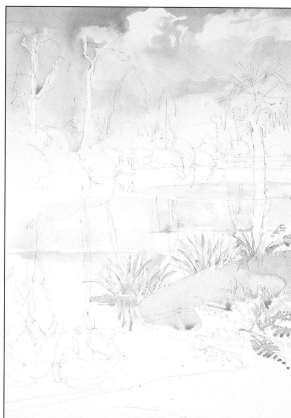

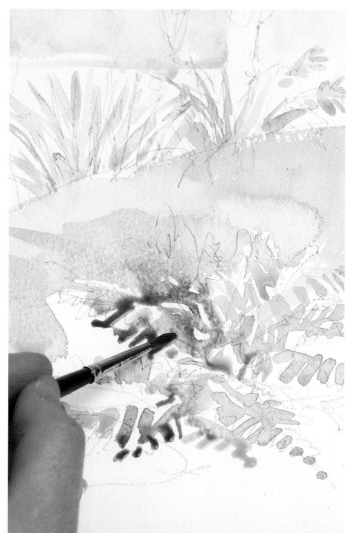

◀ **5** Now add further washes of Winsor green to the grassy bank to represent light and shadow areas. Apply an orange-brown mix of burnt sienna and Indian yellow to the dead foliage at the centre of the fern. Use your No.3 brush for this.

Pools of paint dry much darker than a thin, flat wash (which is readily absorbed by the paper), and they also provide interesting tonal contrasts and crisp edges.

Painting foliage

▲ Lay a flat wash. Then, with a stronger but drier mix, paint over selected areas at random, creating interesting effects.

▲ Dashing a fine round brush in simple lines from a single point is an effective way of creating pointed palm leaves.

▲ For the dense tree tops, lay a dark wash. Then dip the brush into an even darker mix and touch it gently here and there.

▲ Follow the rhythms of the branches with a slightly dry brush to produce this multi-toned fir tree.

▶ **6** Turn your attention now to the two tall Scots pines at the top left of the picture. Paint the trunks with light washes of yellow ochre. (Use your No.3 brush for this and all subsequent steps until you come to step 11.) Fill in some shadows on the left side of the trunks with a light wash of Winsor violet. Then paint the dark branches beneath the tree canopy with sepia and a darker tone of Winsor violet.

◀ **7** Mix a strong wash of sap green, and use this to paint the rounded canopies of the Scots pines. Then dip your brush into an even stronger mix. Touch the point to areas of the canopies. This spreads the paint in a circular effect which, when dry, makes the tree tops appear to burst with clumps of foliage.

Now lighten the wash slightly with a little more water and start to paint the trees in the distance with loose, scrubby strokes.

▶ **8** Just before the first wash dries on the foliage of the Scots pines, touch in a few hints of sepia for the darker clumps – and for the dark left side of the trunks as well – giving form and volume to the tree canopy. The wonderful thing about watercolour is that it can do most of the work for you, if you allow it to.

As this detail shows, the paint spreads of its own accord, forming dark pools in some places and pale transparent shapes in others. All of this adds textural interest to the painting and gives it life and energy.

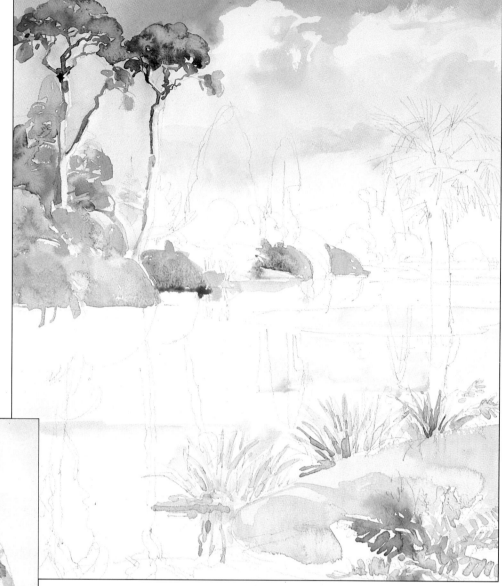

► **9** Now it's time to establish the middleground. Mix a range of greens on your palette using sap green, Winsor green, Indian yellow and yellow ochre. Make smooth washes for the grassy mounds on the far bank of the lake, varying the tones of green as you go. Keep any leftover washes – you'll use them later on.

Make up a mix of permanent magenta and scarlet lake, and paint in the reddish shrubs. Refer to the set-up for their location. Use Winsor violet for their shadows.

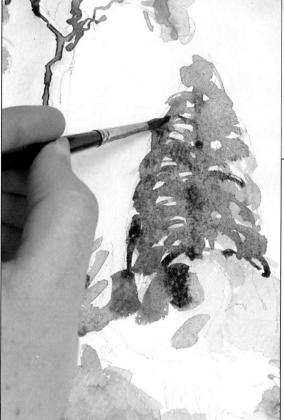

◄ **10** Paint the tall conifer in the centre with a wash of sap green, overlaid with a darker tone mixed from sap green and Winsor green. Again, try to capture the natural shape and rhythm of the tree with your brushstrokes. Don't worry if some of your pencil marks show – you can erase them when the painting is completed.

The artist has left 'sky holes' in the tree. This makes it appear more lifelike, delicate and graceful than if it were painted as a solid block of green.

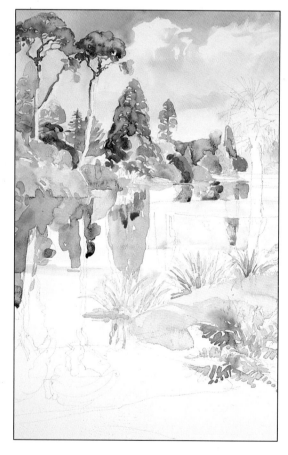

► **11** Switch to your No.10 brush, and start to work on the reflections of the trees in the water. Here the greens are paler and more muted, so add more water to the mixes you used in step 9 and block in the reflections loosely. Add a tiny touch of sepia to some of the greens in the water to give a more neutral tone. Paint the reflection with strong, simple shapes, and allow the washes to spread softly – wet-into-wet – to suggest the smooth, still surface of the water.

▶ **12** Now start to paint the palm tree on the right. With your No.3 brush apply a well diluted, loosely mixed wash of yellow ochre and Winsor violet to the tree trunk. Paint the palm fronds with mixtures of sap green and Winsor green, using the tip of your brush and working wet-on-dry from the centre of the branch outwards. Leave to dry.

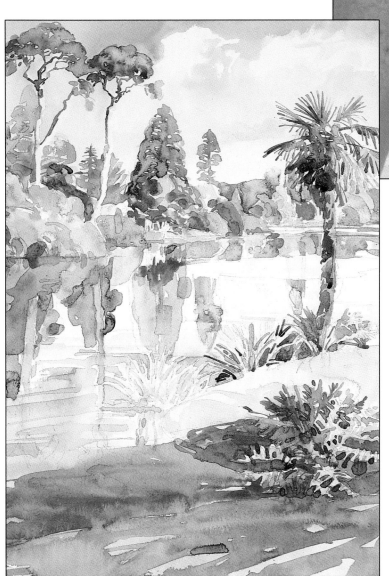

◀ **13** With background and middleground established, start on the foreground. Mix rich washes of ultramarine and cobalt blue, and apply wet-in-wet with your No.10 brush for the dark water. Leave small areas of untouched paper for surface highlights. Paint the foreground grass with a loose sap green wash. Leave to dry slightly, then scrub on more washes of sap green and Winsor green, leaving patches of the lighter tone showing through.

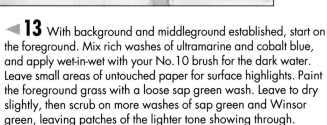

▶ **14** The gentle undulations on the water's surface cause the dark reflections of the Scots pines to lengthen and distort, creating interesting patterns in the foreground.

Mix a rich wash of sap green, Winsor violet and sepia, and paint the reflections with rapid lines and squiggles that capture a sense of light and movement on the water. Use your No.3 brush for this.

Notice how the reflections become darker the closer they are to the foreground, and how the ripples increase in size.

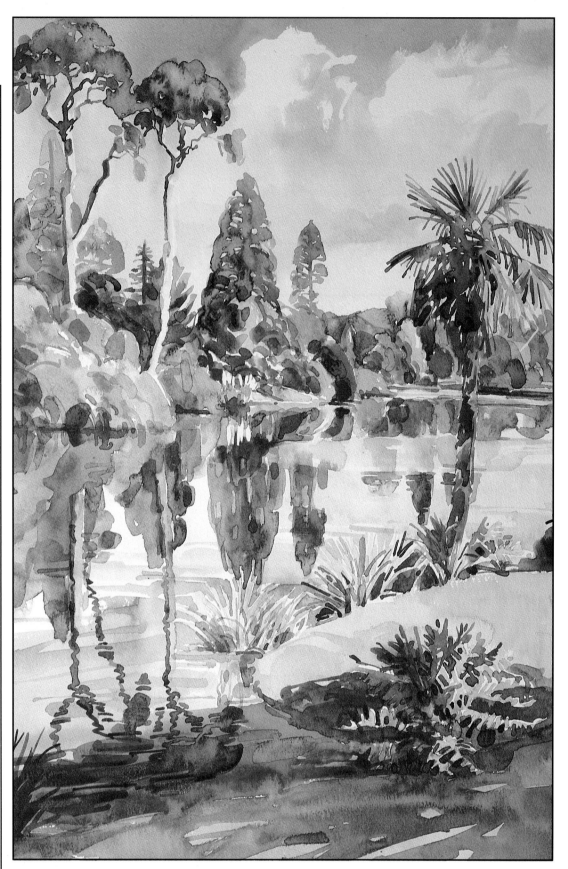

Tip

Marked or unmarked
Some artists don't mind if their initial pencil sketch marks are

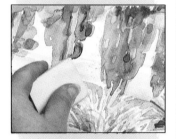

visible in the finished painting because they form part of the working process. If you prefer not to see them, however, remove them with a corner of a putty rubber/kneaded eraser. But do this only when you are absolutely sure your painting is bone dry, or you'll spread still-damp washes.

▲ **15** To complete the painting, our artist strengthened some of the colours in the foreground to bring them forward. This technique increases the sense of space and distance in a painting.

The finished picture is a symphony of colour, pattern and texture, with the calm, glassy surface of the water acting as a foil to the exuberant shapes of the trees, shrubs and grasses.

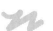

Country crockery cupboard

You'd be forgiven for thinking watercolours and landscapes were made for each other. But don't limit yourself – interiors lend themselves beautifully to the delicate tones and hues of watercolours.

The transparency of watercolours – wonderful for portraying the nuances of landscapes – is just as successful for the intricate patterning and shiny highlights on household crockery. Collect a few objects from around your home and construct an interesting still life. Or you can use our demonstration as a guide.

Before you begin painting, do a few thumbnail sketches of the set-up to help you work out the composition. Then start, as our artist did, by putting down broad washes of neutral colours. Continue by gradually building up the colours, tones and patterns of your objects over these base washes to create a sense of depth.

Our artist made use of many colours (16 in all), adding small amounts of different hues to her washes to create very subtle changes. You don't have to buy all 16 colours – experiment with what you have, trying out different mixes until you find the colours and tones you want.

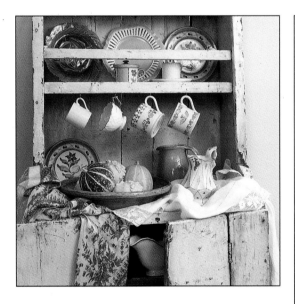

The set-up Our artist chose these objects not only because their colours complement each other, but also because of the interesting textural contrasts between crockery, wood, fabric and vegetables.

YOU WILL NEED

- [] An Imperial (30 x 22in) sheet of rough, 190lb watercolour paper
- [] Drawing board and easel
- [] Masking tape
- [] 2B pencil
- [] Two jars of water
- [] No. 16 round sable brush
- [] Watercolour palette or plates
- [] Masking fluid and small, old brush to apply it with
- [] Sixteen colours: lemon yellow, Naples yellow, cobalt blue, alizarin crimson, cadmium yellow, Prussian blue, yellow ochre, rose doré, viridian, sepia, Winsor red, permanent magenta, terre verte, cerulean blue, raw umber, Venetian red

◀**1** Before you start drawing, look hard at the set-up and think about proportions, the ellipses you can see in the cups and plates and how all the objects relate to each other. Then carefully draw the composition with the 2B pencil. Take your time – the pencil marks serve as a solid foundation to guide you through the painting, so make them as accurate as possible.

◀**2** Mask out the lace pattern of the tablecloth with masking fluid and an old brush. Then, with your No.16 brush, paint the gourds and squashes using varying mixtures of lemon, cadmium and Naples yellows. Work into the objects with the different mixes to build up their rounded shapes. Use clean water to wet the background (the cupboard recess) then paint it wet-in-wet using Naples yellow with dashes of cobalt blue, Prussian blue and alizarin crimson.

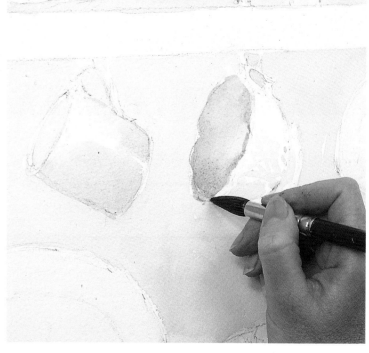

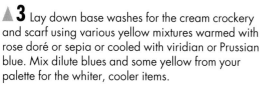

△3 Lay down base washes for the cream crockery and scarf using various yellow mixtures warmed with rose doré or sepia or cooled with viridian or Prussian blue. Mix dilute blues and some yellow from your palette for the whiter, cooler items.

△4 Build up deeper tones on the gourds using your darker yellow mixes, warming them with alizarin crimson. Use alizarin crimson with a dash of cobalt blue to make a cool pink for the hanging coffee cup on the left, its matching cup and saucer and the sugar pot on the shelf. Increase the intensity with a little rose doré to paint inside the white teacup.

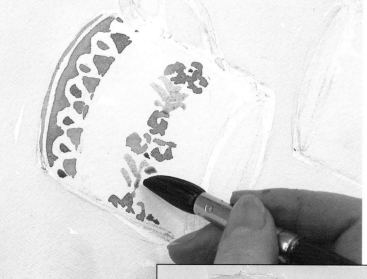

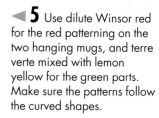

◀5 Use dilute Winsor red for the red patterning on the two hanging mugs, and terre verte mixed with lemon yellow for the green parts. Make sure the patterns follow the curved shapes.

▲ Using a large number of colours means you can recycle your washes, adapting them with the smallest touches of other colours until they look completely different. This makes the most of your washes and gives your painting a sense of unity by linking the colours.

▶6 Dilute your reds to create a cool pink for the centre plate. Put in the pattern on the plate next to it on the right, and on its counterpart behind the vegetable bowl using a dilute mix of terre verte and Prussian blue, with some yellow ochre for details.

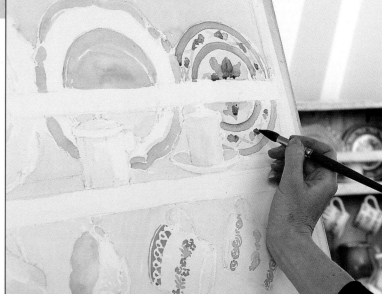

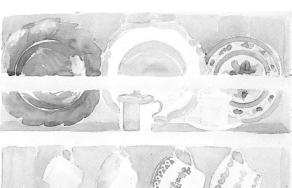

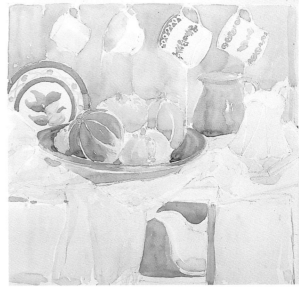

7 Paint the Wedgwood plate on the left with a strong green made with viridian, terre verte and Prussian blue. Mix various consistencies and allow them to run into each other. Make a lime-green for the small sugar pot with Naples yellow, lemon yellow and viridian.

8 Work around the painting, gradually building up tones and colours, bringing everything along at the same rate.
 Make a dark wash of sepia, raw umber, Prussian blue and yellow ochre for the slats in the cupboard recess, varying the mixes for different tones. Mix alizarin crimson and Prussian blue for the shadows inside of the cupboard.

9 Put in the patterns on the crockery and fabrics. Don't try to render detail – aim for impressions. This is your own interpretation of what you see.
 Work into the tablecloth to build up the folds with raw umber mixed with cobalt blue and Prussian blue. Apply this over the masked-out areas to create the shadow behind the lace pattern. Paint the flowers and leaves on the silk scarf.

Tip

Be brave!
When you're working with watercolours, especially on such a large scale, it's best to keep your brush loaded with colour and be bold about your brushmarks. Hesitancy can harm a painting more than the odd mistake. You might find it useful to keep some tissue paper handy to catch drips, although they often add an appeal of their own.

10 Put in the dark lines between the slats of the cupboard with a mixture of Prussian blue and Venetian red. Work up the dark tone on the base of the vegetable bowl with your blues.

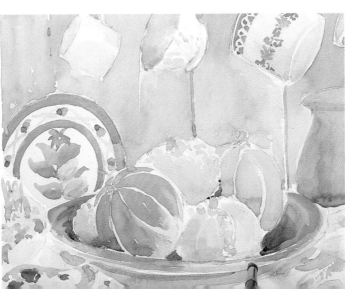

▶ **11** Once the paint has dried completely, peel off the masking fluid by gently rubbing it with your finger. The masked-out areas make crisp shapes with hard edges – perfect for describing the clear-cut pattern of the cotton lace.

Tip

One brush does it all
You don't need many different brushes for a watercolour painting. This size 16 round sable brush copes perfectly well with broad washes, yet comes to a very fine point for the details.

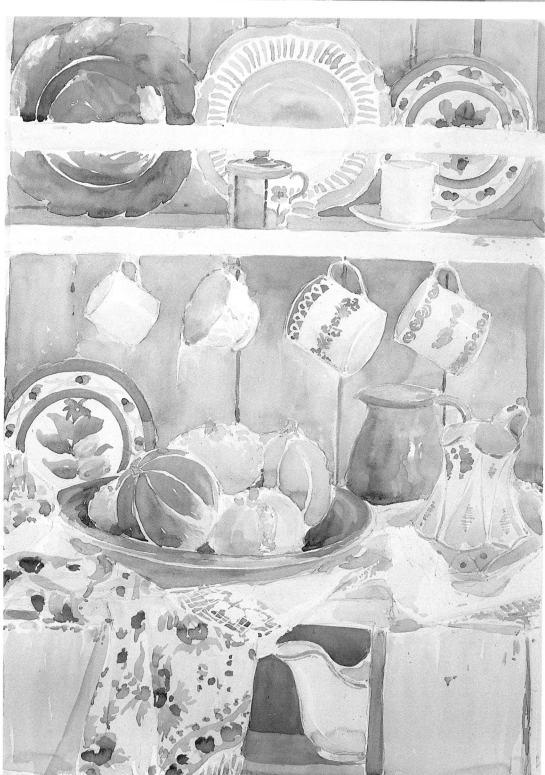

▶ **12** Add the finishing touches to your painting. Our artist decided to knock back the cupboard recess a little more with a dark wash of Prussian blue, Venetian red and alizarin crimson. This had the effect of bringing the cups and fruit forward, giving them solidity.

The subtle shades of watercolour capture the character of this still life, and reveal its different textures – soft fabrics, weathered wood, smooth china and waxy fruit.

Index

Acknowledgements

Artists

Gillian Burrows 28-32; William Callow
(Courtesy of The V&A/Bridgeman Art
Library) 45; David Curtis 51; Roy
Ellsworth 97-100; Shirley Felts 107-112;
William Russell Flint/Bridgeman Art

Library 101; John Harvey 63(c,b), 64-66; R
Maddox 91-96; Caroline Mills 123-126; A
Musker 77-82; Keith Noble 102-106; Penny
Quested 67-70; John Raynes 58-62; Polly
Raynes 17-20, 33(b), 34-38, 57, 113-122;
Ian Sidaway 12-14, 22(c,br), 23-26, 52-56,
83(c,b), 84-90; Stan Smith 71-76; Albany
Wiseman 9, 46-50.

Photographers

Our thanks to the following
photographers: Mike and Julien Busselle,
Jeremy Hopley, Ian Howe, Patrick
Llewelyn-Davies, Robert Pederson, Nigel
Robertson, Steve Shott, Steve Tanner and
Mark Wood.